William Vaughan is Professor of the History of Art at Birkbeck College, London. After studying at the Ruskin School of Art in Oxford and the Courtauld Institute, London, he became an Assistant Keeper at the Tate Gallery, London. In 1972 he was appointed as lecturer at University College, London, until he took up the professorship at Birkbeck. He is the author of numerous articles and books on eighteenth- and nineteenth-century painting, including *Romanticism and Art* (2nd edition, 1994). In 1998 he was chosen to deliver the Paul Mellon Lectures at the National Gallery, London, on the subject of British Painting. Professor Vaughan is married with two children.

World of Art

This famous series provides the widest available range of illustrated books on art in all its aspects. If you would like to receive a complete list of titles in print please write to:

THAMES AND HUDSON
181A High Holborn
London WC1V 7QX

In the United States please write to:

THAMES AND HUDSON INC.
500 Fifth Avenue
New York, New York 10110

Printed in Singapore

1. **Joseph Mallord William Turner** *Yacht Approaching the Coast, c.* 1835–40.

William Vaughan

British Painting
The Golden Age
from Hogarth to Turner

175 illustrations, 67 in color

THAMES AND HUDSON

For Sam

This book has emerged out of classes that I have given on British art
over more years than I care to remember. But I do remember all those
students, past and present, who provided such a stimulus in those
classes and with whom I discussed so pleasurably so many of the
matters that are treated in this book. It is to them that I owe my greatest
debt. I hope that this book will be of use to students in the future as
an introduction to British painting at its greatest moment.

© 1999 Thames and Hudson Ltd, London

First published in paperback in the United States of America in 1999 by
Thames and Hudson Inc., 500 Fifth Avenue,
New York, New York 10110

Library of Congress Catalog Card Number 98-60042
ISBN 0-500-20319-9

Designed by Derek Birdsall
Printed and bound in Singapore

Contents

Painting and the Hanoverian Era

During the period covered by this book, British painting rose from being derivative and provincial to becoming as innovative and challenging as any in Europe. There was a succession of glittering achievements. Hogarth introduced an entirely original way of depicting modern life. Portraiture took on renewed authority – particularly in the hands of Ramsay, Reynolds and Gainsborough. Blake set the pattern for the modern visionary artist. Landscape became a means for reflecting on nature and perception that set a whole new agenda for painting. At the end of his life Turner, the greatest of British landscape painters, was arguably the most advanced artist in Europe. Some of his more 'abstract' works remained without parallel until the twentieth century. Never before or since has British painting played such a critical role in European culture. Even in France, the established leader in the visual arts of the period, it was acknowledged that *le style anglais* had something unique to offer. In the 1820s British painters were widely feted by those interested in reforming the grand French tradition by introducing greater naturalism and modernity. Constable was awarded a medal at the Salon of 1824 for one of his best known works, *The Haywain*, which was admired as a representational *tour de force*.

Naturalism and Modernity are, in fact, the keywords for the British pictorial achievement at that time. We think of such art as traditional now. But in its time it was largely radical and progressive, as was much of the society from which it came.

2. **John Constable** *The Haywain,* 1821. This picture was shown at the Salon in Paris in 1824, where it was awarded a gold medal. Constable embodied the qualities of British painting which were most admired on the Continent and which were to have an influence on Impressionism: spontaneity of brushwork, feeling for nature and bold use of colour.

The new age

It is no coincidence that this great age of painting should have occurred in Hanoverian Britain. Following the 'Glorious Revolution' of 1688 and the securing of a constitutional monarchy, the country experienced a prolonged period of unprecedented expansion in commerce, industry and political power. Britain outpaced its major rivals – first Holland and then France – to become the leading economy in the world.

The age was marked by pragmatism and materialism – tendencies that caused Napoleon to dismiss the British as a 'nation of shop-keepers'. But while the success was fundamentally a commercial one, it was not without its intellectual and moral dimensions. It was widely felt that the 'practical' approach of the British was a consequence of that empirical spirit of enquiry that had distinguished British science and philosophy – as evidenced in the major achievements of Newton, Locke and Hume. The marked naturalistic tendencies so evident in British painting could be related to this spirit of enquiry. Hogarth – the first to address this as a theoretical issue in his treatise *The Analysis of Beauty* (1753) – deliberately placed himself in the tradition of experimentation and observation established by Francis Bacon in the seventeenth century. He rejected the 'abstract' image of beauty in favour of the notion of its being derived from the observation of life and movement, something that he symbolized by the changeable, serpentine line. This was so important to him that he included it as a kind of signature in one of his self-portraits.

Many painters saw themselves as experimenters like scientists. Some, such as the animal painter Stubbs, made original contributions to scientific enquiry; and towards the end of the period covered by this book Constable declared: 'Painting is a science, and should be pursued as an inquiry into the laws of nature.'

The modernity of British painting can also be related to developments within society. Expanding commercial wealth engendered a new audience for art. London became the first city in the early eighteenth century in which a modern urban society developed. While regal and aristocratic authority was not undermined, it had to take its place beside that of the parvenus. It was the 'new rich' merchants and their families who provided the backbone of support for contemporary culture. Less hidebound in their tastes, they enjoyed the treatment of modern themes in their pictures. They constituted a new kind of market – one in which art was treated increasingly as a commodity. This in itself encouraged the painter to become more of an entrepreneur, painting 'on spec'

rather than to commission. Art tended to be sold more and more to a mass market, through the medium of engraving. Engraving is indeed central to the history of painting at this time. It offered a new form of independence to the artist, much like that that which publication offered to the author. It was the engravings after his 'modern moral' pictures, rather than the paintings themselves that established Hogarth's fame and financial security.

In many ways the position of literature was critical for painting in the period. In the self-portrait in which he displayed the line of beauty, Hogarth has his image resting of the books of three giants of British literature – Shakespeare, Milton and Swift. It was in the early eighteenth century that the new mass market for literature was opened up, and this was the one that painters were soon to be able to exploit through engraving and forms of public display, notably exhibition. The new public became literate before it became experienced in the appreciation of visual art. The growth of periodicals, the novel and theatrical perfomances were all signs of their patronage. To a considerable extent, the visual artist built on these phenomena. Hogarth's first modern narratives, his 'progresses', the 'Harlot's Progress' (1732) and the 'Rake's Progress'(1735) grew, as he himself acknowledged, out of the theatre. There was also a close connection with literature through the

3. **William Hogarth** *The Painter and His Pug*, 1745. Hogarth shows himself with his pug Trump (between whom there is clearly an affinity) and a palette displaying the 'line of beauty' that he claimed was the basis of his art. The books on which his portrait rests are the works of Shakespeare, Swift and Milton.

development of book illustration – one of the growth industries in the eighteenth-century publishing world. Turner, for example, was commissioned to illustrate the works of fashionable writers such as Samuel Rogers and Sir Walter Scott.

This literary connection was important for developing a particular kind of modernity in British painting: the attitude to narrative. Narrative in pictures is probably as old as art itself. But in the eighteenth century it took on a new kind of psychological intensity, much under the influence of the novel – for example Richardson's *Pamela* (1740). This aspect of British painting caused it much censure in the early twentieth century, when such promoters of a modernist aesthetic as Roger Fry considered story-telling in pictures to be a sin against the doctrine of 'pure form'. But in the eighteenth century there was no conflict between pictorial form and narration. British artists were highly innovative in the ways they used narrative and characterization in pictures. They also introduced entirely new types of narrative art – such as Hogarth's modern 'progresses' and the modern style of history painting introduced by Benjamin West with his *Death of Wolfe*. Narration also had implications for developments in types of art less obviously concerned with story-telling – notably landscape painting.

4. **Benjamin West** *The Death of General Wolfe*, 1771. This was history painting in a new mode, representing contemporary events in contemporary costume.

Patriotism

The distinctive nature of British art in the period was seen in patriotic terms. Patriotism in the eighteenth century was particularly intense. It was influenced both by pride and fear. There was pride in the growing material success of Great Britain. In a sense this was pride in a new country. It was only in 1707 that England and Scotland became united and that 'Great Britain' was officially adopted as the title of the new amalgamation of nations. Great Britain was a venture based on the new dispensation that had emerged in the late eighteenth century, after the Revolution of 1688 had led to the establishment of a constitutional monarchy. 'Great Britain' had an ideological as well as a commercial aspect. It was based on a Protestant culture, which was seen as providing the basis for free enquiry and commercial success. This was set against what was seen as the forces of conservatism and repression, embodied by continental Catholic cultures, in particular that of France.

It is only by understanding the fear behind this concept, that one can see the full reason for its vehement assertion. Catholicism represented a particular threat because it was the religion of the Stuarts, the Royal Family that had been ousted by the Revolution of 1688. Twice, in 1715 and 1745, the Stuarts attempted to regain their throne, and the Protestant succession was at risk. Fear also influenced relations with France. It was a spur in the series of commercial wars in which the two countries battled for dominance in international trade, and it came to a head in the Napoleonic Wars, during which Britain was for a time severely under threat. Not surprisingly, this was also the period of the highest manifestation of patriotism. It is no coincidence that Benjamin West's new form of history painting should have been launched with a work showing a victory over the French – that of General Wolfe at Quebec in 1760. As political rivalry grew, so did aesthetic. By the Napoleonic period it was being confidently claimed that a 'British School' finally did exist, and that West and other history painters of the period were maintaining a grand and liberal tradition at a time when French painting had gone off the rails in the hands of that dangerous revolutionary, Jacques Louis David. This is one judgement that certainly has not stood the test of time.

Class conflict

Such conflicts can also be seen in terms of class. Essentially the patrician nobles wished to promote a British art that would be international in style, based on the high art of the old masters, particularly the painters of the High Renaissance. For such people

Hogarth's innovative modernity was the last word in brashness and vulgarity.

There was much at stake here. Both groups claimed to be the conscience of the nation. For the nobles, Protestant Great Britain was a rebirth of the noble republic of ancient Rome. They saw themselves as its public moral arbiters – like the Roman patricians. Their independent wealth, they claimed, meant that they were above self-interest and could dispense virtue, justice and taste dispassionately. They saw the promotion of taste in Britain as their public duty and one in which artists played an exemplifying but essentially supportive role.

The bourgeois had mixed feelings towards the aristocrats. On the one hand they despised them for their arrogance and supposed idleness, on the other they wished to emulate their style and status. While more responsive to the 'modern' taste of advanced artists, they did not wish to appear uncultured and needed to be reassured that the art they liked was also tasteful. One of the reasons that Hogarth's success as a painter was relatively limited, despite his evident genius, was because he was not fully able to reassure his clients on this point.

Patronage, clients and the market

This complex situation meant that the contemporary artist was faced with two different kinds of employment. One was the patronage provided by patrician society. The other was the clientèle market offered by the new bourgeoisie. The latter tended to buy rather than commission.

The problem for the ambitious artist was how to balance these two sets of interests. They had on the one hand to pay obeisance to the traditional artistic hierarchy that placed 'old master' painting and history painting at its head. Yet they could not afford to lose touch with the more popular market, where most of the profit was to be made. This tension was not necessarily detrimental to achievement. Indeed it could be argued that the most significant innovations of the period were a result of compromise. Hogarth, Reynolds and Turner all invested their 'popular' art forms of modern life painting, portraiture and landscape, with something of the artistic ambition of old master painting.

One key factor here was the growing sense of status amongst artists themselves. For they were one of the groups being affected by the new expansion of bourgeois status and wealth. They began acting less like traditional craftsmen and more like capitalist entrepreneurs.

The visual artists in this period went to great lengths to make their practice a profession. They broke away from the traditional guild of painters/stainers, leaving this to cater for more down market crafts such as signwriting and house painting. Instead they set up clubs – that characteristic means of organizing both political and commercial power in the eighteenth century. Eventually these were superceded by more rigorous organizations, of which the Royal Academy, founded in 1768, became the most significant.

The Royal Academy was based on the model of the academies that already existed on the Continent, in particular that of France. It was widely valued as the organization that could confer status on the artist. Membership was, according to the Academician James Northcote, 'like a patent of nobility'.

Yet while it secured status, it was also important at a commercial level. Unlike its Continental equivalents, the British Royal Academy was an independent organization rather than a state run one. The Academy needed to make money to survive. Principally it did this by organizing an annual exhibition which drew revenue from admission charges and from sales. Exhibition is indeed one of the most significant developments in the eighteenth-century art market. The Royal Academy was the most prestigious, but was far from being the only exhibition site in London. It had been preceded by the Society of Artists (1760) and was to be followed by many more, notably the British Institution and the two Watercolour Societies in the the early nineteenth century.

5

5. **Pugin** and **Thomas Rowlandson** *Private View at the Summer Exhibition*, 1807. The crowded walls are typical of exhibition methods of the time. As now, the Academy exhibition was an important society event.

6. Thomas Gainsborough
Mr and Mrs Andrews, *c*. 1750.
A country gentleman and his wife
are shown proudly displaying their
land, a statement of ownership
that is at the same time a
naturalistic landscape.

Style and individualism

It has already been suggested that the various forms of art during this period can be related to complex social patterns. But what about style, the actual manner in which particular artists painted? Whether individual pictorial achievement can ever be fully explained in historical terms is an open question. But at least it can be shown that there were distinct economic advantages in developing a personal and readily recognizable style. Innovations of forms and motifs could easily be pirated in this highly competitive market. This is what happened to the hapless portraitist Robinson, who pioneered the vogue for Van Dyck costume in the 1730s, only to be overtaken by more adroit rivals, such as Hudson and Ramsay. A well crafted personal manner, however, could not be so easily imitated. It was a demonstration of uniqueness in a highly competitive world. The most successful painters were those who established an obviously individual style – such as Ramsay and Gainsborough. Less successful painters had to be constantly adapting their style to fit in with current fashions. 7.8

7. **Sir Thomas Lawrence** *Pinkie*, *c.* 1795. A portrait with all Lawrence's vivacity and charm.

8. **Allan Ramsay** *The Painter's Wife (Margaret Lindsay)*, *c.* 1757. The artist's second wife, probably painted soon after their marriage.

9. Sir Godfrey Kneller
Joseph Tonson, 1717. Tonson established the famous 'Kit-Cat' club, whose members included most of the famous politicians and men of letters of the early eighteenth century.

As the status of the artist grew in Britain, so did the emphasis on individual style. This may account for the increasing emphasis on the personal handling of paint. The florid manners of Gainsborough and Lawrence are utterly opposed to the plain matter-of-fact portrait style of the earlier tradition of Godfrey Kneller, Jonathan Richardson and Hudson. With the coming of regular exhibitions this tendency to individualize became stronger.

9

The geography of art

Painting and the graphic arts centred around the major cities. This was where artists did business – either from their studios or through exhibition or the publishing of engravings. This urban market was more important in Britain than in most other European countries, where church and court patronage often played a decisive role. The established Anglican church felt little need for paintings at that time, and the Hanoverian rulers prior to George III were notoriously uninterested in the visual arts. Even after that time the constitutional nature of the British monarchy meant that the court had little influence in the area of public patronage. London remained the principal centre, as it was for most commercial transactions.

There was an overall growth in the number of artists, in both relative and absolute terms. According to estimates derived from contemporary records, the number rose in London from approximately 2,500 to 4,500 between 1801 and 1851. This was a proportion increase well ahead of the general rise in London's population at the time.

London itself became increasingly cosmopolitan. Not only were there people from all over the British Isles working there. There was also a large and increasing international community. Both groups had a strong impact on the art of the period.

But despite this, there was a growth of regional strength; particularly in Scotland with the Scottish Enlightenment and in the north of Britain with the coming of the Industrial Revolution. Even here, however, it could be argued that the dialogue between London and the regions was fruitful. Ramsay's superb and perceptive portraiture can rightly be seen to be a product of that new mode of enquiry promoted by the philosophers of the Scottish Enlightenment. Yet at the same time London provided him with a show case and a stimulus for much of his work. His exquisitely beautiful portrait of his wife has a uniquely Caledonian elegance and refinement to it. Yet it seems to have been used by him as an advertisement to gain clients in London.

8

Similarly Wright's brilliant innovations in subject matter 10 were stimulated by his contact with the new industrialists of the Midlands. Yet it was in London that he sought to exhibit the results of this relationship and gain wider fame.

Gainsborough's delightful early works as a provincial artist in Ipswich reveal a small town world. Yet his art had been formed by his contacts with the rococo while an apprentice in London. And it was to London that he returned, ultimately, when he had been able to climb higher in his profession.

Indeed, rather like the tension between bourgeois and aristocrat, British art is informed by a constant tension between metropolis and province. London might have been the leading partner, but it did not have absolute authority and power. Throughout Britain there were art centres where artists served a local community but kept half an eye on London at the same time. These centres varied greatly from each other. Some were traditional capitals – such as Edinburgh and Dublin. Some were major trading centres – particularly seaports such as Bristol and Liverpool. Some were places that seemed to flourish more because of local traditions of independence rather than for any obvious commercial reason. The most striking – and in many ways the most puzzling – is Norwich. Norwich was a hotbed of radicalism, and a place of intellectual ferment around 1800. Yet it was not one of the new commercial centres. Indeed, its relative position within Britain was declining. However it was the site of one of the most independent-minded of regional schools, led by the earthy figure of the landscape painter John Crome, who delighted in representing scenes from the life 11 and topography of his native city.

Yet even Crome was working for a 'fine' art market and his work was bought largely by the well-to-do and the educated. It should not be forgotten that there were very different sets of local traditions flourishing throughout the country at the same time. Possibly a majority of the pictures produced then were actually made by journeymen painters and printmakers for people living outside polite society. These were the artists who produced paintings of square-shaped prize sheep for yeoman farmers or woodcuts 12 of gruesome murders to be sold to the populace as cheap broadsheets. Sometimes referred to as 'naive' or 'folk' art, this work is rarely either. Popular art is a better term. For its producers were by and large professionals, working to satisfy popular demands, much as commercial artists do in our own society. The late eighteenth century and early nineteenth century was a particularly rich period for such work.

10. **Joseph Wright of Derby**
Experiment with an Air Pump,
1768. Scientific demonstrations
were a popular social pastime
in the late eighteenth century.
Wright is interested in conveying
the conflicting emotions of the
spectators and in the drama of
a night scene illuminated from
a single source.

11. **John Crome** *The Poringland Oak*, *c*. 1818–20. Crome remained rooted in his native city of Norwich and its regional scenery.

Criticism and dissent

Popular art provides, in one sense, an alternative voice. Yet valuable though this is for gaining an insight into the mentalities of communities too little heeded, it cannot be called a voice of protest; but the new sense of the vocation of the artist encouraged a certain level of opposition, a degree of independence similar to that claimed by radical literary authors. It can be seen at its most extreme in the work of William Blake. A lowly commercial engraver by profession, he would engrave anything he was asked to, even a mundane bookplate or a frivolous rococo design. But at the same time he managed to create his own work, exploring a personal vision of the most exalted kind. And what was it that encouraged him to do that? It was the sense that 'an artist' was a person of imagination and insight who could dwell in eternity in his own mind no matter what his personal circumstances. Blake's freedom was strictly circumscribed. But it was, nevertheless, sufficient to enable him to make his protest and inspire others to do likewise.

Like so many other artists working in Britain in the Hanoverian age, Blake discovered new meanings for painting, ones that were to reverberate in centuries to come.

12. **W. Williams** *A Prize Bull and a Prize Cabbage*, 1804. An example of 'popular' art made for a local clientèle. In this case, a farmer appears to be recording his wife as well as his prize produce.

Chapter 1: Portraying Society: Hogarth's Modern Moralities

13. **William Hogarth** *Marriage a la Mode: I: The Marriage Contract*, 1743.
The Earl (his gouty foot bandaged) is on the right, his foppish son, marrying
for money, on the left. In the centre is the bride's father, a city merchant.

Vitality. This is a word that comes to mind readily when looking at a picture by William Hogarth (1697–1764). Whether it is a harsh satirical print or a sensitive study in oils, e.g. the artist's servants, it will always be full of life and movement.

Hogarth is a phenomenon, whose importance reaches far beyond his own time. He was, of course, deeply engaged with the world he lived in. His work was thoroughly commercial and political. He was no paragon, either. He had his charitable side, it is true, and was capable of great kindness. But he was also arrogant and argumentative, frequently verging on paranoia. He schemed and grafted, sought office, was savage and unfair to his enemies. His later life was isolated and bitter. Yet he remains one of those innovators who change the nature of the art they practice.

His central achievement was the invention of the 'modern moral subject' – the series of pictures that tells a story of contemporary life to show up the foibles of the age. From 1732, when the engraved version of the first of these – the *Harlot's Progress* – was published, he was a celebrity; not just in Britain, but throughout Europe. Indeed, he was the first British painter ever to achieve international fame. This in itself made him a leading figure in the school that was just coming into being. It gave an incalculable boost to the confidence and prestige of his fellow artists. In that sense he is undoubtedly what he has often been called, the 'father' of the British school.

Anti-Hogarth

Hogarth's reputation as a modern moralist is secure not just because he invented a new type of picture, but also because of the skill he brought to the realization of his cycles; his mastery of pictorial narrative, his biting wit, his courage in tackling difficult and unpleasant subjects. He was as well a superlative handler of paint – despite being largely self-taught. No one in his own generation could match him, and few since have surpassed him. Given these facts, it seems strange that Hogarth inspires so much antipathy in certain historians and critics. Disdain for Hogarth has been as constant as his fame.

I think the main problem here is that he appears to the arbiters of good taste to be impossibly vulgar – what the Bloomsbury critic Roger Fry (one of his opponents) called a *primaire* – the French term for a small-minded bigot. Despite his matchless skills as a painter – and indeed his sensitivity to paint – he seems to be dragging art out of the temple and into the gutter. He has never been quite forgiven for this by the art establishment, even to this day.

Hogarth's popular acclaim, despite the best efforts of certain aristocratic connoisseurs to thwart him, was also a sign of the limits of their power. The new commercial market was too resilient for the patricians to able to impose taste on it from on high. Hogarth knew this better than most, for he had grown up in this world, and suffered from it. His father had been an early victim of the new world of commercial writing, the 'Grub street' of early eighteenth-century journalism. A Latin teacher who became bankrupt through failed attempts to publish a dictionary, he ended up in the debtors' prison. As was habitual in those days, his family went with him. It was an experience Hogarth shared with Dickens, who also ended up in the Fleet as a result of his father's bankruptcy. Perhaps this is one of the reasons why Dickens was such a passionate admirer of Hogarth. For both of them knew about London life in the raw. Hogarth grew up in a family with high intellectual ambitions and grinding poverty. When he showed skills as an artist he was apprenticed to an engraver rather than to a painter. Engraving was the humbler and more practical craft. Apprenticeship in it also cost less.

It was his skill as a satirist that first brought him success. The early eighteenth century was a great age of satire. At its highest level – as promoted by Shaftesbury himself – it had the sanction of antiquity. For moral satire had been practiced in ancient Rome. The poet Pope modelled himself on such work in such mock-heroic satires as *The Rape of the Lock*. Jonathan Swift used biting irony in his tales of *Gulliver's Travels*, which lampooned contemporary society and politics. It was a sign of the new and more open society that invectives could be launched so freely against the great and powerful. Hogarth began at the low end of this market, with comic satirical prints. His targets were often political, but he also launched his salvoes against the pretentions of high art.

Perhaps rather unwisely, one of Hogarth's earliest targets was the 'arbiter' of taste, Lord Burlington and his pet architect William Kent. In one print he shows the two promoting a grandiose 'Academy of Art' which stands uncared for in the back of the print, while the populace rush to see a popular rendering of *Faust* in the foreground.

Hogarth himself, however, had a higher ambition. At the same time as he had set up as an independent print maker, he had also enrolled at an art academy and begun to consort with fine artists. His progress surprised everyone, particularly as he was largely self-taught. By the late 1720s he became adept at the new informal

type of 'Conversation' portrait (see Chapter 3) that was then coming into vogue. For a few years Hogarth was the leading figure for Conversations, bringing his unique sense of wit and vitality to the practice. The Conversation that truly made his name, however, and which actually caused his career to develop in a quite different direction, was not the normal kind of domestic gathering. It showed the final scene of one of the most popular plays of the day, John Gay's *Beggar's Opera*. On one level it was a portrait group – for it shows the actual actors who performed the play as well as some of the audience. On another level it was a subject painting, relating the dénouement of the play. Gay's 'opera' simultaneously mocked the fashionable taste for Italian opera and the pretensions of the high in society. Telling a story about London's low-life criminals and prostitutes, it implied that there was little to distinguish these from the rogues who ran the country. The only difference was that the former were caught and punished for their misdemeanours. The satire was aimed at the corrupt – though highly effective – administration of the Prime Minister Robert Walpole.

14. **William Hogarth** *A Scene from 'The Beggar's Opera'*, 1729–31. The denouement of John Gay's highly popular 'Beggar's Opera' which satirized the society of the day. In it the condemned highwayman Macheath is shown having to make a choice between the two women who love him.

Harlot, Rake and Marriage

This success gave Hogarth the notion of creating his own satirical narratives in a cycle of pictures. The idea seems to have grown by stages. At first he designed a single scene – showing a prostitute in her lair counting her takings from the night and about to be arrested for immorality. But soon he saw the advantages of extending the narrative to a cycle of scenes that could tell a larger story.

The single scene became the third in the enlarged narrative. Even on its own it encapsulates Hogarth's skills as a pictorial story-teller. He knew the importance of making a first impression, of striking with 'one blow'. We are drawn into the picture by a central moment of eroticism, the whore is seated on her bed half-undressed, exposing a tempting nipple. Gradually, as our eye moves from her to survey the room, we become aware of telling details that add to the narrative. We spot the goods she has stolen, the squalor of the surroundings, the prints that show her twin admiration for highwaymen and popular priests – another Hogarthian analogy. Finally we notice the arrest party coming in at the back, the leader pausing in a moment of lust at the sight of his victim's undress, a mockery of the spectator's reaction.

Each picture tells its own tale. Yet these link together to form a grander narrative. There are a series of moves. Starting with the innocent young girl arriving in London from the country each picture represents a loss; the loss of virtue, of status, of liberty, of

15

health, and finally of life. Such story-telling pandered to bourgeois morality, demonstating the maxim 'The Wages of Sin is Death'. It had a mythic simplicity about it. But there were more complex undercurrents as well. For while providing moral uplift, it also offered sensuous gratification with its glimpses of naked flesh and hints at unbridled passion. For the thoughtful there was yet a further dimension. For was not Hogarth also implying that we, the spectators, colluded in the horrors we were witnessing by complying with the hypocrisies that made such double standards possible?

Hogarth was quick to recognize he had hit upon a winning formula. With characteristic astuteness he swiftly took moves to secure his position. He arranged for a copyright bill to be passed that would protect the authorship of original prints (an act that transformed the fortunes of printmakers in Britain). Then he set out to produce engravings after other series of paintings of 'modern moral subjects'. *The Rake's Progress*, produced in 1735, was designed as a counterpart to the *Harlot*. This time the 'progress'

16

16. William Hogarth *The Rake's Progress: VI: The Rake at a Gambling House*, 1735.
The sixth scene in Hogarth's life of a Rake. The profligate has just lost all his money gambling and is cursing the heavens for his misfortune.

told is of the son of a miser, one of the 'new rich' merchants, who squanders his patrimony and ends up in madness. As before, Hogarth followed the example set by *The Beggar's Opera* and crammed his scenes with thinly disguised portraits of contemporary notables. The locations too, are specific. The Rake is arrested in the fashionable area of St. James. When he engages in a disgraceful marriage it is in an out of town chapel at Marylebone.

Hogarth flourished by means of the new market. He became a 'brand name' for rumbustious social satire. But he paid a price. For once he had achieved this reputation, he could not be taken seriously as the more elevated kind of artist that he also sought to be, the painter of histories and grand portraits.

Hogarth's success occured at a time when the art world was expanding rapidly. Artists were increasingly combining together in clubs and promoting their higher ambitions. He was an enthusiastic participant in this movement. He had married the daughter of Sir James Thornhill (1675/6–1734), the most prestigious British artist of the older generation, who had, amongst other things, decorated the Great Hall at Greenwich. Thornhill ran an academy, and when he died in 1734, Hogarth took this over. The 'St. Martin's Lane' academy, as it became known from its location, created a focus for a lively circle of painters committed like Hogarth to a humorous and satirical modernity in their art. Their art was influenced by the painterly wit of French rococo art. Francis Hayman (?1708–1776) was the artist who used this with most appeal and charm. Like Hogarth he was employed to provide decorations for the pleasure gardens at Vauxhall, one of the principal public meeting places for the new society. As will be seen later (Chapter 6) Hayman also developed a career as a history painter. Hogarth also began to try his hand at 'serious' history painting,

17

17. **Francis Hayman** *The Milkmaid's Garland*, c. 1741–42. A decorative scene for the famous pleasure gardens at Vauxhall.

18. **Joseph Highmore** *Samuel Richardson's Pamela. II: Pamela and Mr B. in the Summer House*, 1744. This is one of a series of illustrations to Richardson's novel, concerning the fortunes of a virtuous bourgeois girl who resisted the advances of the aristocratic 'Mr B' until he offered his hand in marriage.

donating works to institutions where they would be on public display – such as St. Bartholomew's Hospital. It may be that his reputation as a satirist undermined his chances of success here. But it must be admitted that there is some justice in the verdict of his contemporaries. Despite his qualities as a painter, these large histories lacked the originality and acuity of his satires. At worst they are mawkish, at best dull imitations of old masters.

By 1740 Hogarth was also being challenged on his own pitch; that of the modern narrative. This was, perhaps an inevitable development. But it was speeded by a change of mood in society. With the growth of bourgeois power, biting satire was giving way to the celebration of decency and expression of sentiment. The hero of the new age was Samuel Richardson, a successful printer turned novelist. His *Pamela, or Virtue Rewarded*, became a bestseller when it was published in 1740. It tells the tale of a virtuous middle-class maiden who finally manoeuvres an aristocrat into marrying her after having resisted his attempts at seduction. Richardson introduced a new form of novel – that based on a series of letters. This both gave the book a heightened sense of realism and also introduced an intimate tone. There was less scope in the narrative for the theatrical engagements used in Hogarth's 'progresses'. The new mood was brought to painting by Hogarth's rival Joseph Highmore (1692–1780), in the series of demure depictions of scenes from the book. They seem tame enough to us now. But at the time they were seen as providing precisely the

18

refinement and decorum that Hogarth lacked. It is significant that Richardson's heroine should be a bourgeois marrying a nobleman. For while the bourgeoisie might criticize the aristocrats, they still wanted to emulate their power and status.

The latter part of Hogarth's career was coloured by these challenges and set-backs. He tried simultaneously to oppose and absorb them, in a manner that became increasingly schizophrenic as he got older.

Marriage a la Mode, his next 'modern moral subject', shows him attempting simultaneously to demonstrate his skills as a 'high' artist and attack high society. Richardson's *Pamela* had adumbrated an ideal rapprochement between the bourgeoisie and the aristocracy. Hogarth's *Marriage*, mapped out a much less satisfactory alliance.

As in the case of the two 'Progresses' the story has an inexorable end. This time the two main characters are bound together in a loveless marriage; both meet death. The series lampoons high society mercilessly. The first scene shows the interior of an aristocrat's house, stuffed with copies of old masters. This was part of Hogarth's complaint that old masters were flooding the market while good British painters were left to starve.

The satire is as telling as ever. But one cannot help feeling that there is something chilling about its unrelieved pessimism. This becomes clearer when one contrasts him not with Richardson but with the other great novelist of that age, Henry Fielding. Fielding was an admirer and active supporter of Hogarth. He shared his wit and vigour and was equally censorious of the priggish moralizing of Richardson. But in his own work – particularly his great novel *Tom Jones* (1749) – there are heroes who personally triumph over the iniquities of the age. In Hogarth there are no heroes, only wrong-doers and victims. Perhaps even more chilling is his implication that it is folly, rather than evil, that usually leads to punishment. Unlike Fielding, Hogarth had no solace to offer to a sentimental age. On the other hand, he could be seen to be the more modern of the two in his bleak and anti-heroic view of humanity.

Theory and politics

Meanwhile Hogarth's skill as a painter continued to improve. His recent attempts to establish a practice as a society portraitist had accustomed him to introducing a greater level of *finesse* into his painting manner. His engraving style, however, had not been

19. **William Hogarth** *Captain Thomas Coram*, 1740. Hogarth's magnificent picture of the old sea captain who established the Foundling Hospital. The pose is that of the aristocratic portrait, but given realism and immediacy.

13

19

The Royal Charter

Painted and given by W. Hogarth, 1740.

similarly refined, and it was probably for this reason that he decided to commission a fashionable French engraver to reproduce the *Marriage* series, rather than do the work himself.

Hogarth also attempted to secure his position as a painter by establishing a reputation as a theorist. As has already been seen, his self-portrait of 1745 shows his image resting of three volumes of the great English authors, Shakespeare, Milton and Swift, to give literary authority to his work. On the palette in front of this is inscribed a serpentine motif with the telling title of 'the Line of Beauty'. This was to become a symbol for his notion that beauty arose out of life and action, rather than out of the abstract symmetries promoted by conventional art theories. He later elaborated his argument in a treatise *The Analysis of Beauty* (1753). This was a difficult and sometimes contradictory work. Yet it made an impact (typically more in Continental Europe than in this country) for the freshness and acuity with which he related pictorial beauty to experience and observation.

It was part of Hogarth's sense of the importance of the artist that he also sought to be active politically. Indeed, he may have been encouraged to do this by his relative lack of success in the 'higher' realms of art. Only through political alliance, it would seem, would he have a chance of the preferment he craved. His personal ambition to become a Royal Painter – something that had been thwarted in the 1730s when he failed to gain permission to paint the Royal Family – was achieved in 1757 when he engineered his appointment as Sergeant Painter to the Monarch. For some time before this he had affected a great show of patriotism. This was a promising line to take in an age that was witnessing increasing conflict with France and which had experienced the trauma of the Jacobite rebellion of 1745. Hogarth signed himself on occasion 'Britophil'. He moved patriotism into the artistic sphere by launching attacks on foreign artists and on the authority of the old masters. After 1745 he painted patriotic propaganda pieces – notably the *March to Finchley*, and '*Oh the Roast Beef of Old England*'. The latter, which comments on the poor diet of the French, also contained a typically belligerent incident in which he had been involved. For it shows him being arrested on suspicion of being a spy for sketching the gate at Calais. This is also the time when he embarked on a series of simple, moralizing, didactic prints, such as *Industry and Idleness* (1747), *Beer Street* and *Gin Lane*, *Four stages of Cruelty* (1751). The last was issued as a series of crude woodcuts in order to give them a wider and more popular circulation. These later works attempt to show positive and virtuous

3

20. **William Hogarth** *An Election: IV: Chairing the Member*, 1754–55. The chairing of the victor of a corrupt by-election. The newly elected Member of Parliament starts at the sight of a skull and cross bones, while the shape of a goose flying past in the sky mimics the foolish appearance of his head.

action as well as vice. But he was never fully at home when arguing on the side of the angels. These pictures lack his habitual vigour.

In 1754 Hogarth embarked on his last and most elaborate 'modern moral subject', *An Election*. This time the series consisted of no more than four scenes and each is crammed with incident, as though he were attempting to provide a panorama of the whole political scene. As before they contain thinly disguised portraits. The victor in Hogarth's fictional election bears an uncanny likeness to the portly turn-coat politician 'Bubb' Doddington, who had recently won a notoriously corrupt by-election in Oxfordshire. In the last scene the victor is about to topple from the precarious chair in which he is being paraded triumphantly. In the sky above is a flying goose whose profile bears more than a passing resemblance to the politician's fat silly head and fluttering pigtails.

Despite its evident skill, Hogarth's work was still seen by most as being no more than comic burlesque. In a desperate move, a year after the *Election* series was completed, he made one last bid to achieve success as a history painter by painting *Sigismund* (1759) in imitation of seventeenth-century Italian art. But once again the

20

critics pronounced him incompetent in this area and the patron for whom the work was painted rejected it. The picture is, in fact, a perfectly competant but utterly unremarkable piece of work.

After this last setback Hogarth virtually gave up painting. But he did not give up his combative role. Partly because of his sense of his position as Sergeant Painter he entered into some ill-judged attacks on the critics of the monarch, in particular the populist politician John Wilkes. These led him to produce some elaborate prints, reminiscent of his early political cartoons and curiously out of date in a period when a new form of political cartooning involving portrait caricature was coming into being, and which was soon to be brought to its own pitch of brilliance by Gillray (see Chapter 8). Hogarth had been a bitter opponent of caricature, which he saw as something that undermined the seriousness of comic history painting. Yet his own political satires were at their best when they came closest to it and the caricaturists whom he despised were in fact the one group of artists in Britain who genuinely admired him and sought to follow his example.

Hogarth was now in a sorry position. Isolated, with a sense of persecution, and in ill health, he felt his end was near. Only a few months before he died he made an engraving entitled *Bathos* in which he depicts his own artistic demise. Sadly he thought he had failed. He had been ignored by the artistic hierarchy. There were younger generations succeeding in portraiture and history, taking courses quite opposed to his own. The only artists who admired him were the caricaturists of the street. And the only places where he was taken seriously as an artist were abroad – in France, Germany and Italy – a strange fate for a xenophobe. It was not until the mid-nineteenth century that the range of his ability as a painter became evident to his fellow countrymen. 21

This was when such wonderful works as *The Artist's Servants* 22 and *The Shrimp Girl* came to light, showing an intimate side so little known to most of his contemporaries. They provide precisely that element that seemed so lacking in his most famous satires. They contain a genuine sense of sympathy and humanity that he seemed only able to reveal in his private life. It is a reminder of that charitable streak in him that had made him a supporter of Captain 19 Coram's Foundling Hospital and take orphans into his own household. This side is kept in check in his most public works, it is true. Yet in one sense it is present. For that vigour so evident in all his painting, drawing and engraving makes even his most savage critiques convey a sense of affirmation.

21. **William Hogarth** *The Artist's Servants*, c. 1750–55. Hogarth's vivid studies of his own servants show the more intimate and humane side of his art.

22. **William Hogarth**
The Shrimp Girl, before 1781. An example of Hogarth's wish to escape from academic and fashionable subjects to 'a blooming young girl of fifteen'.

Chapter 2: The Portrait Business

Portrait-painting ever has, and ever will, succeed better in this country than any other. The demand will be as constant as new faces arise; and with this we must be contented, for it will be vain to attempt to force what can never be accomplished...

Hogarth's bitter assessment of the supremacy of portraiture in Britain in the eighteenth century was supported by numerous voices, both inside and outside the country. Britons were obsessed with portraiture, and there seemed to be no other occupation that a painter could follow that could offer comparable rewards.

There appears to be no clear reason why the British should have favoured portraiture more than others. Perhaps the problems of status, connected to the extremely commercial nature of British society had something to do with it. The Swiss miniaturist Rouquet observed that the British were particularly concerned to ascertain the precise social standing of each new person they met. Portraiture was certainly a means of asserting status; a skilled portraitist could give you the airs of a gentleman or lady. Bunbury's cartoon *A Family Piece* shows a painter with a fixed toadying smile on his face about to turn an unprepossessing (and undoubtedly 'vulgar') family into a set of celestial deities. Portraiture may, too, have been favoured on account of that pragmatic streak mentioned earlier (see Introduction), whereby the British seemed to value in particular the arts of observation. From this point of view it is worth recalling that portraiture in the larger sense is the common theme behind the majority of British paintings of the period. For as well as 'face painting' there was Hogarthian portrayal of society, the portraiture of animals and even, if you chose to look at it like that, the portraiture of places, which is more commonly called topography. Portraiture also infiltrated the higher genres – in particular history painting. To a quite remarkable degree, in fact, portraiture set the agenda for other forms of painting at this time.

The portrait ideal

Portraiture was a commercial necessity for most artists. But it should not be assumed that the practice was without its nobler side. While not as elevated as history painting, portraiture could be seen as a worthy calling which involved artistic and intellectual ideals as well as ample remuneration.

In the first place, portraiture could be seen as a means of displaying familial reverence and recording greatness. This is how it had been justified by such classical commentators as Pliny the Elder. In the eighteenth century, when the model of republican Rome figured so large in the minds of the British patricians, such arguments carried particular weight. These dignitaries were not averse to aligning themselves in their portraits with the orators and philosophers of the classical world, often adopting the same dress (a practice, incidentally, virtually unknown at the time in Continental Europe)

The traditional argument that there was a value in recording the features of the great was reinforced in the eighteenth century by the pseudo-science of physiognomy. The most celebrated treatise was the Swiss theologian Lavater's *Essays on Physiognomy*

24

23. **William Dickinson**
(after Henry Bunbury)
A Family Piece, 1781.
A portrait painter sets about flattering an unprepossessing family.

A FAMILY PIECE.

24. **Henry Fuseli** *Bust of Brutus*, engraving for Lavater's *Essays on Physiognomy*, c. 1779. Lavater's influential book on physiognomy claimed that the shape and features of a head were a guide to the reading of character.

25. **Roubilliac's** *Artist's Lay Figure*, c. 1740. Lay models were frequently used by artists for posing figures.

(1775–78), in which the face was proclaimed to be the 'seat of the soul'. From this point of view the assiduous 'phizmonger' could become more than a conniving flatterer. He could aspire to record the true lineaments of human achievement.

The practice of portraiture could also be used to elevate an artist's own intellectual and social status. 'A portrait painter must understand mankind, and enter into their characters, and express their minds as well as their faces…' wrote the portraitist Jonathan Richardson in his *Essay on the Theory of Painting* (1715). He added 'and as his business is chiefly with people of condition he must think as a gentleman and man of sense, or it will be impossible to give such their true and proper resemblances.'

Richardson emphasized the need for the portrait painter to have a proper aesthetic education, gaining that familiarity from the classics and old masters; this was held to be acquired most successfully by a study visit to Italy. Richardson himself made such a journey, as did nearly all the portrait painters with leading practices in Britain in the eighteenth century, the notable exception being Gainsborough.

The practice

The portrait business was the most highly organized and structured aspect of artistic practice at the time. By its very nature, it involved a more intimate connection between client and artist than did most forms of picture making. The portrait painter had to run his studio efficiently, receiving sitters at regular times, providing them with examples of his work from which to make choices about pose, expression and gesture. He usually had a gallery where some of his wares could be seen, and also (if he were well established) with engravings after his most successful works for other people. Then the studio had to be decorated and laid out in a manner that would set people of quality at their ease. Every successful portraitist had to be a good diplomatist, able to engage the client in the right kind of conversation and to observe them at their best. There are stories of painters dancing round the studio with pale-faced ladies to heighten their complexion; and one, Francis Hayman, even entered into a bout of fisticuffs with a male sitter to work him up to a ruddy glow! They had to be up to date with fashion, to know what the young and attractive lady would like most. But they had to have a keen sense of type, and not press an old and gruff individual into some absurd modernity.

As can be seen from surviving records – such as Sir Joshua Reynolds' sitters books – artists would take sittings at regular intervals. The number needed varied according to the practice of the painter and the importance of the sitter. But at very least a one hour sitting for a study of the face. For while many other aspects of the portrait, such as the pose and the costume worn, could be completed using models, the face had to be studied live to give conviction.

Before the commission could be confirmed, it was necessary for the painter to have agreed with the client what type of portrait was to be painted. Was it to be full-length, standing, seated, half-length, a bust, or maybe a group?

Type of portrait was in fact critical. For while each person wished to be seen as an individual they also wished to conform to some social ideal. Passing through any collection of portraits of the period, one can see the same poses and gestures emerging again and again. There is, for example, the grand male portrait of command with arrogant expression and pointing finger; the decorative female, decked out as a nymph or goddess. Then there are the 'relaxed' modes, where the individual might be shown on a country estate or reading a book in an interior. There are depictions of people (usually men) of intellectual distinction or creative achievement, in which genius is intimated by the adoption of a pose of thoughtfulness, forehead bulging forward, or by an upward glance of inspiration.

Size, too, was codified. Most portrait painters used pre-made canvases of standard shapes provided by professional canvas-makers. For single portraiture (by far the most common), they remained the same throughout the period. There was the full-length, the three-quarter length, the half-length, the 'Kit-Cat' (a head and one hand) and the simple bust. Larger group portraits usually required canvases that had to be specially made – something that in itself enhanced their prestige.

Artists also had graded prices commensurate with the size of canvases and number of figures depicted. These varied from painter to painter, but a typical price in the 1750s in a successful London practice was 24 guineas for a half-length and 48 guineas for a full-length. Such prices, when compared with an average labourer's wage of £20 a year, show that such portraits were only for the wealthy. On the other hand, it should be remembered that portraiture could come considerably cheaper than this when practiced by itinerant painters and semi-professionals – such as those discussed in Chapter 11 At the other end of the scale a modish

painter could do very much better. Top of the league was Reynolds, who at the height of his success demanded 200 guineas for a full-length and 100 for half-length. These prices were substantial even within Britain. They were unheard of for painters in other countries. Pompeo Batoni, for example, the most fashionable portrait painter in Rome in the mid-century, could only command 60 guineas for a full-length. All this emphasizes how very lucrative the British portrait trade was; and it says something for the skill of local artists that they were able to provide a product that satisfied demand and kept foreign competition at bay.

All types of portraiture focused on the head – usually placed centrally on the canvas no matter what the pose. In the case of highly organized studios – such as that of Sir Godfrey Kneller – this might be all that the artist himself would execute. The picture would then be passed over to assistants to complete the body, drapery and background. Frequently – particularly in the

26

26. **Sir Godfrey Kneller** *Richard Boyle, 2nd Viscount Shannon*, 1733. An unfinished portrait, showing the common practice of completing the face before proceeding to the rest of the picture.

mid-century when a new and more intensive practice of portraiture began – the picture would be farmed out to a specialist drapery painter to complete the costume. The most famous specialist of this kind was Joseph Van Aken, who was much used by Allan Ramsay in his early years. 32

While large scale group portraiture was relatively rare (doubtless prohibited by time, complexity and cost), the period abounded in that particular kind of small-scale group portrait known as a 'Conversation'. This genre is so important that it will be treated in a separate chapter (see Chapter 3). Although Conversations were occasionally painted by most portraitists, it was usually the domain of a specialist.

Another important specialist was the miniaturist. Unlike their counterparts in the Elizabethan and Jacobean periods, Hanoverian miniatures are overshadowed by more glamourous and innovative full-scale portraits. Yet we should not forget that they were often works of superlative craftsmanship and observation – for instance, those of the charming high-living Richard Cosway (1742–1821). 27 Relatively cheap and quick to execute, miniatures were in fact by far the most numerous kind of portraits produced. They tended to have intimate associations, like the snapshot today. They would be exchanged as gifts. Lovers would secrete a lock of their beloved's hair in the frames. Wives would wear miniatures of their husbands, as Queen Charlotte does in the grand full-scale portrait of 57 her by Lawrence.

The miniature is an intimate form of portraiture. But it is no more likely to be an introspective one than the full-scale work. Perhaps because of its commercial nature, it rarely shows any form of complex psychological exploration. Only amongst artists involved with the notion of the spiritual can one find such work towards the end of the period. The dramatic painter Fuseli produced a number of anguished self-portrait drawings. Probably the 80 most beautiful and sensitive example of this tiny genre is the self-portrait by the landscapist Samuel Palmer, in which his face seems 28 troubled by passing atmospheric moods, as though he were intuiting nature.

27. **Richard Cosway** *Mary Anne Fitzherbert*, *c.* 1789. Miniature portraits were produced in large numbers for a popular market, sometimes (as here) painted on ivory.

28. **Samuel Palmer** *Self-Portrait*, *c.* 1824/5. An intensive self-exploration by the visionary landscape painter.

29. **Robert Dighton** *A Real Scene in St Paul's Churchyard on a Windy Day*, *c.* 1783. This picture shows the window of a print shop, in which portraits and popular subjects are displayed. In the foreground a young boy with a tray full of fish has been thrown to the pavement.

Engraving

The portrait business was surrounded by ancillary trades, such as those of frame-maker and colour merchant. Probably the most important was that of the engraver. In the days before mechanical reproduction, this was the only way in which the portrait could be made known to a wider public. One of the most striking features of eighteenth-century artistic life is the rapid increase in the engraving business. Its significance for Hogarth's career has already been mentioned. In the case of portraiture it became increasingly important as the fascination with fame grew. All the celebrities were available in print shops – such as the one whose window is shown in Dighton's cartoon. However, it also had a more private function and people would sometimes have an engraving of their portrait made for circulation amongst friends, much as

30. After **Sir Joshua Reynolds**
Mrs Siddons as the Tragic Muse,
1784. Reynolds has posed
the famous actress as the
personification of Tragedy.
The design is based on those
of the prophets and sibyls of
Michelangelo's Sistine ceiling.

photographs would be circulated today. Horace Walpole, for example, had a portrait of himself by Reynolds engraved for this purpose. Shrewd artists also recognized the value of engraving in order to advertise their wares. Reynolds was particularly astute in this matter and frequently commissioned mezzotints after his works. 

The portrait business centred on London but, there were also thriving studios in most large cities. Bath – the city in which Gainsborough first achieved fame – was a special case. It was so habitually visited by the fashionable from London that the portrait practice here could be seen as more or less an extension of that of the metropolis. More independent businesss flourished elsewhere with the century. This reflects some shift in power in the country itself, as the north increased in importance with industrialization. In Scotland there was a mounting sense of independence in this as in other aspects of cultural and intellectual life. In the early nine-teenth century Raeburn, arguably the greatest British portrait painter of his age, had a thriving practice in Edinburgh.

Most portraits that survive from the period come from these fashionable and powerful centres. Yet we should not forget that a huge amount of portraiture – perhaps indeed the majority – was actually being produced throughout the country. On the whole this was patronized by the middle ranks of the bourgeoisie – peo-ple outside fashionable society but still keen to affect a sense of sta-tus. Often such people were served by journeymen painters of low ability, such as the itinerant painter described by Goldsmith in the *Vicar of Wakefield*. There were even more modest practices than this, such as those semi-skilled craftsmen who would record the features of soldiers before they went off on active duty (see Chapter 11).

We know all too little about such work. Historically speaking this is regrettable – and perhaps also aesthetically. For it should not be assumed that the quality of pictures produced in modest practices was always poor. You needed more than just artistic tal-ent to rise to the top in the cut-throat business of eighteenth-cen-tury portraiture. From time to time signs of what has been lost emerge. A few decades ago works by George Beare, an artist active  in Salisbury between 1744 and 1749 came to light. Beare's won-derfully frank portrayal of women is something that would never have been allowed in the studio of a society portraitist in London. It is a remarkable social document, as well as a minor realist mas-terpiece. It is a reminder, too, that portraiture could be about more than fashion, fame and vanity in this period.

31. **George Beare** *Portrait of an Elderly Lady and a Young Girl,* 1747. A rare survival of provincial portraiture, showing a realism little known in London practices.

Chapter 3: Conversations

The family is taking tea with a visitor. The lady of the house sits in the centre of her domain, dispensing cups of tea. Her husband leans on a chair-back above her, authoritative and protecting. Children may be playing in the background while the visitor, perhaps a parson or an officer, delivers a well-turned phrase, emphasized by a wave of the hand.

This is one of the enduring images of polite society in the eighteenth century. It has been relayed to us by one of the most characteristic types of painting of the period: the Conversation portrait. The typical picture shows some elegant social gathering, its delicacy usually enhanced by minuteness. For it is usually a cabinet size painting, the sort that could fit easily into a domestic setting, and the figures will be no more than a few inches tall. The gestures of these Lilliputians are frequently a little stiff, something that adds incongruity to their charm and points up the artifice of the scene.

For we should not be deceived into thinking that the eighteenth century was actually like that. Such pictures were about ideals, not realities. As soon as the painter has dropped his brush, one feels, the bickering will start. The lady will dash the teacup to the floor and accuse her husband of flaunting his mistress in public, while he will wonder how he will break it to her that they have just lost everything through an ill-judged speculation. The healthy-looking child will rise painfully from the floor, revealing limbs weakened by inherited syphilis. The vicar (who is also a highwayman) will make an assignation with the maid. Later her body will be discovered in a ditch on the common with its throat cut. At every turn a vile world of Hogarthian darkness is waiting to engulf these immaculate, well-ordered scenes.

Like the wedding or school photograph of our own times, such pictures tell us more about aspirations than actualities. First, and

32. **Joseph Van Aken** *An English Family at Tea*, c. 1720. The family as it would wish to be seen, a statement of gentility rather than a portrait of real life.

perhaps most important of all, they secure its inhabitants in the world of politeness. They belong to the acceptable part of society. Their stilted gestures can be related to those in books of etiquette of the period, the ones that told you how to stand, to bow, the proper way to enter a room and address your host, the manner in which you should depart. That books on such subjects were published in such profusion is an indication of how many people at that time were having to learn new ways, how many parvenu businessmen and their families needed a guide to the charmed world of taste. To have a group portrait of yourselves enacting these skills was a way of confirming that you had arrived.

The 'Conversation' was not a new kind of picture. What was new was the use of it for this particular kind of social portrait. The word itself simply implied a picture of a group engaged in some kind of communal activity. It continued to be used in this way, and throughout the eighteenth century a picture described as a

'Conversation' was as likely to be a fictional scene as it was to be a group portrait. The genre can be traced back to the Renaissance but was best known in Britain through the example of Netherlandish art.

The earliest known reference to Conversations in Britain is to work by Heemskerk, a producer of 'lewd and bawdy scenes'. Perhaps the very fact that the word 'to converse' could be used in those days to describe the act of sexual intercourse may have had its impact. Low-life conversations remained a feature in the British scene. Hogarth, typically, painted many such Conversations, including a drunken debauch – entitled *A Modern Midnight Conversation* and pairs of pictures showing a young man and girl just *Before* and *After* they had 'conversed'.

33
34

However, a clear distinction was made between such low-life Conversations and the elegant type used as a vehicle for portraiture. This latter type was formed by a fusion of the Netherlandish genre with a more recent and stylish form of group figure painting, recently imported from France.

33. **William Hogarth** *Before,* *c.* 1730–31. Hogarth's pair of saucy pictures exemplify the least polite meaning of the word 'conversation'. In the first, the man pleads, the girl modestly resists.

The Conversation cult

The fascination with French rococo art and taste began in England in the 1720s. In France this art signalled a relaxation from the strict conventions of the court of Louis XIV, who had died in 1714. The main painter who effected the transformation was Watteau, creator of the *fête galante*, a scene of groups conversing easefully in graceful parklands. Watteau's pictures rarely contained portraits. They were poetic evocations. However, they provided an ideal image of social relations that the portrait Conversation could emulate.

The Conversation portrait was fashioned for a British audience by Flemish and French emigré painters in London. The most successful of these was Philip Mercier (1689/91–1760), a French Huguenot, who had been trained in Berlin and who arrived in England in the early 1720s. Mercier was a limited painter, but he managed to overlay his rounded, doll-like groups with a Watteauesque veneer. Frederick Prince of Wales made him his principal painter during the height of the Conversation vogue.

34. **William Hogarth** *After,* c. 1730–31. Now it is the girl who clings and the man who is less keen.

Frederick, who did not survive to inherit the throne, was at that time playing the role (traditional to Hanoverian Crown Princes) of chief opponent to the King. His alternative court contrasted with that of his parents in taste as well as in politics. Doubtless the modish modernity of the Conversation was one of its attractions for him. Mercier's portrait of the Prince playing music in front of his house at Kew seems full of innocent charm. But there may be an ironic side to it. For the Prince was on bad terms with his sisters and is hardly likely to have engaged in such harmonious conversation with them in reality.

The novelty of the Conversation portrait provided opportunities not just for recently arrived foreigners, but also for young, unknown and ambitious British artists. Hogarth used it to claw an entry into the portrait business. As early as 1728 he is recorded (with some astonishment by George Vertue) as being one of the leading practitioners in the genre. A year later, as has already been seen (Chapter 2), his theatrical Conversation of *The Beggar's Opera* set him on the path that resulted in the invention of the 'modern moral subject'. For a time he painted both kinds of Conversations

35. **Philip Mercier** *'The Music Party', Frederick Prince of Wales and his Sisters at Kew*, 1733. The Crown Prince is depicted playing in harmony with his sisters. In reality they were on bad terms with each other.

36. **William Hogarth**
A Performance of 'The Indian Emperor or the Conquest of Mexico by the Spaniards', 1732–35. Amateur theatricals performed by the children of the fashionable and powerful. Royalty are present in the audience.

together, the moral narratives reaching the public at large through engraving, the portraits entering the homes of the few. Hogarth's portrait groups do not share the pessimistic mood of the 'Progresses', but they profit from the same developing skills in narration. He is masterful at orchestrating a social gathering. Sometimes the subject would play into his hands. In *The Indian Emperor* he was recording an amateur theatrical production by children. However, these were no ordinary children. They were the sons and daughters of the socially ambitious Master of the Mint, and royalty are present in the audience. Hogarth has captured the mixture of gaucheness and vanity of the children on stage as well as giving us the voyeuristic pleasure of observing the audience from behind and spotting such incidents as the little child in the front row being directed to pick up the fan she has dropped.

36

37. **Joseph Highmore**
Mr Oldham and his Guests,
c. 1750. A group of bourgeois
men at the end of a pleasant
evening. They have been
drinking but decency and
decorum are not sacrificed.

Intimacy and informality

By the end of the 1730s the portrait Conversation was losing its
modishness. It gave way, as will be seen in the next chapter, to a
grander style of society portrait, whose *gravitas* seemed to accord
with the growing sense of seriousness and national ambition.

Yet the Conversation persisted in a minor capacity. It became
more varied, and could be used to record appealing moments of
intimacy. One of the finest of these is Highmore's *Mr Oldham and*
his Guests. Just as Highmore had given the demure version of a
Hogarthian 'progress' in his series of illustrations to Richardson's
Pamela, or Virtue Rewarded, so he provided here a genial response
to that painter's satirical *Modern Midnight Conversation*. Highmore's
late night topers are not reeling about and vomiting as Hogarth's
are. They are sedately settled, enjoying the warmth and friendli-
ness that comes from being slightly tipsy. The bourgeois modera-
tion is given spice by a comic story which appears to have been the
occasion of the picture. Mr Oldham, a farmer, had invited some
guests to dine. These had turned up only to find that Mr Oldham
had forgotten them and gone out. They settled down to avail
themselves of his punch. When the errant host finally returned,
late at night, he found his guests in mellow mood. Mr Oldham is
the standing figure. The man at the back on the right, giving a wry,
sidelong glance, is the artist himself, one of the forgotten invitees.

Provincial Conversations

Conversations not only went 'down market'. They also became
provincial. The most prolific master of the genre in the mid-centu-
ry was a painter from Preston. Arthur Devis (1712–87) drew his
clientele from the old world squirearchy of rural Lancashire –
many of whom shared his outmoded (if risky) sympathy for the
Jacobite cause. Although Devis also had a studio in London – in
Great Queen Street – his patronage base remained in the North.
Perhaps this explains the quaint formality of his work, its stiffness
and meticulous sense of detail. It might also account for the mag-
nificent contrast provided by the exquisite landscapes that are
often included. Devis seems to be looking backwards and forward
at the same time. For while recording the *mores* of an old rural soci-
ety, he is also presaging a romantic taste for wild nature.

Regional variants of the once fashionable Conversation can be
found through the country. While Devis was making his adapta-
tions for the gentry of rural Lancashire, the young Gainsborough
was providing his own interpretations of the Conversation for the
landowners of his native Suffolk. Gainsborough had learned his

craft in London in the 1740s, when he had studied under the rococo engraver Gravelot and become an associate of 'St. Martin's Lane' painters such as Hayman. Because Gainsborough finally achieved fame as a fashionable London portraitist we tend not to look at his early works in their provincial context. But in the 1750s he was a practising portraitist in Ipswich. As with Devis, his largely rural clientele seem to have encouraged him to combine Conversation portraiture with landscape. His *Mr and Mrs Andrews* is his masterpiece in this mode. The couple, a young squire and his recently-acquired wife, affect a certain rococo elegance. They certainly seem proud of the amazingly convoluted piece of garden furniture upon which Mrs Andrews is seated. But they are even more concerned to make clear their ownership of the land they occupy. The scenery that surrounds them is not included to satisfy some prescient romantic sensibility. It is a display of their property, more valued for its fecundity than its beauty. This is probably why it is so extensive, and includes the woods where Mr Andrews has been hunting, a ploughed field and an emphatic corn stoop in

6

38. **Arthur Devis** *Sir George and Lady Strickland, of Boynton Hall*, 1751. Devis's figures have a naivety and formality that marks them as provincial rather than metropolitan.

the foreground. There is a curious unfinished passage of painting on Mrs Andrews' lap. This seems to have been intended to be a dead pheasant – which Mr Andrews has presumably just shot. Perhaps either the artist or the clients had second thoughts about this detail because of its inelegance, even in a rural context.

Gainsborough's records of rural pride are enlivened by his own light touch and sensibility. Throughout his period in Suffolk (he was there until 1760) he explored themes in which groups are engaged in some activity. Perhaps the most appealing – certainly one of the most intimate – is the picture of his two daughters chasing a butterfly. The eager expressions on the little girls' faces as they chase their prey have a fetching innocence. Gainsborough has associated them with the object of natural beauty they pursue by making their linked bodies simulate the outline of a butterfly. Perhaps he knew that the butterfly was used in high art as a symbol of transience and the soul. Without knowing it, his daughters have become metaphysicians, seeking the spiritual in the floating world. Like Devis, Gainsborough looks both backwards and forwards in his regional works. He is on the threshold of the age of sentiment which looked appreciatively on childhood innocence; in contrast to the harsh attitudes of an earlier age, which saw children as animals to be tamed, instructed and ordered.

Conversations on show

1760 marked a watershed in British art, as it did in British politics. With the accession of George III, a more active and authoritarian style of monarchy emerged. The new king felt it was one of his public duties to promote the arts, and gave his patronage to the Royal Academy when it was established in 1768. Even before this time, however, contemporary fine arts had begun to occupy a more public position through the activities of societies that held annual exhibitions – notably the Society of Arts and the Society of Artists. The ramifications of this will be explored in the next section of this book. For the purpose of the present (and the next) chapter, however, it needs to be noted that the emergence of regular art exhibitions provided a new context for portraits, and one in which public and private spheres became more sharply divided. Even the Conversation piece was affected by this change.

39. **Thomas Gainsborough** *The Painter's Daughters Chasing a Butterfly*, c. 1756. Gainsborough's daughters make a poignant image of innocence and the transience of childhood.

40. **Johann Zoffany** *David Garrick in 'The Farmer's Return'*, c. 1762. The farmer is describing how the ghost made a knocking noise. On the stage, everything except the table would be painted flats.

New opportunities encouraged new practitioners. The German Johann Zoffany (1733–1810) – recently arrived in 1760 – found that his meticulous painting manner had an unexpected application. He was employed by the famous actor-manager David Garrick to provide records of his theatrical triumphs. The artist's depiction of Garrick in his play *The Farmer's Return* was praised for the accuracy with which the action was represented. Garrick was at the height of his powers both as an actor and a writer. One telling feature of Zoffany's theatrical scene is that, unlike Hogarth's *The Beggar's Opera*, no audience can be seen on the stage. Garrick was one of those who had brought about a separation of audience from performance by introducing a raised stage illuminated by a magic row of footlights. The play is now behind a frame, like a picture. There is also a distancing in the subject of the play. The wit in Garrick's piece is not directed at society, but at a country yokel, someone that the city audience can laugh *at*, rather than *with*. But it is Zoffany's powers of recording, rather than any attempt at wit that recommended him to Garrick. He not only puffed Garrick's plays, but also recorded his life as a country gentleman, taking tea on the lawn at Hampton Wick. Such pictures were displayed in Garrick's city apartment and served to remind any visitor that this actor/manager had made it to the higher ranks of society.

Exhibition had given new life to the theatrical Conversation piece. It also encouraged other developments, in which the group portrait appeared to be repaying a debt to the fictional social gathering. Significantly, the initiative came from the provinces, where traditional Conversations had maintained a presence. While living in Derby, Joseph Wright (1734–97) was able to make a bid for fame in London in the 1760s through exhibiting an utterly original kind of Conversation – scenes of contemporaries engaged in some kind of social and philosophical investigation. He was presenting fashionable London society with an image of that impressive upsurge of intellectual vigour that underpinned the emerging Industrial Revolution. His clientèle in the Midlands were high-minded, non-conformist, and pragmatic. They also constituted a community, in a way that was becoming less and less possible in the expanding metropolis. And just as he presented this community using a pictorial type that had already become outmoded in London, so he reached back to an earlier age for the pictorial effects that make his works so arresting. His dramatic lighting contrasts are based on those innovated in the seventeenth century,

by the Italian Caravaggio and his Northern followers. Like the Northern artists, Wright focused on the use of artificial light, emphasizing the interior nature of these scenes and enhancing the sense of community. These works were widely praised, and sold well as engravings.

At a popular level, Wright certainly succeeded. But sadly he was no match for the new level of elitism that entered the artistic profession with the founding of the Royal Academy. He was kept at arm's length by this organization and only finally allowed associate membership in the 1790s, by which time his practice was in terminal decline. He was the last major artist to attempt to use the Conversation as a means of building a career. The limited success that he achieved with this indicates the extent to which the genre was by this time becoming marginalized.

However, there were many fine Conversations still being painted in these margins. George Stubbs (1724–1806), like Wright, was an artist locked into a provincial career. His main achievement was his mastery of the 'specialist' and 'low' genre of animal painting (see Chapter 10). Yet Stubbs was certainly up to

41. **Johann Zoffany** *Colonel Poitier with his Friends*, 1786. Gentlemen in India amidst servants and possessions. The artist is shown painting in the background.

capturing all the nuances of the social gatherings he was employed to record. *The Melbourne and Milbanke Families* shows two families 42 related by marriage meeting up on a journey. In theory they are on neutral territory, but there is no doubt about which family is superior. The dominant male displays himself against the horse grazing in the centre. All is recorded with that meticulousness common to provincial art – though with considerably more *finesse* than either Wright or Zoffany could muster. Stubbs is, after all, one of Britain's greatest painters. His capacity may have been surplus to the requirements of his contemporaries, but it is something for which subsequent generations have been duly grateful.

The end of the trail

Even in the provinces, however, the Conversation portrait was in retreat by the 1780s. Perhaps this was because a growing sense of the division between public and private,was now spreading to the country as well as the city.

Appropriately, the last echoes of the vogue could be captured furthest away from the centre. This was not in the remoter parts of the British Isles, but out in the colonies. This is where Zoffany made his last stand. In 1783 he went to India, where he depicted British settlers in the manner that was falling out of favour at home. There is a poignant sense of disjuncture in his pictures. English gentlemen and ladies act out their 'conversations' as though everything is normal, as though the native servants, exotic animals and wild scenes through the window were really no different from what you might expect to find in Surrey or Wiltshire. Other portrait groups show some men gone half native, like Colonel Potier, surrounded by specimens of the strange sub-conti- 41 nent they wished to make there own. For us there is a near surreal charm in such works.

The Conversation portrait did not die out altogether. Few pictorial types do once they have been created. But it did sink to the lower reaches of the portraitist's repertoire. There were not many after Zoffany who made it their speciality, and none who were able to use it to build a fashionable career. Once that continuity between the social and professional that had existed in the age of Conversation began to break down, communal portraiture polarized increasingly into the representation of professional associations on the one hand, and of private family gatherings on the

Overleaf: 42. **George Stubbs** *The Melbourne and Milbanke Families,* 1770.
The members of two families related by marriage are shown meeting. The social superiority of the central figure is conveyed by both his position and attitude.

Chapter 4: The Grand Portrait

The Conversation portrait might provide the most poignant evocation of the eighteenth century. The grand, full-scale portrait, however, is probably the pictorial achievement most closely associated nowadays with Britain during that period.

These portraits were designed to impress. They still continue to do so, long after the world they were fashioned to support has disappeared. Yet even at the time, one wonders how closely they related to political realities. The imagery that had traditionally been the preserve of the aristocrat was being shared increasingly with the successful bourgeoisie; not just financiers and professionals – but parvenu tradesmen, manufacturers and even actors!

The grand portrait was a fantasy. But it was a brilliant and powerful one. It was sufficiently important to preoccupy the most gifted painters up to the late eighteenth century. The imagery they created was richly convincing – so convincing that even in the twentieth century certain historians have responded to these works as though they conveyed the true character of genuinely superior beings. The grand portrait was successful not just because it made sitters look grand. It was because it was able to turn them into 'men of sense' and associate them with intellectual and moral ideals of the age as well.

In terms of both wealth and status the business of painting grand portraits was the key artistic activity in Georgian London. It is hardly surprising to find that it was a keenly competitive one. Each artist established his practice through successes in a prestigious repertoire. Style was more than a personal whim here. It was a trade-mark that had to be carefully preserved and could only be developed and changed with caution.

The tradition
These images gained authority through being associated with a grand tradition of courtly portraiture that reached back to the Renaissance. Its most important representative for the British was Sir Anthony Van Dyck (1599–1641), the Flemish painter who had worked for Charles I in the seventeenth century. It is hard to overemphasize the sway that his elegant pictures had on later generations. Van Dyck had constructed images of the King and his

43. **Sir Anthony Van Dyck**
Charles I in Robes of State, 1636. Van Dyck's portrait of Charles I became a model for the aristocratic grand portrait in Britain.

43

courtiers that suggested natural grace and authority. The figures stood nonchalantly in spacious surroundings, with accoutrements such as swags and columns to hint at grandeur beyond. The clothes were silken and gorgeous. But most important of all was the fluidity of the brushstrokes that delineated features with such sensitivity. Van Dyck's painting manner was the last word in *finesse*. Its unbeatable virtuosity was all the more impressive because it appeared to have been carried out so effortlessly. It was clear that Van Dyck was as much of a gentleman as his clients. He was a courtier, a knight, identified to the tips of his fingers with the world he depicted. And added to all this was the sheer romanticism of knowing that he had been painting a doomed world, soon to be swept away by the horrors of civil war.

44. Thomas Gainsborough *The Blue Boy, c.* 1770. Gainsborough's 'Blue Boy' shows a clear debt to Van Dyck, although the subject was not in the least aristocratic.

45. Jonathan Richardson *Lady Mary Wortley Montagu, c.* 1725. The celebrated traveller and writer is shown here in a 'Persian' costume that alludes to her exotic journeys.

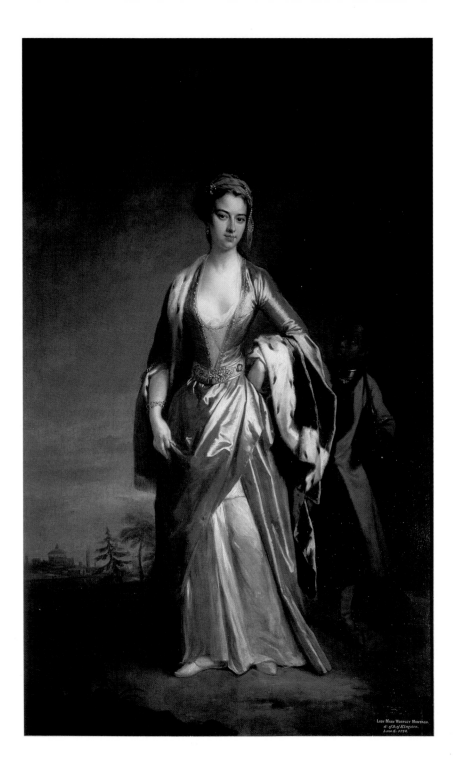

Lady Mary Wortley Montagu.
d: of D. of Kingston.
b. 1690 d. 1762.

Van Dyck was venerated by all portraitists. Even Hogarth saw himself as following in his footsteps and used an image of the great Fleming as his shop sign. From the 1730s onwards there was a developing vogue for being portrayed in Van Dyck dress. This culminated in the 1770s, when Gainsborough produced the ultimate Van Dyckian tribute in *The Blue Boy*.

Gainsborough, in fact, emulated Van Dyck more than any other in his own elegant manner – which might be seen as taking Van Dyckianism to excess. It is hardly surprising that he was the favourite painter of George III, a monarch who tried, in his early years at least, to emulate the authoritative reign of Charles I. Yet while seeming aristocratic, Van Dyckianism in the eighteenth century was also bourgeois. The subject of *The Blue Boy*, a youth wandering so nonchalantly in a wild pastoral parkland, was in fact the son of a prosperous Soho ironmonger.

Court portraiture continued to be dominated by foreigners after Van Dyck's day. The most important of these were Sir Peter Lely (1618–80), who recorded the voluptuous beauties of Charles II's court, and Sir Godfrey Kneller (1646/9–1723), who brought a solid sobriety to the grand tradition. With Kneller's death the reign of foreign court painters came to an end. By this time George I was on the throne, and the court was playing a less dominant part in British cultural life. Kneller himself had to some extent helped to engineer the change. He had encouraged indigenous artists, setting up an academy in 1715. His own sober style accorded with the ideals of the patrician Whig politicians for whom he worked. He innovated a small informal portrait type to record the features of the most influential of these – the members of the celebrated Kit-Cat Club.

Indeed, in the early eighteenth century grand portraiture seemed to be against the spirit of the age. Those who practised it were on the whole minor artists, such as Closterman, who produced what must be one of the most absurd essays in the genre ever perpetrated; a portrait of Lord Shaftesbury and his brother pompously posing as arcadian beings in what seems to be some ghoulish recollection of fourth-rate schoolboy acting. Yet absurd though this picture is, it is worth remembering as a sign of patrician ambition at that time – and also as a marker set down for an aestheticized grand portraiture that was eventually redeemed by Reynolds. For if grand portraiture seemed hard to realize in the age of the first George, it was nevertheless still dreamed about. This was the time when the most inspiring description of the elevated position of the portrait painter was created by the painter

44

Jonathan Richardson (1665–1745), in his *Essay on the Theory of Painting*. Richardson had been to Rome, and, like the patricians, he associated the grand portrait with a more general revival of the classical tradition. His own painting style was normally too timid to do more than illustrate this idea. But he could at times rise to a sense of grandeur, as when he painted the grand and elegant portrait of Lady Wortley Montagu.

45

Perhaps it was the sheer exotic nature of the sitter that swept him off his feet here. Lady Montagu was a lady well out of the ordinary. A leading intellectual, she had also travelled to the East and described her adventures in celebrated letters. Here she is shown in a revealing version of a Persian dress against a tempestuous sky attended by a negro servant. Opportunities like this were, however, rare indeed in the age of reason.

Return of the grand portrait

The grand portrait remained marginalized until the late 1730s. The arrival of certain foreign artists in Britain, in particular the French portraitist Jean-Baptiste Van Loo (1684–1745) and the Italian Andrea Soldi (1703–71) are cited as causes of the revival. But it seems equally likely that these arrived to exploit a perceived opportunity. This can be related to a change in politics, the renewed nationalism that began to sweep the country as Walpole's peace policy came to an end and war with France began. The revived grand portrait was not confined to the aristocracy. Hogarth made the boldest challenge with his portrait of Captain Coram, the founder of the Foundling Hospital. It was a bourgeois apotheosis, showing the new order playing a major charitable role in society. In it Hogarth deliberately addressed and challenged the conventions of the grand manner. Coram sits on a raised platform with the column and curtain of the traditional court portrait behind him. The globe at his feet, the ship seen through the window symbolize his nautical past. In his hands he holds the royal charter for his hospital. The picture is a painterly *tour de force*. But in the place of Van Dyckian elegance Hogarth has put his own kind of virtuosity, a vigorous, breezy manner.

19

Hogarth painted many pictures at this time which challenged the grand tradition. His brilliant portrait of the *Graham Children* is a play on Van Dyck's *Children of Charles I*. Yet while he set the formula for a confident bourgeois appropriation of the grand manner, this was not responded to. Doubtless this was because the bourgeoisie did not wish to distance themselves so much from the decorum of the aristocrat. They preferred the subdued elegance of

Thomas Hudson (1701–1779), a painter now virtually forgotten.

Hudson's portrait of Theodore Jacobson, architect to the 46 Foundling Hospital, displays all the good behaviour that Coram lacks. Jacobson leans on a plinth, his legs fashionably crossed. While Coram clutches the seal of his royal charter with a firm grasp, Jacobsen lets drop in a nonchalant manner a piece of paper with the plans of the Foundling Hospital inscribed on it.

46. **Thomas Hudson** *Theodore Jacobsen*, 1746. The architect of the Foundling Hospital nonchalantly displays his plan for the building.

Ramsay

In Hudson's hands, the revived grand portrait might well have settled down into respectable dullness. But in the late 1730s a more exciting practitioner emerged. This was the Scot Allan Ramsay (1713–84), who had recently studied in Italy and had a thorough knowledge of the old masters and of contemporary Continental practices. The son of the Edinburgh poet of the same name, he was a man of intellect who brought a new sense of enquiry to portraiture. His dashing self-portrait from this period is full of the subtlest observation and deployment. He turns, as though we had interrupted him. He fixes us clearly and shows his face in remarkable detail – even down to his five-o'clock shadow. There is a touch of intrusion, of danger even, but a sense of it being held in check. Ramsay kept up his Scottish connections (they were central for his career) and may even have had Jacobite sympathies.

47

47. **Allan Ramsay** *Self-Portrait*, *c.* 1739. A vivid self-portrait painted when the artist had recently returned from Italy and was setting up business in London.

Technically his work is also exquisite. It is quite different from the English painterly manner. Described by Vertue as 'rather lick'd than painted' it was viewed by many London artists with suspicion. Yet while clearly based on modish French and Italian manners, it goes beyond suaveness to become a real vehicle for observation.

Ramsay was also able to give his manner authority and grandeur while retaining remarkable directness. This can be seen in his portrait of Lord Argyll, Provost of Glasgow. Dressed in his robes, this powerful man turns to confront us, leaving his book and work to inspect the intruder. This gesture forms a telling contrast

48

48. **Allan Ramsay** *Archibald Campbell, 3rd Duke of Argyll*, 1749. A portrait of power. The Lord Provost of Glasgow in his robes, turning as if we interrupt him at important business.

to that of *Coram*. Despite his bluffness and ebullience, Coram is portrayed in the old allegorical mode. He is in a sham studio setting, surrounded by symbols. There is no sense of him being observed in his natural environment. Argyll is shown about his business, and the look he gives us makes us feel that we must be sure to have some serious purpose for interrupting him. One of the remarkable features about the portrait is the way in which the figure dominates despite the fact that we are looking down on it.

There is no doubt that Ramsay set a new agenda for British portraiture. What is remarkable is that he could make his pictures so authoritative and penetrating by the simplest of means. In later years, particularly after a second visit to Rome and Paris, he introduced an increasing delicacy and sensibility into his work, as can be seen in his exquisite portrait of his second wife. At such moments he seems to be working on the level of his French contemporary Chardin. It has been argued that the new sensibility that Ramsay brought to portraiture can be related to the spirit of enquiry evident in the Scottish Enlightenment. Ramsay kept his contacts in Scotland and was a friend of the leading philosopher of the age, David Hume.

Ramsay maintained his position as a leading portraitist in London and in 1760 became painter to the new King, George III. But he was never able to dominate the field. That position belonged to Reynolds.

The coming of Reynolds

The central character in British portraiture – and indeed artistic life – of the mid-century was Joshua Reynolds (1723–92). For the thirty years that covered the first half of George III's reign (1760–90), he was the unchallengeable authority. Returning from Italy in 1753 he rapidly established himself as one of the leading portrait painters in London. By 1760 his reign was already undisputed. In that year he moved to a grand house in Leicester Fields – then in the heart of fashionable London – and started living in a style rarely seen amongst painters. From then until his death in 1791 his career was punctuated by success after success. The most important of these was his election to President of the Royal Academy when it was founded in 1768. His career in that respect will be considered in the next chapter, but it should be noted that it gave enhanced dignity to his portrait practice. By 1782 he was charging an unprecedented £200 guineas for a full-length portrait – more than twice that of his nearest rival Gainsborough.

Reynolds was not, of course, without competitors. The most important was Gainsborough, who arrived in London in 1774 after a provincial career. But this did not threaten his pre-eminence. Neither – significantly enough – did the lack of royal patronage. George III had a distaste for Reynolds which might have been personal, but which was probably also because the art of the latter was less suited to the depiction of courtly life than to emerging forms of society that were independent of monarchical power and influence. George III preferred the subtleties and sensitivities of Ramsay and Gainsborough. When he came to the throne in 1760 he appointed Ramsay his court painter – despite attempts by Reynolds to woo him. Reynolds only became court painter on Ramsay's death in 1784, when his position was so commanding that the appointment was unavoidable.

Because of his centrality – his seemingly effortless command of both the technical and intellectual sides of his art and his powerful efforts to promote the cause of artists in England – Reynolds is often called the 'father' of British painting, the founder of a 'school'. With characteristic magnanimity, however, he handed that palm to Gainsborough in his discourse eulogizing that artist after his death. Such titles mean little nowadays, but they are a reminder of how important Reynolds seemed to his own and to many subsequent generations. And the reputation itself can obscure an appreciation of what his actual achievements were in portraiture, his principal line of business.

Reynolds made his reputation mainly through demonstration. None was more important than that offered by his portrait of his friend and patron, Commodore Keppel. Keppel was the sailor who had made it possible for Reynolds to travel to Italy by offering him free passage on his ship. Before that time the artist had trained in London, under Hudson, and gained some sense of the new standards for portraiture then being set by Ramsay. He had worked also in his native Devon, where he had made important aristocratic connections – including that with Keppel. In Italy he had set himself to absorb systematically the art of the old masters. Unlike Ramsay he did not learn from contemporary Italians. It was the classical tradition that he absorbed.

The portrait of Keppel was painted on his return. While a thanks gift for his friend, it remained seventeen years in his studio, where it could be admired by all potential clients.

The picture shows Keppel striding along the sea shore in a commanding pose. It also shows the things that Reynolds could do for a sitter. The first was to idealize. It has frequently been

49

49. **Sir Joshua Reynolds**
Commodore Keppel, c. 1753–54. Reynold's naval friend is shown striding along the shore in commanding position. This picture established the artist as master of the grand portrait.

commented that the pose of Keppel resembles that of the famous antique sculpture the Apollo Belvedere, visible then as now in the Vatican Museum in Rome. That precise borrowing is now questioned by some, but none would deny that the Keppel is clearly based on a classical sculpture and illustrates a practice for which the artist was to become famous. This is the habit of basing the poses of his sitters on some antique sculpture or old master painting. Even in his own lifetime Reynolds was accused of plagiarism for this habit. But this misses the point, which was that the artist was ennobling his sitter by infusing him or her with the dignity of a work of art. As he later made clear in his *Discourses*, he saw portraiture as being as much about enhancement as representation. '...If an exact resemblance of an individual be considered as the sole object to be aimed at, the portrait-painter will be apt to lose more than he gains by the acquired dignity taken from general nature. It is very difficult to ennoble the character of a countenance but at the expense of the likeness, which is what is most generally required by such as sit to the painter.'

Reynolds mentioned 'dignity taken from general nature'. It was his belief that classical art was based upon a general appreciation of the laws of nature, and this was a perception that he wished the modern portrait painter to share. Reynolds was skilled in combining such a general appearance with a convincing presentation of the individual. One can see how this appealed to a generation of public figures who wanted to be shown commanding, but in a way that seemed to be natural. Nevertheless he could overplay his hand at times, and more than one contemporary recorded the amusement of seeing an acquaintance known to be a hapless halfwit emerge in a Reynolds portrait as a person full of purpose and substance.

This brings us to the second great gift of Reynolds. For as well as idealizing, he also dramatized. He had a great feel for theatrical presentation. Keppel is a striking conceptualization – he strides along the shore, with storm clouds gathering above him. One of the paradoxes in Reynolds is that, while he vaunted the virtues of classicism and simple nature, his own style was heavily influenced by Rembrandt and the Venetians. The former indeed had been an element in his art before he went to Italy. From such resources he gained his marvellous command of tone and chiaroscuro which were centrally important for lending weight to his work. Reynolds' style is a sonorous one – like the Augustan prose of his friend Dr. Johnson. And like Johnson this style, while classically based, is also related to a tradition of empirical common sense. Reynolds was the pupil of Hudson, himself in the line of solid

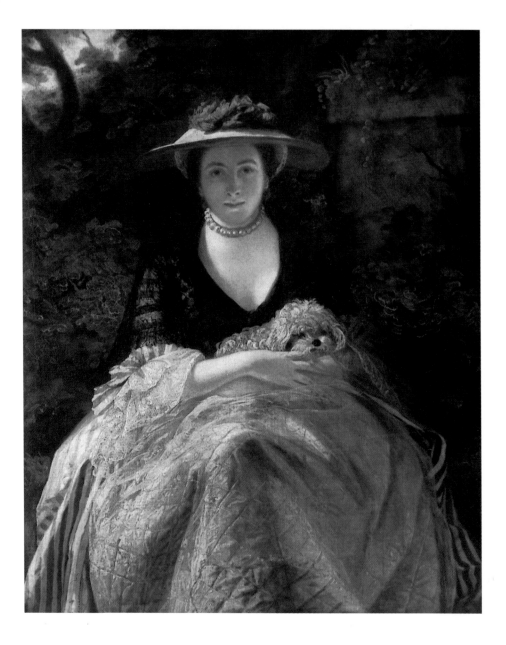

50. **Sir Joshua Reynolds**
Nellie O'Brien, c. 1763.
Reynolds did not excel in painting
women, but this portrait of a
celebrated courtesan shows
unusual warmth and sympathy.

51. **Sir Joshua Reynolds**
Lawrence Sterne, 1760.
The novelist Sterne in his
character of Yorick, a man
of intellect.

British painters that led back through Richardson to Riley in the seventeenth century. Reynolds outshone all of these in brilliance. But there was a fundamental soundness about his art that suggested something satisfyingly British to contemporaries.

Reynolds is perhaps best understood in terms of his literary contacts. He was notorious for preferring the company of writers to that of artists. He was already a friend of Johnson's in the 1750s. He was also close to Edmund Burke, who helped him with his *Discourses*. Another figure who was important to him was the actor and writer Garrick, who like Reynolds was bringing dignity to an art commonly held to lack it.

Reynolds, Johnson and Garrick were in many ways in similar positions. For while professing the intellectual dignity of their callings, they all had to live by the market. Johnson was, basically, a high class journalist, and his philosophical thoughts were stimulated by the events of the day, rather than being the speculations of a cloistered academic. They were all empiricists drawing their conclusions from observation.

It was perhaps through his literary contacts that Reynolds understood so well the value of publicity. As has already been mentioned, he was assiduous in having engravings made of his pictures for wider circulation. When Laurence Sterne shot to fame with the publication of *Tristram Shandy* in 1760, Reynolds painted his portrait and had it engraved, achieving great profit. This portrait showed him triumphing with the representation of an intellectual - a counterpart to the figure of the leader seen in *Keppel*. Men of action and men of thought were to become the staple of his career.

He did not stop at that. It was part of his claim to pre-eminence that he was universal in his sympathies; 'Damn him how various he is', his rival Gainsborough muttered on one occasion. Early in his life Reynolds also set out to master the female portrait. Here he was to adopt – according to the fashion of the day – more decorative and intimate solutions. Men might borrow classical poses, but would have looked absurd if they had actually masqueraded as Jupiter or Caesar. For the fair sex it was different – they could be tricked out as nymphs and allegorical figures. Reynolds also used his gift with light effects to achieve images of telling directness and sympathy. Usually these did not depict grand ladies, but actresses or courtesans, as in the case of Nellie O'Brien. Reynolds remained a bachelor himself and moved in a clubbish male world that easily admitted females of the demi-monde into its company.

In the early years of Reynolds' ascendancy, when his authority was not complete, the question of his prowess with painting

women was disputed by Horace Walpole who remarked 'Mr. Reynolds seldom succeeds in women; Mr. Ramsay is formed to paint them.' This may not have been strictly true, but it was an acknowledgment of a remarkable development in Ramsay's art in the 1750s. Like Hudson, Ramsay was one of those portrait painters who travelled extensively in Italy at the time when Reynolds was gaining the ascendency. But he did not come back with an imitation of Reynolds' classicism. Instead he returned with a kind of refined palette that showed a renewed and penetrating experience of French contemporary art.

His wonderful portrait of his wife – produced after he returned to London in 1757 certainly showed something that Reynolds' broader style could never achieve. It has an exquisite pearl-like quality, a sense of refined and precise observation that makes one think momentarily of Chardin or even Vermeer. As with the earlier Argyll, the portrait gains presence from the sense of momentary interruption. But this time it is merely an interruption of the placing of flowers in a pot and one feels that it causes surprise but not resentment. Nothing could be more tender or intimate in mood – and one can easily see why such delicacy should commend itself at court. Ramsay also had the advantage of being close to George III's principal adviser, Lord Bute, a fellow Scot. Added to this, the erudite and learned painter was able to keep the new Queen happy by conversing with her in her native German.

Ramsay's portrait of his wife shows him using his formidable skills to explore an intimate feminine world – and this is the one he was frequently required to focus on in later life, when his former broad career was being encroached upon by Reynolds. But it would be wrong to assume that his capabilities were – as Walpole supposed – formed purely for the depiction of women. Ramsay's penetration of character was every bit as effective when dealing with a masculine subject. A prime example of this is the portrait of Jean-Jacques Rousseau, a work that is commonly held to be the most revealing of that unhappy and unstable philosopher in the last years of his life. It is perhaps a sign of this that Rousseau himself rejected the work as a deliberate caricature.

Despite maintained royal favour (he became principal painter in 1767 on the death of Shackleton), and continued Scottish patronage, Ramsay painted less and less, and had almost completely given up by the early 1770s. A fall from a ladder in 1773 which permanently injured his right hand, hardly helped. One of the curious features of Ramsay is that despite developing a style that seemed to have all the hallmarks of intimacy, he was still

8

52

52. **Allan Ramsay** *Jean-Jacques Rousseau*, 1766. A revealing portrait of the Swiss-French philosopher in the later troubled stages of his life.

essentially a public man with little sense of painting as a private resource. His personal world was an intellectual one, and when his career in painting drew to a close he occupied himself with writing and with archaeological excavations.

It is perhaps not surprising that Reynolds' other principal rivals were also those who could challenge him best in the depiction of the feminine. In the years in which Ramsay was gradually leaving the field, this role fell to Francis Cotes (1726–70). Like Ramsay, Cotes was influenced by continental pastellists such as Rosalba Carriera, and could produce fine works of intimacy – such as his portrait of the watercolourist Paul Sandby genially at work half leaning out of a window. But even if untimely death had not removed him from the practice, it seems that this painter would never have provided a serious alternative to the master.

Gainsborough

Thomas Gainsborough (1727–88) finally emerged on the London scene in 1774. By this time he was a fully formed artist at the height of his powers. Forty-seven years old, he had already had an extensive practice in Bath for fourteen years, and before that for more than a decade in his native Suffolk. His coming to London indicates perhaps a falling off of business in Bath – already ceasing to be the height of fashion that it had been a decade earlier – but he was probably also encouraged by the hope that Sir Joshua might now be relaxing his grasp on portraiture as he occupied himself more with the business of the Academy and with history painting. If this was the calculation, then it was wrong. Reynolds may have let his portrait practice decline a little in the early years of the Academy. But he responded to the threat of rivalry with one of his grandest pronouncements in the genre, *Three Ladies Decorating a* 54 *Herm of Hymen (the Montgomery Sisters)*, a work full of allegory and rhetoric and dealing with a female subject – the kind that Gainsborough, like Ramsay before him, was held to succeed in inordinately well. This was a statement to make the newly arrived provincial look like a country bumpkin.

Yet if Gainsborough could not rival historicized portraiture, he could offer much else. Indeed, he wisely never challenged Reynolds' learnedness – and although his art was in its way as full of references to the old masters as Reynolds' was, these were used for very different intentions. Gainsborough played the role of Reynolds' 'other' in the portrait business in London in the 1770s and 1780s.

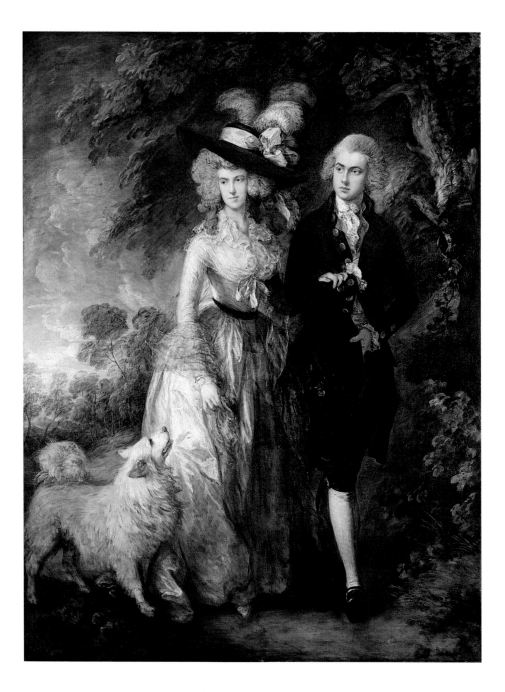

53. **Thomas Gainsborough** *The Morning Walk (Mr & Mrs Hallett)*, c. 1785.
A major example of the artist's late style. An elegant young couple engaged
in the fashionable practice of going for a walk.

54. Sir Joshua Reynolds
Three Ladies Decorating a Herm of Hymen (the Montgomery Sisters), 1773.
An allegorical representation of three sisters in celebration of the marriage of the one in the middle. Typical of Reynolds, and in contrast to Gainsborough, is the symbolic meaning embodied in the painting.

Indeed, from the very start, Gainsborough seemed to 54 approach portraiture from an utterly different angle from Reynolds. Reynolds came to art from the professional classes and was concerned to make it a suitable career for a learned man. Gainsborough came from trade – his father was a clothier in Suffolk, and he started as an apprentice in London to the engraver Herbert Gravelot (1699–1773). Gravelot – a brilliant student of Watteau – was the principal agent for the introduction of rococo art into Britain at this time. It seems to have struck a natural chord with Gainsborough and a rococo sensibility pervaded all his later work. He also absorbed a hint of the erotic sensuality that is so related to that style. Here again there is a contrast. Reynolds was a bachelor who preferred the society of men. Gainsborough married young, when he was only nineteen, and was very much a woman's man. He greatly enjoyed the mental and physical companionship of women. There are stories of how he would sometimes leave his studio to seek gratification with a prostitute because he had become too erotically aroused by one of his lady sitters.

It is symptomatic of Gainsborough's position that he was noted for his exact likenesses. While Reynolds claimed that too close a resemblance was a hindrance to the expression of true grandeur in portraiture, Gainsborough held it was 'the principal beauty and intention of a portrait'. He was also able to demonstrate in his work that attention to likeness did not in any way hinder the production of a portrait full of grandeur and style.

While Reynolds' career pursued a mainstream line – Roman

experience and then a portrait practice in the heart of London – Gainsborough's was full of circuitous curves. He briefly practised in London before his marriage, but then returned to his native Sudbury, and seemingly a career of provincial oblivion. Moving to Ipswich in 1750 he embarked upon a rather more profitable but still highly local practice, producing portraits of gentry in which the rococo is mingled with a regional taste for Dutch landscape. The result was some of the most poignant and appealing works of the 1750s – many worlds away from the grand patrician work Reynolds was creating at the time. These pictures, however, would probably have been forgotten or lost by now had not Gainsborough subsequently made the leap in 1759 to move to Bath and embark on a more fashionable portrait career. It is at this point, too, that he begins to produce paintings that address the grand portrait tradition.

Like Reynolds, Gainsborough announced his new direction with a sample picture. This was the portrait of Ann Ford – *Mrs Thicknesse*. The lady, a professional musician, is given a boldly serpentine swagger.

56

It was a picture, above all, that proclaimed that Gainsborough had an individual voice. What might have been put down as naivety in his Suffolk pictures would now come across as style. Even in Suffolk people had complained at his 'roughness' – that is his lack of finish: 'we have a painter here who take the most exact likenesses I ever saw. His painting is coarse and slight, but has ease and spirit', wrote one commentator.

Now he could show that this lack of finish facilitated a different kind of appreciation of brush stroke and paint. This was to remain a key factor in Gainsborough portraits. It gave them their particular aesthetic. This is very different from the way in which Reynolds aestheticized his pictures through classical allusion and learned reference. It is a difference that can be brought out by their related interests. Reynolds was a highly literary figure, and his approach to painting by quotation, so to speak, seemed to mirror that scholarly interest, as did his general sense of gravitas. Gainsborough, on the other hand, was firmly anti-intellectual. Despite having considerable verbal gifts – as the repute of his brilliant conversation suggests and his surviving letters confirm – he was not interested in the world of rational thought or argument. His passion was music. He was an expert performer on several instruments. Here too, typically, it was performance and improvisation that were his forte, rather than theory. Rimbault, the organist of St. Giles-in-the-Fields, said of him that he may

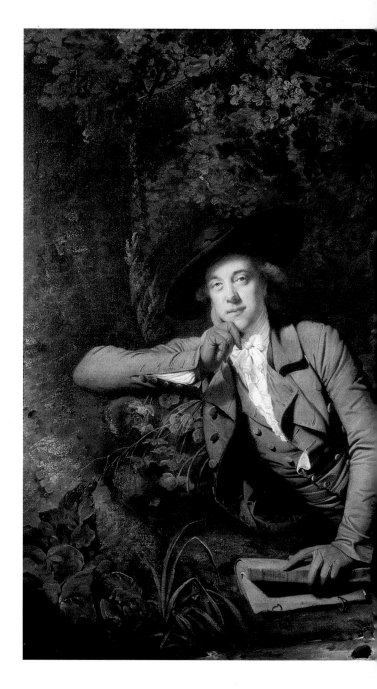

55. Joseph Wright of Derby
Sir Brooke Boothby, 1781.
The sitter, a country gentleman
who edited one of Rousseau's
late works (which he holds in
his hand) is shown here lost in
reveries about nature.

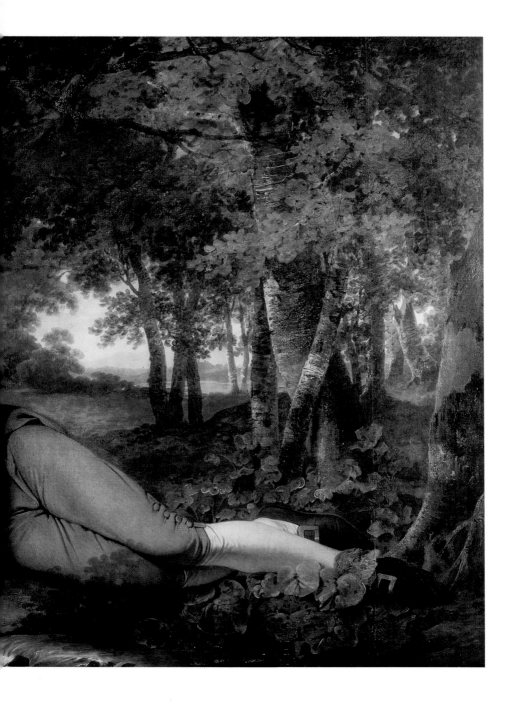

have been 'too capricious to study music scientifically' but that 'his ear was so good, and his natural taste so refined, that these important adjuncts led him far beyond the mechanical skill of the mere performer who relies only upon technical knowledge...his chief forte consisted in modulating upon the harpsichord.'

It is tempting to see some affinity between this taste for modulating on the harpsichord and the brilliant improvisation of his painting technique. His style is full of melody and nuance. His art is very much an art of performance, and the way in which he leaves his brushstrokes so clearly to be seen is a mark of this interest in the pure pictorial motif. Reynolds, who had little sense of music, once compared the use of colour in history painting to martial music, the bold colours striking out like separate notes in some kind of battle cry or march. How far removed is this music

56. **Thomas Gainsborough**
Portrait of Mrs Philip Thicknesse (Miss Ann Ford), 1760.
A grand representation of a musical performer who later married one of the artist's closest friends.

metaphor from the art of Gainsborough, where everything turns on the brilliance and nuance of the moment. Gainsborough, you feel, is discovering as he paints, while Reynolds appears to be carrying out some preconcived plan. It is a sign of this that Gainsborough was a brilliant and intuitive draughtsman, whereas Reynolds' drawings are studiously laboured.

The rhythmic arabesques of Ann Ford seem set in motion by the musical instrument she holds on her lap. The picture is full, too, of glowing, harmonious colours.

While in Bath Gainsborough made concerted attempts to infuse his art with aristocratic elegance. He studied the old masters, particularly those noted for their painterly effects. He had an affinity to the Flemish tradition perhaps through having been taught by a pupil of Watteau. In Bath he was able to study Van Dyck and Rubens directly, from examples in nearby great houses. One might regret a certain passing of innocence with this move, and long for the poetic poignancy of the early Suffolk portraits. On the other hand, it must be admitted that he performed his new repertoire magnificently.

Gainsborough's debt to Van Dyck was made evident in the painting of *The Blue Boy*. Ostensibly painted to counter Reynolds' claim that no picture could succeed that was predominantly blue in tone, it drew heavily upon both the style and attributes of the Flemish master. The taste for Van Dyck costume had been prevalent in Britain since the mid-1730s, but in the age of George III it took on a new resonance because of the monarch's own attempts to refound a court along the lines of Charles I. For Gainsborough it was a way of showing he could match the elegance of the earlier court portraitist – a fact that must surely have stood him in good stead when he came to be employed by the Royal Family after Ramsay was in decline. It is also significant is that this picture is not of an aristocrat but of the son of an ironmonger, who was a friend of Gainsborough's. This shows once again a bourgeois encroachment upon aristocratic values.

A further feature that emerges in these Bath paintings is the growing importance of landscape for Gainsborough. He had begun as a landscape painter and always claimed it was his principal love. This will be explored in a later chapter. But one thing seems clear: his taste for landscape informs the atmosphere of his portraits and gives them a peculiar sensibility.

But it is increasingly a fantasy landscape, an Arcadia. While coming from a small market town, Gainsborough's attitude to landscape became increasingly urban. He saw it more and more as

the place of retirement. And in this he fitted in perfectly with the tendencies of his urban sitters. He might even have been connecting with a long-standing courtly tradition, the longing to return from the artificiality of society to that of arcadian ease. It is a tradition alluded to by Van Dyck in his courtly portraits and by Watteau in his *fêtes champêtres*. After he came to London, Gainsborough provided a version of this for the Royal Family and for others. It is a mood captured by the portrait of Mr and Mrs Hallet, 53 as they stroll along so elegantly in a poetic and evocative landscape.

Gainsborough died before Reynolds. The latter came to see him on his deathbed and there was a rapprochement which led amongst other things to Reynolds' fourteenth *Discourse* in which he praised Gainsborough and in effect hailed him as the founder of the British school. This was a generous gesture and also perhaps a sad admission that Reynolds had in some measure failed in his own ambition.

But the grand portrait was losing too, and for reasons that reached beyond those of the professional rivalry of two artistic *virtuosi*. The notion of a society regulated by patricians was being undermined on all sides in the 1780s. There had been blows to prestige both at home and abroad. Insurrection had been shown to pay, first of all in the American Colonies and then, even more traumatically, in the events of the French Revolution. At home the growing pace of industrial and commercial change was making it clear that new patterns of power were emerging. The storm clouds that Reynolds' men of sense managed to master and relegate to the background were now threatening to engulf the whole picture. This does not mean to say that large-scale portraiture ceased to be practised. But it did take on a less urbane mood and register new levels of anxiety.

Towards Romanticism
Gainsborough's later works already showed a new sensibility, though this still rested on an underlying sense of order. Elsewhere the new perception of nature brought more troubling treatments.

In the 1780s this trend could be seen in many places. Wright of Derby – one of the great painters who remained in the wings in the provinces – produced one of the definitive images of the time in his portrait of an eccentric local gentleman, Sir Brooke Boothby, the 55 first British editor of Jean-Jacques Rousseau, who has himself displayed cast down in a glade as though in thoughtful reverie. The pose is all the more striking because of the elegance of his disarray. He looks as though he is actually on a sofa and that the landscape has been painted around him.

57. **Sir Thomas Lawrence**
Queen Charlotte, 1789.
A telling depiction of the Queen in later life when she had endured many troubles, including her husband George III's loss of reason. Perhaps not surprisingly, this brilliant portrait was not appreciated by the Royal Family.

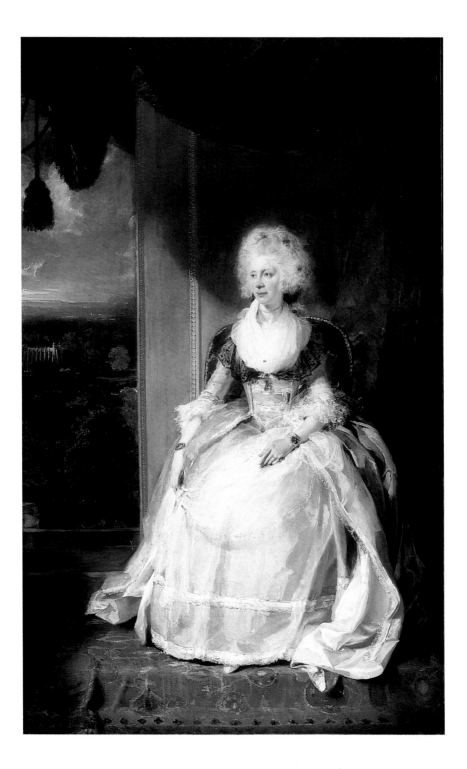

58. George Romney
The Spinstress, Lady Hamilton at the Spinning Wheel, 1787. Emma Hart – later to gain notoriety as Lady Hamilton, the mistress of Nelson – held Romney in her thrall at this time. He frequently used her as a model for subjects of virtue and innocence. Here she poses in a white dress as a simple country spinstress.

Directness and simplicity were key words in the work of George Romney (1734–1802). A slightly younger contemporary of Reynolds and Gainsborough, this artist had a modest practice in London from 1762, when he arrived from his native Lancashire and won a Society of Arts Award for a *Death of Wolfe*. In 1773 he took the bold step of making a journey to Italy. he came back imbued with a sense of history and the sublime, having moved in Fuseli's circle there and wishing to introduce more of the heroic in his work. His productions in history painting were scant, but his portraiture took on a new lease and seemed for a time to be offering a more vigorous version of Reynoldsian portraiture. In 1781 he met Emma Hart (later Lady Hamilton) and tried for a time to combine portraiture with images of this flighty lady in poses of 'simplicity'. These seem close at times to the sentimental scenes of the French painter Greuze, whose work he must have known.

But the master of the later Georgian age, after the deaths of Gainsborough and Reynolds and Romney's lapse into sentimentality was undoubtedly Sir Thomas Lawrence (1769–1830). An infant prodigy, Lawrence was already practising in the metropolis by the age of eighteen when he boasted 'excepting for Sir Joshua for the painting of a head, I would risk my reputation with any painter in London.' In keeping with the views of the age, his reputation as a 'natural' genius stood him in good stead. He cultivated, too, a glittering style that accorded well with developing notions of sensibility.

His portrait of *Queen Charlotte* was intended to be his 'show piece' and entrée into royal patronage. It was executed at a critical

58

57

moment when Gainsborough had just died and Reynolds was on the point of abandoning painting. Yet despite its brilliance, the work did not please, perhaps because it showed the Queen too frankly as the old and care-worn woman that she was. Lawrence learned not to renounce flattery after this, and his later works – while conveying a sense of the tensions of the time – always manage to do so in a glamorous way.

As a painter, Lawrence appeared to remain in a state of permanent adolescence. He put paid to grand portraiture, but never quite replaced it with anything substantial. The result was a brilliant modishness which was admired throughout Europe. He was the first portrait painter of the age – a point that was born out when, after the Napoleonic wars, he went to Rome to paint the Pope for the European Chamber of the Prince Regent. He was admired by the young Romantics, particularly in France, where Delacroix imitated him for a time. Yet his art never penetrates as does that of such French and Spanish contemporaries as Géricault or Goya.

Lawrence's portraits seem to demonstrate the vacuity of grand portraiture in the Post-Revolutionary world. Although the genre continues, it seems increasingly hollow.

Yet it should not be supposed that all portraiture went this way. Outside high society there was a sober tradition that remained, and which can probably best be seen outside London. In Scotland a pithy sense and humour prevailed. This comes out best in a picture that has gained iconic fame, the profile portrait of the Reverend Walker skating on Duddingston Loch, in which seriousness and comedy seem perfectly, if precariously, balanced. For a long time this picture was thought to be by Sir Henry Raeburn (1756–1823), the leading Edinburgh portraitist of the age, but this is now in some doubt.

Raeburn is mainly known for works in which a rich painterliness is evident that one is tempted to describe as wholesome. Early in his career he visited Italy (financed by a wealthy marriage) and this experience provided a cosmopolitan breadth to his art. In 1798 Raeburn was able to afford to build his own studio. This still survives and shows a controlled use of a high north light. Raeburn's pictures certainly have a sense of being viewed from a top-light, and this steady, rather cool source, seems to fit in with a kind of common-sense analysis of his sitters. Following on from Ramsay, Raeburn was able to draw sustenance from the Enlightenment tradition of Hume to see portraiture as an exploration of phenomena, a form of philosophical enquiry into both form and character.

Raeburn's portrait of *Isabella Mcleod* was painted in the year ⁶⁰ that he constructed his new studio and it shows the benefits in its fine effects. Miss Mcleod was a celebrated beauty who married a sober divine. Raeburn has captured both her charm and her practicality. She wears a delicious diaphanous dress. But there is thought in her expression, and her arms look the kind that could get down to solid work.

In 1810 Raeburn contemplated moving to London. But after a brief visit, he concluded that his chances were not strong enough. He was overawed by Lawrence's flashy style, and his later work shows its impact. Lawrence, for his part, called one of Raeburn's portraits the 'finest representation of a human being that he had ever seen'. It is a grand tribute, but also a shrewd one. For it seems to recognize that Raeburn's art was about people and their characters. Unlike Lawrence, he did not romanticize his sitters. Raeburn was a level-headed lowland Scot, and was not amongst those who were in the business of promoting a glamorous image of the Scottish past. He did not hit it off with the principal purveyor of that myth, the great author of *Waverley*, Sir Walter Scott. Despite being the first Scottish painter to achieve an international reputation while remaining working in his own native country, he was an end rather than a beginning. He is the last and greatest visual representative of the Scottish Enlightenment. In him the grand portrait tradition can truly be said to have had its last great flowering.

60. Sir Henry Raeburn
Isabella Mcleod, Mrs James Gregory, c. 1798. A portrayal of a celebrated beauty, married to an Edinburgh scholar and divine.

Chapter 5: The Academy

61. **Johann Zoffany** *Members of the Royal Academy*, 1771–72
A group portrait of the members of the Royal Academy soon after its
foundation. The two female members are shown as portraits on the wall.
The artist has depicted himself, palette in hand, on the extreme left.

In 1768 one of the most important events in the history of British painting took place. The Royal Academy of Arts was founded. For the first time artists had a prestigious organization powerful enough to promote their professional status and provide the kind of organized training that had become associated with the visual arts by this time in every other major European country.

The Academy was undoubtedly a success. In the century following its founding, it was the most influential institution in British artistic life. Its members enjoyed unique status. It held an annual exhibition, ostensibly to provide examples of the best work being produced. Very early in its life the Academy's Summer Exhibition became the event of the London season, and artists' reputations were made or broken at it.

However, it should not be supposed that the Academy was an unalloyed bonus. In many ways it was repressive and divisive. Despite promoting an image of art as a noble and intellectual calling, it often failed to support the most ambitious and imaginative work being created. In the end this led to its downfall, as more and more independent-minded artists (such as the Pre-Raphaelites) turned away from it. We are most aware of this process in the Victorian period, when its power was beginning to decline and an avant-garde was springing up that was turning to different methods to promote their art. But it was restrictive throughout its history, and perhaps did as much harm as good even at the time of its foundation.

Zoffany's picture of the Academicians in 1772 shows the group soon after its foundation. It can tell us a lot about the institution and its ambitions. It was (apparently) painted for George III, its royal patron. This in itself was an important point, for royal patronage was held to be critical for establishing its status. It shows almost all the members of the original group of forty. Two were absent because not in London (Gainsborough was in Bath, Dance in Italy). Two were absent on account of their sex. The female painters Angelica Kauffmann (1741–1807) and Mary Moser (1744–1819) are present only as portraits on the wall. The ostensible reason for their absence is that the men are painting from a nude model, and it would have been improper for them to be present on such an occasion. This very fact suggests that their position was marginal. This situation was to worsen. No further women were made Academicians until the twentieth century and females were excluded from studying at the Academy schools until the late nineteenth century.

61

It is noticeable that the Academicians are shown dressed as gentlemen, and disputing and deciding rather than painting or sculpting. For it was their status as gentlemen that the picture wished to proclaim. A number of them are discussing the posing of a model. The study of the nude was a central activity for academies. Mastery of the human form was held to be the most important skill an artist had to acquire. On the wall behind the Academicians are antique busts. These made clear the other major teaching activity of the Academy – to instill a knowledge and reverence for the idealized classical forms of the ancient world.

This picture shows the social ambitions and educational aims of the Academy. The third area in which it was principally active was exhibition. From its start the Academy held an annual show which was crucial both for its influence and its finances. This was the point at which the Academy encountered the public, where it entered the market place.

For the rest of this chapter, I shall consider how these three main functions of the Academy – status, training, and exhibition – operated in the period covered by this book.

Status
The very word 'academy', taken from the name of the place where Plato taught his philosophy in Athens, suggests a learned body. For the visual arts the term had a particular significance as it countered the image of the practice as a purely 'manual' craft. When Sir Joshua Reynolds – first President of the Academy – painted his self-portrait to hang in the Academy's council room he showed himself in the robes of the University of Oxford. He had been given an honorary doctorate; not because of his status as a painter, but because of the intellectual merit of the discourses he had delivered on art. Reynolds emphasized that an Academician should be learned and encouraged others to follow his example and deliver lectures on art.

The issue of status had been raised by academies ever since they first began to spring up in Italy in the sixteenth century. From the start they had been promoted by rulers and were usually associated with the court rather than with the town. Their rivals were the traditional craft-based guilds, which were controlled by civic authorities. In every country a struggle arose between guilds and academies that was simultaneously a dispute about training methods and about the rights of a ruler to interfere with local organizations. The most powerful academy was that of France. Founded in 1648, it grew under Louis XIV to become an agent of

62. Sir Joshua Reynolds
Portrait of the Artist, 1780. The President of the Royal Academy shows himself in the robes of his honorary doctorate from the University of Oxford, beside a bust of his hero Michelangelo.

monarchical absolutism. French Academicians were state officials who gained the right to control most areas of artistic activity. Much of the hostility to the Academy in Britain was based on the fear that it was emulating a French authoritarian model, instead of promoting practices more in tune with British democracy.

In fact, while sharing many of the artistic ideals of the French Academy – and modelling its training methods on it (as did virtually every other academy in Europe) – the British Royal Academy never acquired a similar level of power. It was not state funded, and was reasonably free of royal influence. The monarch, it was emphasized, patronized it only in a private and personal capacity rather than as head of state. The authoritarian model that the Royal Academy set up for the visual arts was in fact one familiar in British political and social life. It was (and is) essentially a club. Membership was strictly limited (to forty full members during the first century of its life) and was by election.

Artists' clubs had proliferated in early eighteenth-century London. This was part of a general expansion of the club system

which could be seen as a central part of the new forms of government that had become established after the 'Glorious Revolution' and which was epitomized by the Kit-Cat Club.

Hamilton's picture of artistic 'virtuosi' in 1735 records one such organization. Some were purely social gatherings. Others were democratically run places of instruction, such as Hogarth's 'St. Martin's Lane' Academy. They were important both for raising morale in the profession and for emphasizing that artists had a place amongst the ranks of men of discernment and taste.

Taste was the all-governing artistic principle of the eighteenth century. Only the gentleman – the person of good education and natural refinement – could have taste. It was common amongst the patrician classes to believe that they alone possessed taste, and that artists therefore had to be guided by them in this matter. Artists, on the other hand, argued that they had both the experience and innate disposition to enable them to be arbiters of taste as well. As a demonstration of this the Royal Academy was adamant that artists alone should be admitted to membership. For their part, the artists were convinced that mere 'craftsmen' lacked

63. **Gawen Hamilton**
A Conversation of Virtuosi...at the Kings Arms, 1736.
A club of artists from the early eighteenth century. The last three figures are the sculptor Rysbrach, Hamilton himself and the architect Kent.

taste. It is for this reason that engravers were not allowed to be Academicians. At that time it was argued that engravers were merely engaged in the 'mechanical' reproduction of images and not in their invention. Not until 1857, when photography was becoming the principal means of reproduction and engraving was being used increasingly as a 'creative' art form, did the Academy admit engravers as full members.

Eventually the exclusion of gentlemen connoisseurs from the Academy provoked a backlash. In 1805 the British Institution was set up. This was run purely by gentlemen (artists were excluded from the governing body) and its intention was to provide the leadership in taste in areas where it was felt the Academy had failed. In particular it held exhibitions of old masters – largely drawn from the collections of members of the Institution. But it also had an annual exhibition of work by modern artists which rivalled those of the Academy for more than fifty years.

Training and education

Instructing students has always been a central activity for academies. In contrast to the guilds, who monitored apprenticeships in a particular craft, such as painting, sculpture or metalwork, the academies provided general instruction in drawing. *Disegno* – to use the Italian term – was considered to be the most intellectual aspect of the visual arts. It comprised both the ability to design and conceptualize a work and the development of observational drawing skills. The Academy also taught those scholarly subjects that would help master appearances – such as the natural sciences, anatomy, mathematics, perspective – and those that would help the erudite painter of elevated subjects – in particular history and literature. Such study was open to mature artists as well as to students, and some painters (such as William Etty) studied in the life class throughout their careers. The instruction was free and was intended primarily to guide the young into the higher realms of art.

Wright's picture, *An Academy by Lamplight* exhibited at the Society of Artists in 1769, appears to represent the academic ideal. It shows young students gathered together to contemplate and study an antique statue. Wright's characteristic use of lamplight adds to the wonderment of the picture. But it also is a reminder that study at academies (including the Royal Academy) usually took place by lamplight and in the evening. For these students would have been working as apprentices to their crafts in the daytime. Unlike the modern art school, the academies were part-time

64

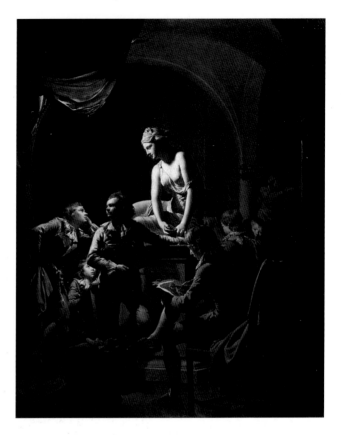

64. **Joseph Wright of Derby**
An Academy by Lamplight,
c. 1768–69. Wright's imaginary
portrayal of a group of young
artists studying and receiving
inspiration from a classical
sculpture.

institutions, intellectual supplements to the craft learning that
would be acquired by the more traditional method of working as
an apprentice in an artist's studio. It was only in the nineteenth
century, that painting and sculpture and other practices were
included and academy study took over as a full training method for
the young artist.

Wright's picture may well have been intended as a criticism of
the Royal Academy. For, unlike the serried ranks ruled over by a
master, it shows students indulging in free study of the antique.
One of the arguments by the opponents of the Royal Academy (of
whom Wright was one) was that it imposed method rather than
inspiring the imagination.

This imposition of method came from the example of the
French Academy. While academies had started in Italy, it was the
French Academy that had, following the model of Louis XIV's
method of government, produced a fully structured and codified
method of teaching. In this the Platonic ideal became combined

65. After Charles Lebrun
The Expressions of the Passions,
1692. Codified representations
of expressions by the president
of the French Academy.

66. Pugin and Thomas
Rowlandson *The Life Class*
at the Royal Academy.
The life class in practice, the
students in ranks as at a lecture.

with the new scientific rationalism of the seventeenth century.
The student had to learn the parts of the body like the words of an
alphabet. Just as those learning to write would have to copy letters
from copybooks, so the student would begin by copying engrav- 65
ings of individual parts, of hands, feet, eyes, noses and the like,
before going on to study the antique and then the living model. 66
Gesture and pose were systematized, models being chosen who
had physiques that resembled those of classical statues and who
knew how to hold poses. Systematization was preparation for the
idealized historical compositions which were held to be the ulti-
mate aim of the artist. For these were coded and structured as
rigorously as classical drama. Academies promoted the notion

that there was one timeless ideal of beauty to which all art aspired. What was good in fifth-century Greece was still good today and there was no reason why modern artists should not try to rival such ancient masters as Phidias. Modernity was frowned upon as vulgar and debased. There was a strict hierarchy of different types of pictures. Subjects involving human forms were highest – with history and allegory at the top, followed by portraiture, then 'low-life' subjects (or 'genre' paintings). After this came representation of the animate world – animal paintings and vegetative paintings, still-life and finally landscape.

The problem for the academic system was that this structure accorded less and less well with contemporary interests. History painting in the traditional, idealized and timeless form, had very little popular following. In France this lack was not vital since the government commissioned history paintings as well as training artists to produce them. But the British system wasn't fully worked out. That democratic spirit that opposed academic hierarchy also hindered publicly funded patronage of historical art except in moments of political or aesthetic crisis. The result was chaos, although – as will be seen in the next chapter – the chaos was not always unproductive but could lead to remarkable innovations. For the most part the market demand was for contemporary pictures, or romanticized versions of history that had more to do with novels than with high art. Portraiture and landscape were also perennially popular.

One final point to be made here is that the Academy, by focusing on high art, did little or nothing to deal with the issue of promoting design as applied to commercial work. This was a growing problem because new industrial methods were undermining traditional apprenticeships in manufactures and there was no provision made in the new entrepreneurial industries for training designers. Once more the contrast with France (and most other Continental countries) was marked. In France the system that regulated artists to be trained and produce via the Academy also provided for separate institutions for the training of designers specifically related to art manufactures – such as for example the Sèvres porcelain factory. In the 1830s a government commission investigated the problem and came to the conclusion that the only solution was to establish separate 'Design' schools that would train designers to work specifically for manufactures. This started the erosion of the authority of the Academy. The Design Schools set up gradually evolved to form the backbone of the modern art education system.

Exhibition

As has already been mentioned, the Academy's annual exhibition became the mainstay of the institution. From 1780 to 1838 it took place in the grand, purpose-built exhibition rooms at Somerset House in the Strand.

In traditional academies, exhibition had not been the principal objective. In so far as it existed, it was a means of 'showing the best' so that examples could be studied. However by 1769 – the year of the first Academy exhibition – commercial exhibition had become a strong part of modern artistic life. Those who could not afford to buy a picture could still admire what was on display, perhaps later buying an engraving after a favourite work. It also gave those who could afford to buy pictures the opportunity of coming and choosing from a range of work of 'guaranteed' quality, rather than having to slog round several studios and perhaps have untimely and embarrassing encounters with artists.

The Society of Artists, who mounted highly successful and well regulated exhibitions in the 1760s, was the organization that really established the viability of the regular art exhibition in London. It was this that suffered most from the setting up of the Royal Academy, which stole its thunder by being more up-market and more exclusive. Unlike the Academy, The Society of Artists was not restrictive in its membership and had a more open exhibition policy. While the Academy opened their exhibition to all comers, those who were not Academicians had to have their work judged for exhibition by a jury. In other words they operated a quality control. This practice became increasingly fraught as artistic standards changed. The habitual complaint against academies in all Western societies in the nineteenth century was that they imposed outdated standards which excluded or crippled the display of innovative work.

Unlike some institutions, the Academy charged for entry to their exhibitions. The initial reason for this was to ensure that 'undesirables' did not roam in casually from the street. They even had a bylaw that said that no 'improperly dressed persons' or servants in livery would be allowed entry. However, the charge that was meant to restrict entry became the key to commercial success. The takings were soon sufficient to fund the whole of the Academy's operations.

The success of the Academy was due in large part to carefully managed publicity by Reynolds and the others. For while professing high art, they also took care to remain viable in the market place. Thus, while decrying such lesser genres as low-life painting

Chapter 6: The Tragedy of British History Painting

There was no doubt in the minds of both artists and connoisseurs in the eighteenth century that history painting was the highest form of art. The problem was how to produce it. In Britain there was neither training nor patronage to enable a sustained school of history painting to come into being. The attempts made in the Royal Academy and elsewhere to stimulate one ultimately failed. Yet the failure was not altogether ignominious. There were many individual works of great originality produced in the genre, and some of these achieved international fame at the time. There were considerable side-effects too: both the visionary images of Blake and the sublime landscapes of Turner can be said to have been stimulated by those artistic ideals that form the basis of history painting.

Before going on to look at the chequered history of this type of painting in Britain, I would like to begin by considering what history painting was understood to be in this period.

The name suggests that it concerned the depiction of historical events. But it was more than that. 'History' in this context meant grand and heroic stories from the past – no matter whether these described actual events or were mythological or literary creations. In fact the history painter was more likely to draw his subject from a literary classic – such as Homer – than from a direct historical record. The model for history painting was epic poetry. As Jonathan Richardson put it in his *Essay on the Theory of Painting* in 1715;

*…as to paint a History, a Man ought to have the main qualities of
a good Historian, and something more; he must yet go higher, and have
the Talents requisite to be a good poet; the rules for the Conduct of
a Picture being much the same with those to be observed in writing
a poem.*

For history painting was not just defined by subject matter. It also implied a particular way of representing things. Noble events from the past should be depicted in a noble manner. In his *Discourses* Reynolds – following Richardson and other theorists

before him – argued that the history painter should paint broadly, and not be hampered by minuteness of petty detail. The heroes of the past should also be shown as paragons of human beauty, even if this flew in the face of the evidence. Alexander the Great was said to be small of stature 'but the history painter should not depict him thus'. For the history painter needed to show his greatness by giving him greatness of stature. Similarly flowing robes (preferably classical) should be used so that grandeur of form could be displayed.

History painting and the new order

The first twenty years of the Royal Academy was the time when British history painting received its greatest impetus. There had already been a practice of history painting in Britain, although on a minor scale. Like other Protestant countries, Britain lacked that background in patronage for religious commissions that was provided by the Catholic Church. Furthermore, lacking an absolutist monarchy, there was not the usual lead provided in this field by court patronage. But in the early years of the century there had been some patronage of both sorts. Partly because of the need to support the Protestant succession, Queen Anne had commissioned Sir James Thornhill to decorate the Painted Hall at Greenwich (1707–27). Thornhill was no more than competent. But his pictures 'did the job', and were important for boosting the morale of British artists. There were, too, many foreign artists at work at the time such as Verrio, Laguerre and Amigoni, who worked largely for the aristocracy during the period.

The baroque extravagance of such work was looked on by many with disdain, as can be seen by Pope's irreverent couplet in his *Epistle to Lord Burlington* of 1731;

On painted ceilings you devoutly stare
Where sprawl the saints of Verrio and Laguerre

By the 1730s the call for public history painting had become a political matter. This can be seen in the essay on the subject published by the opposition writer James Ralph in the *Weekly Register*. Concluding that Protestantism was at the base of the lack of British history painting, Ralph called for churches and public buildings to commission them. Such a call was to be repeated time and again over the next century. It only began to be answered at a governmental level in the Victorian period. From the 1730s onwards, however, there were repeated individual attempts to use the decoration of public institutions as a means of promoting

British history painting. One of the earliest such occasions was at St. Bartholemew's Hospital where Hogarth saw off the foreigner Amigoni and gained the commission for some works of his own.

Hogarth's own attempts at historical composition are, it must be admitted, not very distinguished. They lack the spark and verve of his portraits and satires. Amongst his circle, however, there was one painter who did succeed. This was Francis Hayman, a decorative artist who gained a reputation by painting more than fifty

69. **Francis Hayman** *Robert Clive and Mir Jaffir after the Battle of Plassey, 1757, c.* 1760. An early modern history painting showing the celebrated architect of British power in India receiving obeisance from one of the local rulers.

112

decorations for boxes in the Vauxhall Gardens. Such work was novel in its subject matter, including literary scenes as well as genre. It is important for showing the new kind of commercial patronage for high art. Hayman was to follow this with *The Finding of Moses* for the Foundling Hospital, and his reputation in history grew. Eventually, in the 1760s, he produced four huge paintings depicting scenes from the Seven Years War for Vauxhall Gardens. These are now lost, but the sketch for one suggests that they were strikingly modern in approach. The presence of such works in a popular pleasure garden also suggests that there was a clear public for this kind of history painting. This had probably less to do with high aesthetic taste than with the jingoistic patriotism that was increasing during a period of colonial expansion and rivalry with France.

Unlike Hogarth, Hayman survived to the period of the Royal Academy, and became one of its founding members. But his modern style of history painting was held by then to lack the classical dignity of truly elevated art.

Classical reform: Rome

By this time a severe revival of the classical ideal had been under way in Rome for nearly two decades. British artists had, in fact, played a significant role in this, even if their achievements were not fully recognized at home.

This classical reform was, in a way, quite modern. For while looking back to the example of Ancient Greece it interpreted this in terms of Enlightenment ideals as a return to first principles and order. The principal ideologue of the movement was the German Johann Joachim Winckelmann who, in his celebrated *Thoughts on the Imitation of Greek art in Painting and Sculpture* (1755) not only proclaimed the virtues of classical simplicity, but also associated these with the moral and physical purity of the primitive that the Swiss-French philosopher Jean-Jacques Rousseau was popularizing with his idea of the 'noble savage'. From this time on history painting had a new agenda; one that combined classical form with a sense of radical reform.

Rome might seem to be a curious place for a radical movement of any kind in the mid-eighteenth century. But as well as being a place for painters to come and study the antique, it was also an international refuge – often from political oppression at home. And if the Pope could hardly be seen as a revolutionary, his relatively lax regime made it possible for all kinds of foreigners to co-exist in the Eternal City.

70. **Gavin Hamilton**
The Oath of Brutus, c. 1763–64.
Brutus, an early Roman, was
present at Lucrece's suicide after
she had been raped by Tarquinius
Superbus. Seizing the dagger, he
swore vengeance on the Tarquins,
so initiating the Roman Republic.

71. **Benjamin West** *Non Dolet*,
1766. A Roman patrician lady
commits suicide in order to shame
her disgraced husband into doing
likewise, with the words 'See, it
does not hurt'.

Even amongst the British in Rome, there were many who belonged to dissident groups. The most distinguished British history painter of the period was the Scot Gavin Hamilton (1723–98), who had distinct Jacobite leanings. He was an intimate of Winckelmann's circle and produced a series of Homeric subjects that were at the cutting edge of the revival. His *Oath of Brutus* provided the prototype for the French neo-classicist David's famous *Oath of the Horatii* and was produced twenty years earlier. Unlike David, however, Hamilton could not gain the patronage to continue such work. He eventually gave up the unequal struggle and turned to picture dealing.

Among the young artists who caused the greatest stir in Rome around 1760 was the American Benjamin West (1738–1820). West attracted attention as a denizen of the New World. For some, it gave him the aura of a 'noble savage'; indeed the blind Cardinal Albani assumed that he must be a Red Indian. When West came to settle in London in 1763 he was able to trade on his Roman experiences and rapidly gained a reputation for the noble simplicity of his classical scenes of heroic virtue. In *Non Dolet* a Roman lady is depicted setting an example to her cowardly husband by committing suicide rather than face public disgrace. West was certainly in the right place at the right moment. Such was his reputation that George III, anxious to play his role as a royal Maecenas, appointed him his history painter, giving him a stipend and an opportunity to develop that no other artist in Britain at the time enjoyed.

Modernity: West and Copley

Yet ironically, the picture that made West's name in the international art world was a history painting that seemed to fly in the face of all the precepts he then espoused. This was *The Death of Wolfe* painted in 1770. Instead of depicting an ancient hero, he chose a recent one, who had died while wresting Canada from the French in the Seven Years War. Worse than this, he showed the figures in contemporary costume rather than classical garb. Reynolds warned against this, and the King refused to buy the work, he was so shocked with the innovation. But when exhibited, it was a huge success and sold immediately. The King then relented and ordered a copy for himself.

There was nothing new in itself about West's choice of modern dress. Many had done that before. Hayman's vast paintings in Vauxhall were well known, and Edward Penny and George Romney had both exhibited modern dress versions of the death of Wolfe before West. But they had not invested their modern

70

71

4

72. **John Singleton Copley**
Brook Watson and the Shark,
1778. A stirring depiction of an
incident in which a young British
merchant in the West Indies was
attacked by a shark. He escaped
with the loss of one leg.

representations with the ideality and dignity that was held to be appropriate for history painting. West had made the central section look like a *pietà*; the well-known religious image for the mourning of the dead Christ. This representation had little to do with the known facts of Wolfe's death, which were more faithfully relayed by Edward Penny. West's treatment turned the subject into a 'classical' tragedy. This mood was enhanced by the introduction of a naked Indian, staring mournfully at the fallen hero like a figure from the chorus of a Greek play.

For contemporaries West had succeeded by infusing history with poetry, revealing timeless virtues that lay beyond the temporal. A more cynical view would be that West had achieved a matchless piece of propaganda, legitimizing a significant moment in British colonial expansion by investing it with the heroic and 'impartial' values of classical drama.

Curiously, West himself did not follow up his success. Having demonstrated the possibility of modern heroic history painting he returned to depicting traditional historical and mythological subjects for the king. He achieved wealth and status by these means, succeeding Reynolds as President of the Royal Academy in 1792.

Indeed it is remarkable that the vehicle that West had invented for heroicizing the modern was so little used in Britain in an era when it would seem that there was every reason for it to succeed. Following on from the Seven Years War there was a mounting degree of conflict – culminating in the Napoleonic Wars and the triumph at Waterloo. Surely at a time when the nation was engaged in the largest military conflict known in Europe, and heroic deaths were being announced in the press almost daily, modern history painting should have had its day? It certainly did in France, where David and Gros followed West's lead to produce heroic celebrations of the deeds of Napoleon and his generals.

The most gifted painter to attempt modern history painting in Britain was John Singleton Copley (1738–1815), a countryman of West's, who settled in London in 1775 after having studied in Rome. He had previously gained a reputation in London for the fine quality of the pictures he had sent over for exhibition from his native Boston – notably *The Boy with a Squirrel*. Now he was determined to succeed in the Grand Manner. A private commission gave him his opportunity. This was a depiction of a noted London merchant, Brook Watson, at the most traumatic event of his life. While in the Caribbean as a youth he had been attacked by a shark, losing a leg but saved at the last moment from almost certain death. In *Brook Watson and the Shark* this gripping contemporary

72

117

drama is treated in true heroic manner. The striking arrangement
of the group of rescuers leaning out of the boat towards the endan-
gered victim below show that Copley had learned much from his
study of classical composition in Rome. Yet he has managed to
convey the action without artifice.

Copley soon moved from private to public themes, commemo-
rating first the death of the Prime Minister, Chatham, who col-
lapsed in the House of Lords while making a patriotic speech, and
then the death of a militiaman defending Jersey against the French
in 1780. The latter, *The Death of Major Pierson*, shows a remarkably
confident blending of excitement and high art. Pierson falls in the
height of battle, and as his body is supported by his comrades. His
black servant rises, a magnificent image of vengeance, to annihi-
late the Frenchman who has felled his master. The picture was a
deserved success. And again the question has to be asked: why,
having achieved such mastery in this new and highly topical
genre, did Copley fail to follow it up?

In Copley's case the reasons appear to be different from those
of West. West abandoned topicality, it would seem, in the interests
of security and status. Copley failed because, in the eyes of his con-
temporaries, he played too cravenly to the market. His debacle
came in 1791 when he erected a tent in Hyde Park to show his *Siege
of Gibraltar* to accommodate the crowds pressing in to admire his
latest patriotic tribute to British military prowess. For the
Academy this was going one step too far. He had turned fine art
into a vulgar spectacle. In later life Copley made attempts to
regain his former status without avail. He died embittered, feud-
ing to the end, particularly with West.

The shadow of Reynolds

During the period in which West and Copley were producing their
modern heroic dramas, a very different notion of history painting
was being promoted by the Academy. Here Reynolds delivered his
discourses proclaiming the 'Great Style', with its 'timeless' treat-
ment of the past. He also found some time to paint histories in this
manner himself. One of his most celebrated was *Ugolino* which
showed the tragic Count from Dante's *Divine Comedy* left in prison
to die of starvation with his children. The subject could indeed be
taken as a symbol for the historical painting that Reynolds himself
was promoting and recommending to his progeny. For not one of
the young hopefuls who followed the master survived the experi-
ence to achieve enduring reputations.

73

74

75. **Angelica Kauffmann**
The Artist in the Character of Design Listening to the Inspiration of Poetry, 1782. This female artist shows herself as the muse of painting, guided by that of literature.

Reynolds also promoted established artists. He found much to admire in the elegant 'poetic' canvases of Angelica Kauffmann, the Swiss painter who worked in London from 1766 to 1781. Despite support from Reynolds, however, Kauffmann's work was generally regarded as too tender, too 'feminine' by most critics. In recent years there has been a re-reading of her work which suggests that her delicate art incorporated an ironic questioning of her role as a woman painter. This is perhaps implicit in her portrait of herself as the muse of painting, where she is at once both model and artist, inspirer and inspired. At the time, however, this was not perceived.

The main challenge to Reynolds came from the Irish artist James Barry (1741–1806). No one took the public role of the history painter more seriously than he. A protégé of the statesman-philosopher Edmund Burke he had the highest ideals for his art, particularly after a period of study in Rome. Reynolds welcomed him on his return to London in 1770. In 1782 he was made Professor of Painting at the Academy. Like other aspirant history painters he dreamed of creating a vast mural cycle. When patronage for this was not forthcoming he took matters into his own hands. Between 1777 and 1784 he decorated, largely at his own expense, the walls of the Society of Arts with huge canvases on the theme of the Progress of Human Culture. When he saw them Dr. Johnson commented 'there is a grasp of mind there which you find nowhere else'. Yet this heroic achievement, so admired by Blake and other independents, did not lead to the expected public triumph. Notable though the works are for their intellectual content, they do have both technical and aesthetic limitations. Sadly they seem to emphasize once again that such work can only be carried out successfully with appropriate training and support – precisely those factors that Barry, like all his other British contemporaries, was denied.

76. **James Barry** *The Crowning of the Victors at Olympia* (detail), 1801.
A scene from the great cycle of human progress painted by the artist at his own cost on the walls of the Society of Arts.

In later life Barry became increasingly isolated. Like the French painter David – whom he greatly admired – he was a radical in his politics as well as in his art. He came to see the hobbled state of public art in Britain as a product of elitism and private interest. He became vociferous in his criticism of the Academy, gaining the unique distinction of being the only artist in the whole of that institution's history to have been expelled from its ranks. Sadly, too, while he was so vehemently committed to the public, it is in the private side of his art that he had his most considerable achievement. For while connoisseurs might to this day have reservation about his large, often overblown canvases, he has maintained a high reputation for the quality of his small etchings.

Indeed, it is in the private sphere that British history painting might be said to have achieved most. The most striking examples of such works, those by Fuseli and Blake, will be discussed in a separate chapter. Even those artists who did achieve contemporary success for more conventional forms of history painting did so largely through the agency of engraving. This was the means by which commerce managed to fill in part the gap left by the absence of effective public patronage. The best known venture of the period was the scheme set up by the printer and engraver Alderman John Boydell to commission pictures illustrating the plays of Shakespeare. Boydell's scheme was to create a permanent exhibition of these, underpinning the finances through the sale of engravings of the works. Boydell's Gallery was opened in 1789. For a time the scheme was immensely successful, and provided much welcome employment for a large range of historical artists, including Reynolds, Barry and Fuseli and many of the younger generation. However the project was a prey to the vagaries of the market. In the end Boydell overreached himself and the Gallery had to close. The pictures were sold and dispersed.

The engravings, and such pictures that survive, suggest that this may have been no great loss. What is perhaps most dispiriting is the sorry figure cut by the younger artists, protégées of the Academy such as James Northcote (1746–1831), who was an assistant of Reynolds' from 1771 to 1775 and then studied in Rome. His painting seems dull and mannered today.

Romantic gestures and despair

It was a Briton in exile who played the most significant role. This was Richard Parkes Bonington (1802–28), a student of Gros who died tragically young, but who played a full part in the 1820s in the French *romantique* rebellion. His accomplished, small informal history paintings show a new domestic view of history, in which environment and mood are as important as event. The model for history painting here is no longer the classical drama. It is the modern historical novel – particularly that of Walter Scott.

As with earlier innovations, it was the French who were able to profit from this change more than the British. Through his friend Delacroix, Bonington's work became part of the dialectic of French history painting, in which issues of ideality and modernity were battled out in a public and politically charged field.

In Britain there was little recognition of this, although Bonington's work did help in the development of popular history painting of the Victorian period. But the wider ramifications of French Romanticism were still viewed with suspicion. One of the few British painters to show a response, William Etty, was regarded as a dubious, even immoral, figure, because of his obsession with the female nude. At times – as in his *Hero and Leander* – he was able to produce works of rare poetic mastery.

The 'School of Reynolds' meanwhile, ended appropriately enough in bathos. Benjamin Robert Haydon (1786–1846) was a young Academy student at the time when Barry died. Like Barry he was a powerful polemicist and was tireless in promoting his own art and the public cause of history painting. A man of considerable intellect, he impressed many, including the poets Wordsworth and Keats and influential politicians. He did in fact play a significant role in persuading the government that they should become actively involved in the patronage of art, both by providing public-funded training in design and in commissioning large frescoes for the Houses of Parliament. The latter began to be erected in the 1840s and their story properly belongs to the Victorian period. Yet the point that is relevant here is that the style of the paintings made for the Houses of Parliament by younger artists such as Daniel Maclise and William Dyce were in emulation of Continental models – French Academicism and German Revivalism – rather than in the British tradition of Reynolds. In vain did Haydon complain in his diary about how he and his contemporaries had avoided 'David's Brickdust' only to see their principles sold abroad by their younger colleagues. Haydon had all his

77. **Richard Parkes Bonington**
Francis I and Marguerite of Navarre, c. 1826–27. Intimate scenes from history were popular amongst the *romantiques*. Here the French King is shown relaxing with his favourite sister.

78. **Benjamin Haydon** *Marcus Curtius Leaping into the Gulf*, 1843. Haydon's vast portrayal of an ancient Roman sacrificing himself for the good of his country. A great gap had opened in the forum, and the Oracle proclaimed that it would not close until Rome threw into it her most precious possession – a Roman.

attempts in the competitions held for the commissioning of Parliamentary frescoes rejected. In 1846 he killed himself.

Haydon's story is a tragic one. What is particularly poignant in it is the huge gap between his ambitions and his pictorial talents. Like the 'tragedian' Mcgonegal in poetry, he is so bad he is almost good. But not quite. One of his last paintings is a ten-foot canvas (not large by his standards) showing *Marcus Curtius*, the leg- endary Roman hero who leaped into an abyss to save his country. Unfortunately this depiction of the noble event is ridiculous rather than sublime. Possibly Haydon hoped his own act of self-annihila- tion would do for British history painting what Marcus Curtius' had done for Rome. But sadly it was probably caused by a bleaker realization; that the art he espoused could not be saved by anything.

78

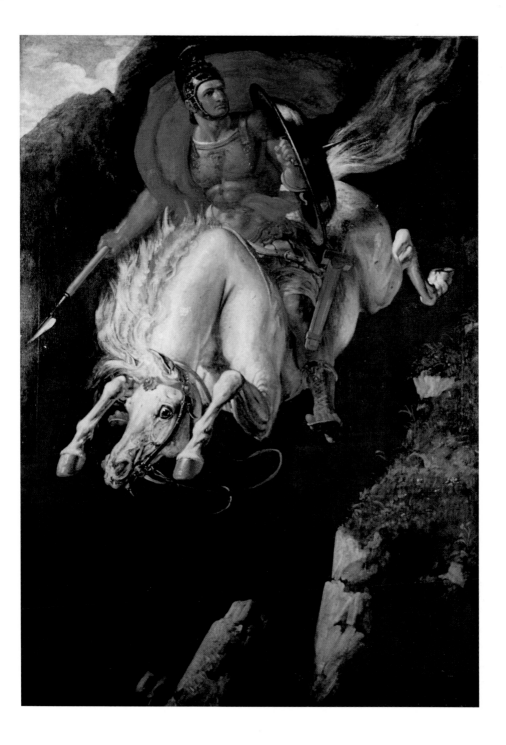

Chapter 7: Vision

The Academy was important for raising the status of the artist in Britain and for making it seem possible that history painting, the most learned and prestigious form of art, could be practised here. It brought Britain up to date with concepts of art and the artist that had been current in Italy since the sixteenth century and in most of Continental Europe since the seventeenth.

But at the same time as this was happening, a new understanding of creativity was emerging which was to become the norm in modern times. This was the view of the artist as original genius, whose works made visible unique and innate gifts, rather than the fruits of earnest learning. It was in Britain that the concept was first fully exemplified, in the career of the poet-painter William Blake.

The new artist

The emergence of this new concept can be related to a social and an aesthetic factor. The commercial society of the eighteenth century favoured the entrepreneurial independence exhibited by the man of genius. The cult may have been particularly strong in Britain because this country was then so advanced economically. Some have argued that originality was a kind of market ploy, a way of singling out a product in the face of competition. It was also, as Blake's career shows, a means of maintaining psychological resilience in adverse conditions. One could always claim to have been misunderstood. The concept of original genius fostered self-sufficiency as well competitive rivalry.

The close relationship in Britain between the visual arts and literature – already a factor in Hogarth's career – may have been important for the application of the notion of original genius to painters. For it was as a literary phenomenon that the idea of original genius first really developed. As early as 1711 it was adumbrated by Addison in an essay in the *Spectator*, where the distinction was made between 'innate' genius of the first rank and 'rule obeying' genius of the second. A more extreme view was expressed by the poet Edward Young in his essay on original composition in 1759, where genius was represented as an untrammeled force of nature.

The idea took root in the visual arts in the 1770s, in the work of a group of independent-minded artists in their thirties. The principal figures were Mortimer, Barry and Fuseli. Significantly all three were political radicals who seemed ready to set the tone of imaginative historical art in the period. But their rebellion did not last. John Hamilton Mortimer (1740–79) died young, Barry became marginalized, and Fuseli made his peace with the establishment. By 1790 (the year in which Fuseli became an Academician) it was all over.

All three artists believed that art should be public and political. It was the impossibility of making it function in Britain in this way that was their undoing. Blake shared their concerns, but unlike them he managed to reconcile these with a private and isolated practice. Perhaps Mortimer, had he lived, would have done likewise. He was a man of noted independence and eccentricity, a leading light in the Society of Artists and one of those who did not move across to the Academy when this was established in 1768. Like Barry, he excelled in making etchings. He exploited the ability of this medium to create sketch-like effects to the full. His subject matter was full of fantasy. He drew *banditti* and monstrosities based on the art of the Italian fantasist Salvator Rosa. His most influential work was from the Apocalypse. It showed *Death on a* 79 *Pale Horse* riding forth in Gothic grimness.

79. **John Hamilton Mortimer**
Death on a Pale Horse, 1784.
A macabre scene from the
Apocalypse that heralded a new
era of interest in the fantastic
and the bizarre.

80. **Henry Fuseli** *Self-Portrait*, c. 1780. Fuseli as the melancholy, intellectual artist, haunted by his own visions.

81. **Henry Fuseli** *The Nightmare*, 1790–91. Fuseli was deeply fascinated by what would later be called the unconscious. A version of this picture gained him his international reputation as a painter of the irrational and the bizarre.

Fuseli and the Sublime

While Barry and Mortimer have more or less sunk into oblivion outside specialist art historical circles, Henry Fuseli (1741–1825) has maintained a wider cultural presence – if only just. He has not become an 'industry' like Blake, but he has his niche as an arresting master of the bizarre. He owes this reputation most of all to *The Nightmare*. This subject – entirely his own invention – deals directly with the irrational and the unconscious. It is hardly surprising that it should have been one of the pictures chosen by Freud to adorn the waiting room of his psychoanalytical practice in Vienna. For it is a picture that questions the workings of the human mind.

Prior to creating *The Nightmare*, Fuseli had a stormy career. Indeed storminess seems to have been his leitmotif. 'He is everything in extremes,' wrote one of his friends. A painter of the mind, he began his career as a literary intellectual. Trained as a Zwinglian pastor, he travelled in Germany after being driven out of his native Zurich for exposing local corruption. If he had not been a political radical before, he certainly was one now. In Germany he made contact with the proto-romantic *Sturm und Drang* (Storm and Stress) movement, which believed in the free expression of emotion and the innate nature of genius. Arriving in London in the early 1760s, he worked for the radical publisher Joseph Johnson, translating such key German texts as Winckelmann's treatise on the Imitation of Greek art. More decisive for his future career was the encouragement he received from Reynolds to become a painter. This inspired him to move to Rome in 1770 where he stayed for nine years. Here he became part of a nothern European clique – including the Swede Johann Tobias Sergel and the Dane N. A. Abildgaard – who evolved a dramatic conception of classical art, inspired by the ideals of the *Sturm und Drang* movement and by Burke's concept of the Sublime as an aesthetic emotion based upon awe and terror.

Fuseli and public art

At the end of his time in Rome, Fuseli painted a patriotic work for the town hall of his native town. It showed the members of the original confederation who took an oath to make Switzerland a republic of cantons, independent of their former master, Austria. It follows on *The Oath of Brutus* by Hamilton as part of a genre of pictures of the period showing heroic political resolve. Yet it is much more succinct and emphatic in expression than the Scotsman's picture. In this sense it was closer to that most famous of all

128

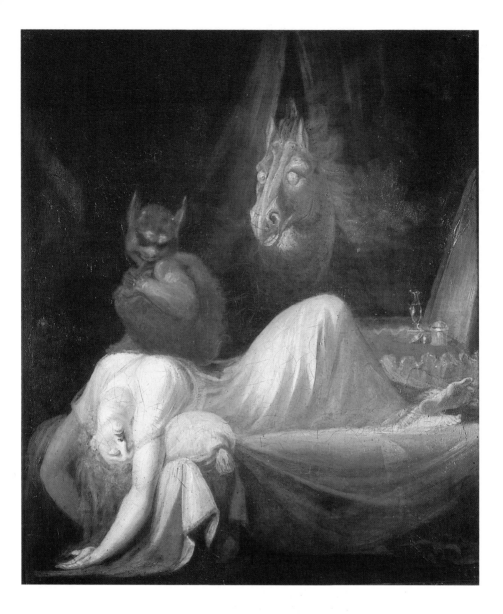

'Oath' pictures of the period – David's *Oath of the Horatii* of 1784.

It was soon after Fuseli returned to Britain that he produced the first version of his *Nightmare*. This work conjured up the violent effect of a terrifying dream. It showed a prostrate woman; thus evoking the erotic desires of the unconscious, moving away from the world of public heroism to one of inner disturbance, a world soon to be explored and developed in Spain by Goya – an

artist who knew Fuseli's *Nightmare* through engravings. Rather curiously, Fuseli did not develop this dimension himself, but returned in large part to creating dramatic and often highly sinister and erotically charged renderings of themes taken from major writers such as Homer, Dante, Shakespeare and Milton. Perhaps because of changed political circumstances in Britain after 1790, Fuseli abandoned his radical position and cultivated paradox instead.

It is typical of his contrariness that after he accepted appointment as Professor of Painting at the Academy, he delivered a series of lectures that undermined Reynolds' claims for the public utility of art. Fuseli stated that art did not contribute to the growth of wealth in a nation, but tended only to flourish when that nation was already rich. He felt that taste was the province only of the few, could never be popular, and that high art had to stand on its own internal merit. By the time he was issuing such 'shocking' denials, he had already been marginalized to the position of an intriguing eccentric.

82. **Henry Fuseli** *The Oath of the Rutlii*, 1779. The founders of the Swiss Confederation swear to an oath to fight to free themselves from Hapsburg dominion. Fuseli was himeslf Swiss.

Blake: the rebel

William Blake (1757–1827) is often thought of as belonging to the same circle as Fuseli. Yet though they clearly respected each other, their circumstances and ideals were very different. Both shared, it is true, a sense of the importance of the imagination in art. Yet Blake was a radical thinker who persisted in the view that art had a message to deliver and spent a life in poverty and obscurity insisting on the authenticity of his vision. In the end Blake was rewarded for the faith he maintained in himself.

In background the two were also utterly different. Blake was the son of a craftsman, a hosier, and had a limited education. He trained as an engraver rather than as a fine artist – as was common for someone with his background. He was always an outsider in those cultivated circles where Fuseli moved with such ease.

Blake was also a sincere visionary who directly experienced what appeared to be supernatural phenomena. This can happen in every age. But that a visionary should emerge as an artist-poet with ambitions to succeed as a historical painter has very much to do with the circumstances of the later eighteenth century. The age gave him his opportunity. He himself had a strong sense of moment and may have felt his position keenly. This might be the meaning behind one of his most teasing aphoristic utterances: 'eternity is in love with the productions of time.'

Blake also profited by the vogue for the primitive. His untutored skills as an artisan/poet gave him an appeal as a kind of 'noble savage' in radical intellectual circles, particularly those of the radical publisher Johnson and Mrs Matthews, the blue-stocking wife of a clergyman.

Because of the naive appearance of much of Blake's pictorial work it is sometimes assumed he was also untutored as a visual artist. This is not strictly true. He was highly trained as an engraver, having served a seven year apprenticeship, and his skill in mastering a hard clear line was recognized and used for all kinds of purposes – including providing illustrations for Wedgwood pottery catalogues. Blake did not lack technical skills as an engraver. The 'peculiarity' of his work has more to do with the particular nature of his perception.

After his apprenticeship Blake studied for a while at the Academy. It was here that his ambition to become a history painter grew, inspired by figures such as Mortimer and Barry and by his fellow student the sculptor John Flaxman. However, his designs for religious and historical themes were not appreciated when they were exhibited. It seems that their flowing linearity was too eccentric at a time when classical form was held to be important, even amongst painters of the fantastic.

Towards the end of the 1780s Blake's art underwent a remarkable transformation. While continuing to work as a jobbing engraver, he developed a mode of expression which was independent of patronage and commercial success, and which brought together his gifts as a visual artist with his skills as a poet.

He invented an engraving process of his own that combined image and text. This was the form that he used to produce illuminated editions of his own poetic works. One of the earliest of these, *Songs of Innocence*, has become his best known work. It is a series of short lyrical poems of deceptive simplicity which celebrate the presence of the Divine in all creation. Innocence, for Blake, is a state necessary for perceiving realities beyond the reach of the worldly wise. Four years later he provided a 'contrary' to the *Songs of Innocence* in *Songs of Experience*. These asked the question why, in a divinely created world, so much evil should be present. For Blake the answer to this is a complex one, and he explores it in his prophetic books. In *Songs of Experience* it is put with moving poignancy in which word and image are combined with rare insight. In *The Sick Rose*, for example, the short poem describes the destructive power of possessive love. At the same time the rose drawn around the poem expresses the sickness in rhythmic and drooping lines. Blake is a master of the expressive line, and never used it to better effect than here.

84. William Blake
The Sick Rose, 1789–94.
In 'Songs of Experience' Blake questions the presence of evil and misery in a divinely created world.

The SICK ROSE

O Rose thou art sick.
The invisible worm,
That flies in the night
In the howling storm:

Has found out thy bed
Of crimson joy:
And his dark secret love
Does thy life destroy.

Prophecy

Despite their evident beauty, the *Songs* sold very little. Blake had even less success with his complex mythological works. These books – which were also created using his special printing method – addressed the predicaments of the present from a cosmic perspective. Retaining his radical vision, he applauded revolution, and deplored the effects of both social and political oppression. In these works Blake was offering a unique insight into his age. Yet for the few of his contemporaries who attempted to read them they were seen principally as evidence of a deranged mind.

Blake hardly helped his cause by casting his narratives as mythological dramas peopled by figures of his own creation with such unfamiliar names as Los, Urizen and Oothoon. For Blake this was a matter of central importance, for he believed in the power of myth as a means of perception that could go beyond the limits of the rational. There may also have been some subterfuge in the strategy. Blake was able to use the disguise of his personal mythology to publish works that would have appeared seditious had they been understood.

The 1790s was a dangerous time for radicals. Britain was experiencing a reactionary backlash to the French Revolution and many were incarcerated in prisons and lunatic asylums for their

85. William Blake
Jerusalem (Bentley copy E)
pl. 28: 'Jerusalem/Chapter 2',
1804–20. A portrayal of sexual love from Blake's great visionary epic.

86. William Blake
Christ in the Sepulchre, Guarded by Angels, c. 1806. Blake's debt to the flowing lines of Gothic art is particularly evident in this scene from the Bible.

85

views. Blake was protected by the apparent harmlessness of his nonsense.

He did, however, experience a growing sense of isolation, and his work often took on a particularly dark character. From 1790 to 1800 he lived in Lambeth – then a relatively out-of-the-way suburb of London. As well as producing prophetic books he also made a remarkable series of large prints in which different kinds of human degradation are shown. Amongst these is the image of God dragging a protesting Adam into existence – a particularly negative view of creation. For Blake believed that the creation of man as described in the Bible had led to a fatal split between the material and the spiritual which had vitiated the whole of existence.

These monoprints of large figures suggest that Blake was still keeping alive his hope of succeeding as a historical artist. Eventually he decided to take matters into his own hands – as he had with his poetry – and mount his own exhibition. This took place in the house of his brother in 1809. It contained designs of biblical and historical subjects as well as representations of modern heroes. One of these showed Nelson – who had recently died at Trafalgar – as a naked figure struggling with the Biblical monster Leviathan. There were few who could follow Blake in such imaginative leaps. The one paper to review the exhibition dismissed it as a 'farrago of nonsense'.

After the failure of this exhibition, Blake made no further attempts to triumph in public as a painter. But he continued to have a career producing illustrations and paintings for a small number of private patrons. These included his old fellow student Flaxman,

87. **William Blake** *Hecate*, c. 1795. For Blake Hecate, the witch, represented the power of darkness and of negativity.

the poet Hayley (who arranged for him to live – not very happily as it turned out – in the country between 1800 and 1803). Despite the evident good intentions of such patronage, Blake often expressed irritation at what seemed to him to be a condescending attitude. He appeared to get on better with more modest patrons, such as the excise officer Thomas Butts who commissioned a large number of designs from Milton and the Bible. Some of these show the most exquisite use of linear effect, often reflecting the sinuous forms of Gothic art – which was particularly admired by Blake for its vibrant sense of spirituality.

86

88

Like most of his patrons, Butts was keener for Blake to illustrate scenes from well-known books than from his own mythologies. Blake appears to have accepted this situation unproblematically. For he could see each work in his own light, and brought his own interpretation to them.

The patriarch

Blake may never have lost his radical views, but he became seen by younger generations in the more reassuring role of the biblical patriarch. He did little to disabuse them. This is the view of him that survived through such followers as Samuel Palmer into the Victorian period, where it was taken up by the Pre-Raphaelites.

As was habitual with Blake, his real meanings were buried in subtexts. When the young artist John Linnell commissioned him to do a series of engravings to the *Book of Job* he obliged with a highly appealing set. Unusually for him, these actually became successful and sold at a profit. The story of Job – the patriarch who had triumphed in the end by keeping his faith in God despite all vicissitudes – might have seemed the perfect one for Blake, now enjoying appreciation in his old age after a lifetime of neglect. But in fact Blake had a different view of the matter, as is clear from details in his drawings and from the texts that he inscribed around them. It seems his real view was that Job had been 'tried' by misfortunes because his faith had originally been based more on convention than perception. Job's triumph at the end was to realize that faith is a matter of vision and enthusiasm, not the cold rule-obeying of the moralists and churchgoers.

89

A similar revisionism can be seen in Blake's last great work, also a commission from Linnell. This was intended to repeat the success of the *Job* illustrations with a far larger set for Dante's *Divine Comedy*. The medieval Italian poet's great vision of his journey through Hell and Purgatory to Heaven had become a cult text in the early nineteenth century. Its sheer imaginative force seemed

88. **William Blake** *The Sun Standing at His Eastern Gate*, Illustration to Milton's *L' Allegro*, 1816–20. The sun is shown in human allegorical form in the illustration to Milton's poem.

Great & Marvellous are thy Works Lord God Almighty

Just & True are thy Ways O thou King of Saints

So the Lord blessed the latter end of Job
more than the beginning

After this Job lived
an hundred & forty years
& saw his Sons & his
Sons Sons

In burnt Offerings for Sin

thou hast had no Pleasure

even four Generations
So Job died
being old
& full of days

W Blake inv & sculp

London Published as the Act directs March 8 1825 by William Blake Fountain Court Strand Proof

89. **William Blake** *Book of Job:*
Plate 21: Job and his Wife Restored
to Prosperity, 1823–25. Job and
his family celebrate the return of
good fortune by praising the Lord.

to reinforce the claims made by the Romantics about the nature of literary genius. Blake, the self-styled visionary, must have seemed well suited to illustrate such work. He approached the work in a critical spirit. For while he appreciated the power of Dante's imagination, he disliked his religious orthodoxy. When Dante describes the punishments of Hell, Blake sees these as the image of earthly oppression. In the fifth Canto of Hell Dante tells the sad tale of Paolo and Francesca, the adulterous lovers condemned to flit about in Hell for ever, buffeted by winds 'like starlings in Autumn'. Blake sees their adultery as the free expression of love. In his picture of the scene he turns the helpless buffetings described by Dante into a dynamic upward spiral.

90

Yet more important than these detailed interpretations is the overall effect of Blake's art. While a major poet, Blake was also a great enough visual artist to know that pictures must strike by effect, by design and colour, and this is how his pictures ultimately triumph. It is Blake's vibrant line and flaming colour that make him a truly visionary artist. While perforce in his own lifetime the most private of individuals, he has become the best known of British imaginative and historical painters since. In the end it is he, the man driven by Reynolds from the Academy, who did more than anyone else to vindicate the President's claim of the importance of the ideal in art.

90. **William Blake**
Paolo and Francesca and the Whirlwind of Lovers, c. 1824. Blake was working on his illustrations to Dante at the time of his death. In this scene Dante has fainted, moved by the story of the fated lovers Paolo and Francesca, whirled round in an endless circle of Hell.

Chapter 8: From Caricature to Cartoon

The late eighteenth century was the period in which the political cartoon as we now know it came into being. It is also the time when it was practised by its most brilliant exponent, James Gillray (1756–1815).

The new genre brought together two graphic media that had flourished independently of each other since the Renaissance – the allegorical print and portrait caricature. One of Gillray's most famous political pictures, *The Plum Pudding in Danger*, a satire on British and French rivalry during the Napoleonic Wars, shows a division of spoils taking place as a result of the conflict. Europe is about to be devoured by France while the Americas are sliced away by the British. The two countries are represented by their leaders, the British Prime Minister Pitt and the French Emperor Napoleon. Both are shown with their physical features exaggerated grotesquely. Pitt is tall and spindly, Napoleon tiny and voracious. Their agreement has been fantasized as a meal, equating personal consumption with political annexation. The fiction is so compelling that we forget how remarkable it is – particularly since this sort of convention has been used in political satire ever since. But it was a brilliant innovation, recognized at the time as an unique British achievement. Gillray was famous throughout Europe, and was described in 1802 by one German magazine, *London und Paris*, as being the greatest artist of the age.

Gillray's reputation is worth reflecting upon. For while his satires were in one sense 'popular' art with a wide and immediate appeal, they were intimately associated with high art practices and were addressed in the first instance to a highly sophisticated audience. Gillray had himself studied at the Royal Academy. Like Blake, he was a 'rebel angel' and, like Blake again, his designs can be seen as a critique of contemporary history painting. His work was published by a printseller in St. James, that area of the West End in London most closely connected with the court and politicians.

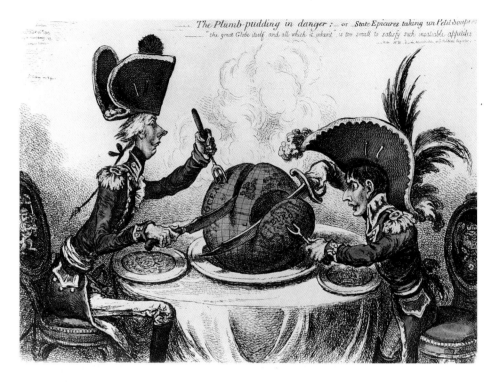

The Plumb-pudding in danger : — or _State Epicures taking un Petit Soup_
—— "the great Globe itself, and all which it inherit" is too small to satisfy such insatiable appetites.

91. James Gillray *The Plum Pudding in Danger or State Epicures Taking un Petit Souper,* 1805. A caricature of British Prime Minister Pitt and the French Emperor Napoleon dividing the world between themselves.

The emergence of this oppositional art seems to relate to changes in political practice. The early years of the reign of George III was the time when an official parliamentary opposition party first came into being. Its presence is a sign of the existence of dialogue within the process of government. By contrast, there were no political cartoons of a similar kind in France in the period. Even after the Revolution, when public political debate became a feature of French life, pictorial satire was limited, and lacked the brilliance and bite of Gillray. Only when there was a resilient (if oppressed) base of opposition – as in the age of Louis Philippe – did pictorial political satire flourish.

Early political satire

The development toward a new satirical art began in the early eighteenth century. It received a great boost from the early emergence of regular journalism at that time, as well as from the critical climate bred by such major writers as Pope and Swift. Portrait caricature began to gain ground in Britain during the 1730s. It was imported at that time from Italy, where it had been practised since

92. William Hogarth
Characters and Caricatures,
1743. Hogarth's demonstration
of the difference between the
observation of character and the
exaggerations of caricature.

93. Thomas Patch
*A Gathering of Dilettanti around
the Medici Venus*, 1760–70.
English gentlemen on the Grand
Tour frequently commissioned
humorous portrayals of
themselves and their friends.
Those shown in this example
are mostly unidentified, but the
man in the centre measuring the
Medici Venus is Patch himself.

the seventeenth century in elite circles – such as the Roman art world. The first really successful publication in this genre was a series of portrait caricatures by the Italian Pier Leone Ghezzi. These were humorous rather than malicious and usually taken with the permission of the sitter. They can be seen as a kind of baroque playfulness – akin to the horseplay of water shoots in gardens. The face of a friend is taken and through the process of exaggeration (*caricare* in Italian means 'to overload') the principal features are made more prominent. This even became seen as a process of extracting character, as though somehow the essence of the person had been captured through the distillation of their individualizing features. Caricature subscribed to the physiognomic fallacy that character can be read in features. But caricature did more than simply test this scientifically. For once extracted, the features could be made to conform to some additional idea. This is the secret of portrait caricature; that it can combine the still recognizable features of an individual with some abstract notion, such as greed or voraciousness. This is the visual equivalent of verbal and punning wit.

Ghezzi's work was strongly opposed by Hogarth. This is probably because he thought it undermined the status of his own art. For he was the painter of 'comic' history, who claimed to base his satires on contemporary society on observation, not exaggeration. He felt strongly enough about the matter to address it directly in a design on the subscription ticket for the engravings of his *Marriage a la Mode* series. Entitled *Characters and Caricatures* this 92 purports to show the difference between the two. Character is dependent upon observation, caricature upon serendipitous scribbling. Hogarth also gives a little art history lesson at the base, showing the development of caricature from Leonardo's grotesques through the Caracci to the current rogue, Ghezzi. He himself claimed his character observation to be based on that of true history painting, as represented by Raphael's cartoons (illustrated bottom left).

Meanwhile Continental portrait caricature continued to make inroads. British artists in Italy would imitate the Italians to produce comic caricatures of visiting *milordi*. Even Reynolds attempted portrait caricatures while in Rome and one British artist, Thomas Patch (1725–82) made a career out of turning the travelling cognoscenti into humorous grotesques. 93

The familiarity of British aristocrats with caricature led directly to the creation of the first political portrait caricature cartoons. This was through the work of the soldier and amateur artist George Townshend (1724–1807). Scion of a noble family, Townshend developed a particular hatred of his commanding officer, the deeply unpleasant Duke of Cumberland known to history as the 'Butcher of Culloden' on account of his brutal punishment of Scottish highlanders after his defeat of the Jacobite Rebellion. Townshend exploited the fat blubbery shape of his target mercilessly in a series of satires exposing his pretensions and ambitions. These caused huge merriment in political circles and high society. 94

Townshend's designs were published anonymously, through a small print shop. Caricatures could be anonymous in another sense, for they could depict people without their having to be directly named. They usually escaped prosecution because the victim did not want to admit in public that the grotesque distortion really was himself.

These early political caricatures were not normally of high quality artistically. In order to be produced while they were still topical the prints were etched rapidly in outline. They could be bought plain for sixpence or hand-coloured for a shilling. These were quite high prices and this emphasized that they were really aimed at a middle and upper-class market. On the other hand they gained a more popular audience thorough being visible in print shop windows, in taverns and in other places of public gathering.

Townshend's intervention was specific and relatively short-lived. But, as oppositional politics grew in parliament, the genre attracted more gifted artists, who saw it as a means of gaining wealth and fame. Foremost amongst these was Gillray.

James Gillray was a professional engraver who also trained at the Royal Academy schools (1778). But from his late teens he had practised caricature, and from 1786 onwards this became his main profession. His training and background provide a vital key to the power and depth of his work. To some extent he was influenced by the fantasy of Mortimer. He also shared with Blake that British penchant for the strongly engraved, expressive line. Gillray was acutely aware of contemporary history painting. Often he would draw on it directly – as when he used West's *Death of Wolfe* to caricature the supposed political death of that great 'wolf', the Younger Pitt. 95

94. George Townshend
The Duke of Cumberland or 'Gloria Mundi', 1756. Townshend innovated the use of portrait caricature in political satire. Here he lampoons his favourite butt – his former commanding officer, the Duke of Cumberland.

95. James Gillray
The Death of the Great Wolf, 1795. Gillray uses West's famous modern history painting to satirize the collapse of the younger Pitt's government. This print demonstrates the symbiotic relationship between the political cartoon and history painting.

FASHIONABLE CONTRASTS; or _ The Duchess's little Shoe yielding to the Magnitude of the Duke's Foot.

96. James Gillray
Fashionable Contrasts or the Duchess' Little Shoe Yielding to the Magnitude of the Duke's Foot, 1792. A classic example of synecdoche – the use of a part to suggest the whole.

By 1791 Gillay's reputation was established and he began his partnership with printseller and publisher Mrs Humphreys. For the next two decades he produced a steady stream of biting and fantastic designs in which he created many of the stereotypes which for many still define the age. During the period of reaction he developed the image of the wild and barbaric French Revolutionary, to be followed later by the voracious image of Napoleon. For a time he attacked Pitt, exaggerating his thinness to make him seem incredibly vain and foppish. By 1797 his power was such that the Tories paid him a pension not to lampoon them. Under this agreement he turned to representing the Whig leader Fox as gross and scheming. Gillray also had an eye for broader and more good-natured comedy. He shows the national stereotype John Bull as oafish, but also as someone who maintains a shrewdness while being taxed beyond endurance.

Gillray also attacked high society, and in particular the Royal Family. In *Fashionable Contrasts* he satirizes a royal indiscretion with a remarkable visual synecdoche – the position of the feet showing clearly what was happening. Such work brings home how truly inventive as a visual artist Gillray was. He was the first caricaturist to realize how his art could transcend normal forms of representation.

Until he collapsed into madness in 1811, Gillray remained unparalleled as a political cartoonist. He had a rival, however, in Thomas Rowlandson (1756–1827). Like Gillray, Rowlandson had studied at the Academy. He too was inspired by the freedom of Mortimer's line; and may in addition have studied in Paris. There is certainly a rococo feel to much of his work. It has a rotundity to it that contrasts with the urgent angularity of Gillray. Rowlandson seems in life to have been rather indolent and easygoing. Certainly he conjures up better than any other a sense of easeful public life, notably in his fine image of the Vauxhall Pleasure Gardens. Exhibited at the Royal Academy, this *tour de force* shows the good and the great enjoying themselves in one of the best known sites in London.

97. Thomas Rowlandson
Vauxhall Gardens, 1784. A humorous depiction of high society in London's most famous pleasure gardens.

Rowlandson represented an image of community here that was on the way out. Although he survived until 1827, this world had long since gone, being replaced by a London that was more frightening and isolating.

Political caricature, too, was changing. After Gillray something of the bite disappeared. The genre was kept alive for a time, it is true, in the brilliant work of George Cruikshank (1792–1878). He was the son of one of Gillray's rivals, Isaac Cruikshank (he once

96

97

said 'I was cradled in caricature'). At the beginning of his career he worked for the radical publisher William Hone, and produced many powerful campaigning pictures. His most memorable was probably that of a parody of a pound note decorated with people being hung – an attack on the imposition of the death penalty for forgery which appears to have been decisive in bringing about the repeal of this savage law. Cruikshank was effectively active during the constitutional crises that surrounded the accession of George IV. But in later life he turned more towards fantasy and social comment. At this later period Thackeray was to lament the passing of Cruikshank's period of political satire:

Knight's in Sweetings Alley; Fairburn's in a court off Ludgate Hill; Hone's in Fleet Street – bright enchanted palaces, which George Cruikshank used to people with grinning, fantastical imps and merry, harmless sprites. Where are they?...Slop, the atrocious Castlereagh, the sainted Caroline...the Dandy of sixty, who used to glance at us from Hone's friendly windows – where are they? Mr Cruikshank may have drawn a thousand better things since the days when these were; but they are to us a thousand times more pleasing than anything else he has done.

98. George Cruikshank
The Drunkard's Children: Suicide of the Daughter, 1848. Cruikshank was an ardent teetotaller. In this scene the drunkard's daughter, driven to prostitution by her parent's intemperance, finally casts herself off London Bridge in despair.

But this was not something that Cruikshank could be blamed for individually. The printshops had given way to wider forms of distribution and the public life of the eighteenth century to something more private and contained. Caricature became 'respectable' in Victorian England. And Cruikshank himself moved almost completely out of satire into sentiment when he wished to make social comment. Like so many before and after him, he emulated Hogarth's 'modern moral subjects' with his own moralities. A keen teetotaller, he told the story of a drunkard driven to madness by his craze, and then a second story of the drunkard's children paying for the sins of their father. This ends with the drunkard's daughter, now a prostitute, committing suicide by throwing herself off London Bridge. The city has become no joke now, and Cruikshank uses sentiment rather than satire to construct this moving image.

The end of subversion

On the other side, political caricature devolved into humour. The successor to the biting attacks of the Napoleonic period was the urbane and dull John Doyle (1797–1868), whose political satires, as Thackeray put it 'cause one to smile in a quiet gentlemanlike kind of way'.

Political satire did not die, of course, but it became safe and gentlemanly. Its physical circumstances changed too. The 1840s saw the birth of the illustrated satirical magazine – notably *Punch* – which soon became the bastion of middle class humour. The political caricature retained its place here amongst the gentle social jokes. Indeed, it was actually in *Punch* that the political cartoon as we know it got its name. For the word 'cartoon' began to mean a political caricature after the *Punch* illustrator Sir John Tenniel (1820–1914) began to draw satires of the 'cartoons' (that is design for a painting) being made of high art subjects for the decoration of the Houses of Parliament in the 1840s. Once more this transference of the word 'cartoon' from design for a history painting to satirical drawing underlines the continuing linking between these two forms of art. But perhaps it also indicates now something of the cosiness that had come into the situation. The days of subversive satire had gone. The birth of the political cartoon in this new sense was really the death of political caricature. It took the savagery of the twentieth century to revive it.

Chapter 9: Everyday Art

The taste for art in our isle is of a domestic rather than a historical character. A fine picture is one of our household Gods, and kept for private worship: It is an everyday companion.

David Wilkie

The above vindication of the painting of everyday life was made by its most famous practitioner. Wilkie dominated the British art world in the early nineteenth century with his neat portrayals of domestic and low-life scenes, frequently taken from his native Scotland. *The Penny Wedding*, exhibited in 1818, contains all the main ingredients of his art. It shows a humble event – that of a poor Scottish rural couple getting married. A 'penny wedding' was one in which each of the guests brought a small sum to the wedding to help pay for it. The wedding is taking place in a barn or rural shed. There is no finery. The dominant colour is brown; brown for wood and earth and straw. The people, though poor, are honest. Their merriment is simple and healthy. We the viewer can feel sympathy for their poverty and envy for their decent pleasure.

99

Wilkie based his style on that of Netherlandish painters of low-life scenes, in particular Teniers. But there is also a whiff of the more 'sophisticated' naturalism of his own day in it. In some ways this art could be seen as a continuation of the Hogarthian tradition. It certainly contained some elements of narrative in it and there are moments of humour and satire. However, unlike Hogarth or the later Realists in France, it was not intended to be a challenging art, and set out more to reassure its public than ask it to reconsider its values. It remained a genre that was essentially dealing with a popular taste and which 'knew its place' in the hierarchy.

99. **Sir David Wilkie** *The Penny Wedding*, 1818.
A 'penny wedding' was one in which guests each brought a small sum to pay for the celebration. Wilkie made his fortune through such seemingly authentic depictions of scenes from Scottish rural life.

The nature and origins of genre

Ever since the Renaissance, 'genre' painting has been acknowledged as a form with its own distinct character. It was a kind of low-life counterpart to history painting. History painting depicted special people doing great things. Genre painting showed ordinary people doing ordinary things. History painting was painted in a high style – rather abstract and generalizing to show a visual ideal matching the ideality of the subject. Genre painting was painted in a 'natural' style – one that dwelled on peculiarity and detail. It was typical of genre painting that it relied for part of its visual charm on illusion – the lowest kind of visual pleasure in the academic hierarchy. Minuteness also led to its charm. It was life miniaturized and distanced. Charlie Chaplin once remarked that

100. **Thomas Gainsborough** *Cottage Girl with Dog and Pitcher*, 1785. Gainsborough was a master of the 'fancy picture', a sentiment-laden depiction of the poor popular in the eighteenth century.

'comedy is a long shot, tragedy is a close-up'. This certainly fits for genre and history painting. Genre painting gives you the distant view of comic characters, history painting, by its scale, brings you face to face with a grave situation.

Genre painting has often been seen as a 'bourgeois' art, appealing to the tastes of the self-made man and the hard-pressed professional rather than the idle aristocratic connoisseur. It had many of those qualities that also made the novel a bourgeois art, and it certainly drew strength from the popularity of that type of fiction in eighteenth and nineteenth century Britain.

The association should not be taken too literally, however. Many aristocrats had fine collections of Dutch genre and promoted modern British genre (the Duke of Wellington, for example,

101. George Stubbs
The Reapers, 1783. Stubbs depicted rural life in a more orderly manner that had less appeal for his contemporaries.

patronized Wilkie, and the Prince Regent was one of the most celebrated collectors of Netherlandish art). On the other hand, it can be seen as a sign of the ascendancy of bourgeois values in society at large. The change in status represented a change of attitude to the subject matter of genre. Traditionally low-life genre painting had been a source of comedy. The higher orders in society looked at the lower and found them entertaining. Now however, the spectator was less clearly distanced from the subject. It was less certain whether the figures in these homely scenes were 'them' or 'us'. In traditional genre painting they had definitely been 'them'. But they might now be 'us' in the sense that they represented our former selves. Did not those healthy decent peasants display the sterling characteristics that underpinned contemporary wealth and prosperity?

In many ways the Conversation piece had set the scene for the change. For the Conversation had replaced the vulgar 'conversations' of the Dutch with a more polite form of social intercourse. In the later eighteenth century – when the Conversation piece was falling out of vogue – a more sentiment-laden return to low life subjects occured.

Gainsborough's celebrated 'fancy pieces' reflect this mood. 100 They seemed to be taking the genre up-market. For the artist visibly used the urchins of the Spanish painter Murillo as a model for his own country children.

The animal painter George Stubbs was another artist who tried to profit from the rustic vogue. But he had less success. His 101 fine and meticulously painted depictions of farm life found little appeal with his contemporaries. Perhaps the very matter-of-factness of the work militated against them being accepted when urban spectators were looking for a romanticized view of the country.

A more immediate link with the Conversation piece can be found in the work of Francis Wheatley (1747–1821). Wheatley began his career imitating the work of Zoffany. By the 1790s however, he had moved from Conversations to sentimental literary pieces, many of which were done for engraving. His most successful series was the *The Cries of London*. Executed at a time when the 102 traditional hawkers and traders of the street were losing their identity in the increasing anonymity of the modern city, these images preserved the idea of a surviving indigenous group of Londoners keeping alive the warmth and picturesqueness of yesteryear. Nothing could have been further from the frightening images of the Revolution-crazed Parisian mob that are their contemporaries.

102. **Francis Wheatley**
The Milkmaid, 1793. Wheatley's *Cries of London* show the 'fancy picture' in an urban context. They often contained portrayals of working girls that encouraged prurience.

103. George Morland
Morning: Higglers preparing for Market, 1791. Morland made his reputation with a bolder portrayal of the more 'bohemian' side of rural life.

Wheatley's London types had their rural counterpart in the work of George Morland (1763–1804). Morland was a precociously gifted artist who had begun his career successfully forging Dutch landscapes. By the 1790s, however, he had made a name for himself with rustic scenes that combined low-life genre painting with some of the grandeur and sentiment of Gainsborough. His rural scenes were immensely successful, partly because they suggested the persistence of a more rugged way of life untamed by modernity. His legendary dissoluteness seemed to reinforce this. Rather like Augustus John in modern times, he was taken to be an untamed force of nature.

103

Morland was painting in a time of war and crisis and his more vigorous image of rural life seemed to act as a reassurance about the essential resilience of the British populace.

104. **Sir David Wilkie**
The Letter of Introduction, 1813.
This scene of a gauche young
man attempting to gain assistance
from an establishment figure
recalled an embarrassing situation
from the painter's own youth.

104. **Sir David Wilkie**
The Letter of Introduction, 1813.
This scene of a gauche young
man attempting to gain assistance
from an establishment figure
recalled an embarrassing situation
from the painter's own youth.

105. **Sir David Wilkie**
Distraining for Rent, 1815.
A poor family is facing ruin, a
scene that contains more social
commentary than was usual in
Wilkie's work. It was poorly
received and the artist did not
attempt such criticism again.

Sir David Wilkie

When David Wilkie (1785–1841) arrived in London in 1806,
Morland had already been dead two years. There was therefore a
gap in the rural genre market, though the young Scot was no imi-
tator of the dissolute Morland. His rural scenes had a far greater
sense of particularity about them, something that was doubtless
influenced by the thinkers of the Scottish Enlightenment. He was
also, almost inevitably, somewhat under the spell of the earthy
vigour of his countryman the poet Robert Burns. Despite having
come south to make his fortune, Wilkie remained proud of his
roots and almost overinsistently Caledonian in his demeanour.
This did, in fact, contribute to his success. For it suggested that his
art was resilient and genuinely natural.

Wilkie's unease in the metropolis is explored with wry
humour in his autobiographical *Letter of Introduction* in which he 104
relived the embarrassment of his early London days. At the time

that he painted this picture he was attempting to follow landscape painters such as Constable in developing a more 'authentic' way of depicting rural life. Like Constable he seems to have seen this endeavour as being analogous to scientific enquiry.

Wilkie was also prepared to run the risk of controversy at this stage in his career. *Distraining for Rent* was an unvarnished depiction of poverty. It was not well received on aesthetic and political grounds. As the engraver Abraham Raimbach commented:

the objection was to the subject; as too sadly real, in one point of consideration, and as being liable to political interpretation in others. Some persons, it is said, spoke of it as a factitious subject.

Painted just after the Napoleonic Wars, the picture drew attention in too unwelcome a manner to the growing problems in the

countryside caused by economic recession and the difficulty of finding employment for returning soldiers.

In the event, Wilkie pulled back from the brink and softened the mood of his work. His *Penny Wedding*, as has already been observed, gave a far more reassuring image of rural poverty. It was also set a generation back, in the past. Like the *Waverley* novels of Sir Walter Scott, which were then enjoying such a vogue, it gave an image of the good old days, made all the more vivid by the sharp detail in which it was described. This picture became the archetype for idyllic portrayals of country life both in Britain and throughout Continental Europe.

Wilkie's greatest success, however, came when he was able to repeat his winning formula with a modern subject set in London. This was the depiction of *Chelsea Pensioners Reading the News of the Battle of Waterloo*. By including this major historical event within a local environment Wilkie was able to appeal to patriotism and also reinforce the idea of a happy resilient populace. He was able to put his knowledge of naturalistic painting to good use as well, since the picture was set in the open air. This work was so successful that a barrier had to be put around it when it was shown at the Royal Academy. It was purchased by the Duke of Wellington.

Wilkie's successful deployment of a sharp-eyed naturalism grew – as has already been suggested – out of a radical interest

99

106

106. Sir David Wilkie
Chelsea Pensioners Reading the News of the Battle of Waterloo, 1822. Old soldiers expressing jubilation at the news of the victory of the Battle of Waterloo. This scene was so popular that it had to be protected by having a rail put round it when it was exhibited at the Royal Academy.

amongst a group of genre and landscape painters in London to produce a new and more authentic record of the appearance of the city. A number of such artists – such as John Linnell and William Mulready – had attempted to show such works during the previous decade. But these had not been responded to and each artist gradually moved into other fields.

After Wilkie

In Scotland, Wilkie's pictures became the basis for a national school, the visual analogue of Burns and Scott in an indigenous cultural revival. Scottish genre scenes continued well into the Victorian period with the work of Andrew Geddes and Thomas Faed. Such pictures fostered the cult for Scotland so much beloved by Queen Victoria.

Not all Scottish pictures of daily life were quite as tame at this however. Walter Geikie (1795–1837) produced pithy etchings that seem closer to the vigourous language of Burns. Like Burns' poetry, too, these images often had a subversive dimension. 107 However Geikie's remarkable works were marginalized, even in Scotland. His physical disability – he was a deaf-mute – led to him being seen as a primitive who could be enjoyed but need not be taken too seriously.

107. **Walter Geikie**
Our Gudeman's a Drucken Carle, 1830. Geikie's etchings continued a tradition of earthy humour and realism rarely encountered in paintings of the period.

In England Wilkie's influence became melded with the sentimental ruralism that had already emerged at the end of the eighteenth century. Here there was an 'English' painterly sensibility thrown over the scenes. One of the leading figures to do this kind of work was William Collins (1788–1847), a former pupil of George Morland. A friend of Wilkie's (and father of the novelist Wilkie Collins), Collins was seen by many as bringing a similar 'authenticity' to the English countryside. Yet it is hard to see more than accepting fantasy. *Rustic Civility* suggests an acquiescence of the country to the intrusions of the visitor. The children are paying obeisance to a person on a horse – whose shadow falls on the foreground of the picture.

108. William Collins
Rustic Civility, 1833. Collins perpetuated the image of a docile rural Arcadia. The spectator is in the place of the man on horseback, whose shadow falls across the foreground.

108

109. William Mulready
The Sonnet, 1839. Like Collins, Mulready adapted the rural idyll to the tastes of the respectable Victorian bourgeoisie.

After having failed in his attempts at authentic naturalist renderings of London scenes, Mulready also moved increasingly toward the lyrical. Like Wilkie, he sought to extend the range of genre, indicating that it had sufficient potential to become high art. His poetic rusticity became timeless, an Arcadia, treated with the broadness and sense of compositional grandeur appropriate for elevated aesthetic experiences. Like the shepherds and shepherdesses in courtly Arcadias, these simple country folk are learned. The young lad has written a sonnet and is bent over coyly as his beloved reads it. They have a level of education far beyond the reach of the average country person of the time. The picture, too, is highly educated, for the leaning boy has adopted the pose of one of the figures from Michelangelo's Sistine ceiling. Daily life is no longer what it used to be.

Chapter 10: Animals

Animal painting was a British speciality, during the eighteenth and nineteenth century. The skills of the artists who practised it varied enormously, but there was at least one major master – George Stubbs – and many others of the highest ability and ingenuity.

It remains true, even so, that many of the best known practitioners were prized as much for their ability to render the features of a favourite animal accurately as from any broader artistic abilities. Some much admired animal painters, such as James Seymour, were, in effect, artistic primitives.

Animal painting is also of great interest to the social historian. The animals depicted in the eighteenth century were normally those connected with sport or agriculture. They were, in other words, working animals and their depiction was for the people who worked with them. Attitudes towards these animals were largely unsentimental. Great store was placed on factual description. In the latter part of the period, however, there was an increasing tendency to turn attention to pets and wild animals. This is the point at which more emotive attitudes began to emerge as part of the great re-evaluation of nature that occurred with Romanticism. Like children and 'primitives', animals became valued as part of a natural state that the modern educated adult no longer had direct access to. While Stubbs is the leading artist in the earlier period – with his sharp and precise mode of delineation – the dominating figure in the later one is Landseer, who dwells on mood and feeling.

Hunting was the oldest sport involving animals. In previous times it had been an aristocratic and royal privilege, 'The Sport of Kings'. In the eighteenth century it became another of those exclusive upper class practices that was invaded by the bourgeoisie. Instead of owning your own hunt, you could now, for a relatively modest fee, join a hunt. Stag hunting began to decline and was replaced by fox hunting – something that could be carried out on a smaller and more manageable scale in most rural areas.

This shift also led to a new kind of oppression. The small scale hunting that had always been a part of peasant life now became restricted by savage gaming laws, driving a rift between the aristocracy and bourgeoisie on the one hand and the working classes on the other. The poacher became a working class hero, celebrated in songs and stories. But there is a much darker side to it than that. And while we look at all those robust and cheerful pictures of people riding out to hounds, we should remember those imprisoned, transported or hanged for engaging in what seemed to them to be the exercise of their traditional rights.

Racing – the other major sport involving animals – underwent a similar transformation. In the seventeenth century the race was something undertaken by one or two gentlemen running horses against each other. Now a regular racing calendar was established (1728). The founding of the Jockey Club in 1750 led to further regulation. Specialized venues such as Newmarket came into being, and famous annual races were inaugurated, such as the Derby (1780).

Regular racing turned certain animals into celebrities. It is hardly surprising, therefore, to find horse portraiture becoming a lucrative practice. In 1755 Rouquet observed;

We may rank among the number of portrait painters, those who are employed in drawing the picture of horses in England. As soon as the race horse has acquired some fame, they have him immediately drawn to the life: this for the most part is a dry profile, but in other respects bearing a good resemblance; they generally clap the figure of some jockey or other upon his back, which is but poorly done.

Such work established a regular set of conventions for portraiture. Since horses were recognized and valued more for their bodies than their faces, they were usually seen in strict profile, the silhouette offering the means of appreciating niceties of the anatomy for the discerning. Dogs, who sometimes tended to be as valued for personality as performance, would still tend to be portrayed in profile, but with the head half turned towards the spectator.

The painting of farm animals had a more ambivalent position. Agricultural improvement was a legitimate and important concern for the landed classes, and many aristocrats (such as 'Turnip' Townshend in Norfolk) were leading reformers. The eighteenth century saw the regulation of agricultural shows and the establishment of prizes and awards, much along the lines that were developing in field sports. However, these activities involved a far wider social range than field sports. Furthermore, as they were

essentially restricted to the farming community, they did not provide the opportunities for bourgeois involvement that racing and hunting did. On the whole, therefore, paintings of prize cows and sheep were executed for modest yeoman farmers, and the artists who worked for them tended to adjust their sights accordingly. Stubbs' painting of a prize ox being lead home by its proud owner (together with the cock that had won the beast for him in a fight) has a slightly comic, almost condescending air, that was presumably undetected by the gentleman in the picture. Although it is tastefully done, Stubbs has given way here to some of the exaggeration that was so desired by the owners of prize-winning animals.

110

110. George Stubbs
The Lincolnshire Ox, c. 1790.
Even a painter as meticulous as Stubbs may have been encouraged to exaggerate the size of this huge animal won by the gentleman in the picture as the result of a cock fight. (Could this be the original 'cock and bull' story?)

It is hard to say now how far the grotesquely oversize square-shaped cows and sheep depicted in this period related to the actual animals. We do, however, have evidence that artists were urged to emphasize these features. The great naturalist wood engraver Thomas Bewick (1753–1828) observed that in his youth there had been a

rage for fat cattle, fed up to so great a weight and bulk as it was possible for feeding to make them; but this was not enough; they were to be figured monstrously fat before the owners of them could be pleased.

Bewick 'objected to put lumps of fat here and there where I could not see it' and moved away from this kind of work, fortunately for us, to the exquisite depictions of natural life for which he is now so justly famous.

However, it is equally significant that Bewick should in the end have made his name through publishing engravings in book form. Unlike the painters of farm animals, he was working for a broad and anonymous urban public. Like Hogarth before him, he rose to greatness by addressing a new audience. While working in his native Newcastle, he was able to reach the whole country – and beyond – through the distribution system of the publishing trade. He was also a beneficiary of the new and informed passion for natural history which was to be so important for the re-evaluation of landscape painting as well – as we shall see in Chapter 13. His exquisite vignettes are feats of observation and execution. He brought a new delicacy to the 'cheap' reproduction method of the wood engraving. This is a transformation that would have been appreciated more by his contemporaries than us. For they would have been accustomed to wood being used for the rough broadsheet accounts of murders and other popular sensations.

111

111. Thomas Bewick
Hedge Sparrow, c. 1795.
Bewick brought a new mastery to wood engraving, using it to convey his fine observations of the natural world and rural life.

Pictorial development

A mastery of factual detail was a requirement for all animal depiction – even that which specialized in systematic exaggeration. The genre – like so much of British painting – had its origins in Flemish art, and many of the early animal painters came from that country. Early British practitioners were often trained by these. John Wootton (1682–1764) was a pupil of Jan Wyck. He was important for bringing a sense of gentility to sporting scenes. He 112 achieved this to some extent by incorporating some of the conventions of the Conversation piece, and also by introducing landscape settings idealized in the manner of the French classical landscapist Claude Lorraine.

While Wootton certainly succeeded in making sporting pictures polite, he veered too much towards idealization for some patrons. It is strange to find that he had a serious rival in James Seymour (*c.* 1702–52), an artist of manifestly lower executive 113 skills. However, Seymour had a reputation according to the

112. John Wootton
The Beaufort Hunt, 1744. Hunting scenes increased in popularity as field sports became a bourgeois as well as an aristocratic pastime.

113. **James Seymour**
The Chaise Match run on Newmarket Heath on Wednesday the 29th of August 1750, 1750. While somewhat unsophisticated as a painter Seymour had a high reputation for the accuracy of his animal portraiture. Like all painters before photography, he shows the legs of a galloping horse quite wrongly.

Universal Spectator as 'the finest draughtsman in his way (of Horses, Hounds etc.,) in the whole world' even though 'he never studied enough to colour or paint well'. It would seem that Seymour gained simply by being closer to the minutiae of his subject. He also had a reputation for riotous living, which doubtless went down well with the sporting confraternity.

It is possible to treat animal painting by and large thematically without doing a grave injustice to most of the practitioners. Skilled though many of them were, they worked largely within definable categories. This is not the case, however, with George Stubbs (1724–1806). He knew his animal anatomy far better than the rest, having dissected a horse and published a book on the subject that remains unsuperseded to this day. But he was much more besides. His classic sense of form and his clear-sighted combination of visual clarity and intellectual enquiry places him amongst the other great visual artists of the Enlightenment – such as Chardin, Ramsay and the sculptor Houdon.

Stubbs came from a modest background, but one that gave him early acquaintance with horses – he was the son of a currier. Born in Liverpool, he was largely self-trained and eked out an existence as a travelling portraitist. Even at this stage he was clearly a man of determination and intellectual curiosity. In the 1750s he managed to get himself to Rome briefly. This was also the period when

he made the anatomical investigations that led to the publication of his classic *Anatomy of the Horse* in 1766.

It was after he moved to London, around 1758, that his career as an animal painter took off. He was one of the artists who profited from the setting up of regular exhibitions. From 1761 to 1774 he exhibited annually with the Society of Artists, where he was able to use his remarkable skills to produce animal pieces which

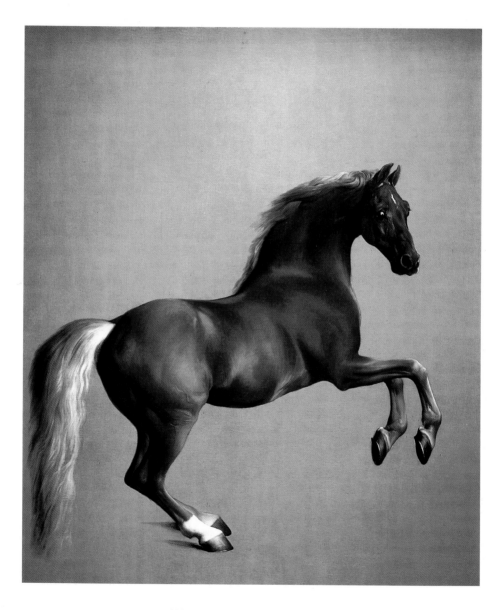

incorporated the neo-classical sense of outline with a delicious mastery of texture. It is almost as though he could infuse the animals he painted with the dignity of the fashionable 'noble savage', though he did so without sentimentalization. No canvas can show this more clearly than the magnificent *Whistlejacket*.

Stubbs' skills were rapidly appreciated by noblemen devoted to racing and breeding horses. Yet while he certainly provided what these patrons wanted, his work is full of wider observations of both animal and human life, giving the handlers of horses the same sympathetic individuality that he gave to the animals.

London also gave Stubbs the chance to maintain his intellectual interests. He worked for patrons with a strong scientific bent, such as Sir Joseph Banks, and frequently painted wild and exotic animals. One of the earliest was of a zebra, brought from South Africa as a present for a member of the Royal Family. This animal seems all the more bizarre by being shown in what appears to be a normal piece of British woodland.

114. George Stubbs
Whistlejacket, 1762. According to Stubbs's friend Ozias Humphry, this horse was originally intended to be the basis of an equestrian portrait of George III. However the commissioner was so pleased with the animal that he decided to leave well alone.

115. George Stubbs
A Zebra, 1763. Portrait of a female zebra brought from the Cape of Good Hope as a present for a member of the Royal Family. Stubbs has made it seem all the more exotic by portraying it in an English woodland.

114

115

116. **George Stubbs** *Horse Frightened by a Lion*, 1770. The theme shows Stubbs engaging with the fashion for depicting subjects of 'sublime' fear. It may have been inspired by a classical sculpture he saw while in Rome.

Stubbs' aesthetic ambitions also encouraged him to seek out classical subjects that included animals, such as the *Fall of Phaeton* as well as to invent subjects of his own that involved animals in dramas. One of the most successful of the latter is *Horse Frightened by a Lion*, where Stubbs engages with the fashionable theory of the Sublime. For the picture exploits the sense of fear and danger that was believed to be at the heart of this overpowering aesthetic emotion.

Like other artists who tried to up-grade a 'minor' artistic genre, Stubbs had an uneasy relationship with the Royal Academy. He was one of those who held out from joining when it was established in 1768. Indeed, he remained with the Society of Artists, and was made President in 1773. Eventually he did capitulate, becoming an associate in 1780. He was even elected a full member in 1781, but this was never ratified as he refused to provide the required diploma piece. It seems that he was in dispute with the Academy – like Gainsborough – over the hanging of his work. Sadly Stubbs was falling out of favour by this time. His reputation was not helped by his experimentation with new forms of painting on enamel that he devised with the potter Wedgwood. But probably the deciding factor was the beginning of a movement which portrayed animals more emotively. This younger generation of artists – such as James Ward (1769–1859) – specialized in more heroic and dramatic portrayals of animals, in which the precision

116

117. **George Stubbs**
Anatomy of the Horse: Table II: Skeleton, 1766. Stubbs's anatomic studies of the horse remain unsurpassed to this day.

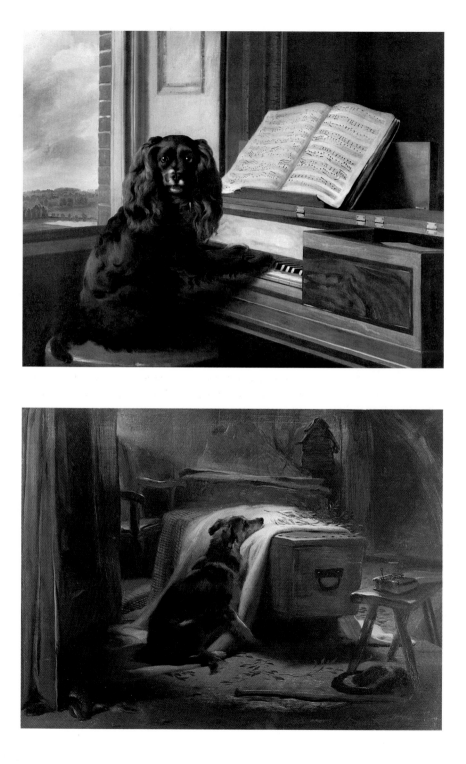

118. Philip Reinagle
A Musical Dog, before 1805.
Hard though it is to believe, this
may be a portrait of an actual
performing animal of the day.
The artist made a speciality of
training spaniels to perform
such feats.

of the specialist gave way to a Rubensian bravura. It is significant
that this broader Flemish treatment of animals was coming more
into vogue again.

It is hard to imagine a time when the portrait of a musical dog
could have been taken seriously, but the animal portrayed by
Phillip Reinagle (1749–1833) does appear to have been billed as a
real performer. This is the mawkish side of the age of the virtuoso.
In reality it took people further away from animals rather than
nearer to them. In Reinagle's painting we can see the modern incli-
nation to invest animals with human characteristics. He also gives
it the suave glossiness that became an increasing requirement in
the new sentimentalized portrayal of animals.

Nobody could manage this with more skill than Edwin
Landseer, (1802–73), a child prodigy, who was by 1820 painting
animals with a brilliantly fluid naturalistic technique that was
admired in France by Géricault and Delacroix. But he was soon
endowing his animals with sentiments and expressions. These
seem to us to be all too human, but at the time they were taken to be
pertinent observations of animal psychology.

His *Old Shepherd's Chief Mourner* was hailed by Ruskin as one
of the most perceptive and poetic of modern pictures. Landseer's
combination of virtuoso technique and sentimental subject matter
brought him great success in Victorian times, and made him a spe-
cial favourite of the Queen. We may now find it hard to believe such
work was taken so seriously. Yet there was a very serious side to
Landseer. His humanoid animals were not a simple sop to popular
sentimentality. He genuinely wished to demonstrate moral feeling
in the animal world, and show that there was indeed such a thing
as natural goodness. In later life he lost this faith, experiencing
almost total mental collapse and turning to terrifying pictures of
carnage and destruction. By this time Darwin had provided an
altogether far more chilling image of nature as the 'survival of the
fittest'; the age in which sentimental animal portraiture could be
seen as scientific enquiry had passed as surely as the world of
sporting heroes and fat farm animals that had preceded it.

119. Sir Edwin Landseer
*The Old Shepherd's Chief
Mourner*, 1837. Landseer made
his reputation through portraying
animals exhibiting human
emotions. In his day they were
considered to be accurate
explorations of animal psychology.
Perhaps, too, the picture would
seem less sentimental if it had a
different title.

118

119

120. **Anon** *Joseph Pestell, Wife and Child, 1844, of Her Majesty's 21st Regiment, or Royal North British Fusiliers*, 1844. The art market was not concerned exclusively with work of high quality. Ordinary soldiers often had portraits of themselves made before they went off on active service. This family group may be the result of one such occasion.

The subject: portraits, views and anecdotes

Portraiture was as important in popular art as it was in fine art. The desire for self-preservation was as strong for the lower orders as for the upper – as the subsequent history of the snapshot makes clear. Much of this portraiture was executed by itinerant painters who would travel through the towns and villages picking up what work they could. There were also those who focussed on more specialized markets. Probably the most important of these was the portrayal of sailors and soldiers who were about to go on active service and wanted to leave a record of themselves for the families and loved ones they left behind. Joseph Prestell was presumably one of these. It is hard to say how well this schematic rendering worked as a record of individual appearance. But it clearly conveys the hierarchies and affections of a family – his wife, their child, arms linked together and bravely smiling.

As well as sitting for portraits, sailors were prodigious consumers and producers of pictures of ships. As professionals, sailors tended to pay great attention to the accuracy of rigging and other nautical features. They frequently made pictures of ships in

120

121

needlework, using the skills they had developed for handling ship's canvas to help while away long hours of enforced idleness when on the high seas.

Local views were also highly popular. These images can be related to the growth of interest in topography at the time. But the vernacular view of a town or piece of countryside had much less of the picturesque about it than the conventional artistic views of the period. Whereas the latter tended to be 'vista' paintings – showing the viewpoint of one travelling through the country, the former tended to adopt a more conceptual approach. They were pictures for people who 'knew' a town, and could see all its parts together in their mind's eye. It was for people who lived there, rather than for those who visited. 122

Similarly animal painting was usually executed for those who knew their subjects well. Mention has already been made of the wider variety of sporting and farming pictures that were produced by popular artists. Usually this is of the animal itself, but sometimes more personal circumstances come in. *A Prize Bull* 12 *and a Prize Cabbage* has what is presumably the farmer's wife proudly holding the cabbage and standing beside the bull. Their farmhouse – an important indication of location – stands like a doll's house at the picture's edge.

121. **Walters** *The William Miles of Bristol*, 1827. Ships were often painted by or for seamen and were expected to show rigging and other nautical features accurately.

122. **Anon** *The Market Cross, Ipswich*, early nineteenth century. Local views were common in the period, often reflecting a sense of civic pride. Unlike the 'picturesque' views intended for tourists, these dwelt upon details of interest to those living in the community.

123. **W. H. Rogers** *The Lion Tamer*, mid-nineteenth century. Circus and zoo scenes were common in popular art. The scene shows a lion and tigress with their 'liger' progeny.

124. **Anon** *The Nine Angry Bulls*, mid-nineteenth century. A variant of the traditional comic story of the angry bull, this scene has not less than nine irate beasts descending on a hapless hare, to the great consternation of the humans in the picture.

Another area of popular culture much celebrated in vernacular art was the spectacle. In parallel with art exhibitions, concert performances and theatre there had grown up in the eighteenth century a wide variety of popular shows and displays. As communications increased, so did the viability of mounting travelling displays and menageries of all kinds. The lion tamer was a popular figure – particularly because he combined a calm display of courage with the frightening and exotic – as well as bringing some hints of the Biblical story of Daniel in the lion's den. The lion tamer being celebrated here is displaying a particular curiosity. He is surrounded by infant 'ligers' – the progeny of a lion and a tigress.

123

There was as well a smaller genre of illustrations of local stories and anecdotes. It is not known what the occasion for depicting *Nine Angry Bulls* was. Perhaps it is a record of some local mishap, or perhaps it is a humorous invention. Whichever way, it is a minor comic masterpiece, particularly in the way it shows how the bulls' convergence on a hare in the middle ground unintentionally creates mayhem and panic amongst humans and waterfowl in the bottom corner of the picture.

124

125. *Popular print from the Bristol Police Chronicle* published by J. Sherring, Bristol, 1837. The bottom end of the art-market. Such crude portrayals of murders and hangings were usually produced as illustrations of broadsheet accounts.

The print market

There are, too, paintings of topical events, although these are more likely to be represented in cheap prints. Such events were more immediate and could best be covered by the press. Murders and executions were staple subjects. Frequently an image made for one event would do for another. Detailed accuracy seemed less important than vivid evocation. Vividness was in any case usually achieved by the broad effects of light and dark that the wood cut or engraving lent itself to.

The makers of such works were professionals who did it for a living. Publishing markets were clearly defined then as they are now and the artists and printers who made such work knew what they could sell.

The variety of painters was, as has already been suggested, much more varied. It was far more common practice then than now for housepainters to engage in figurative depiction as well. Signpainting, too, was a more widespread occupation – particularly in a time when the ability to read was limited and visual images had to be relied on more. Other craftsmen who had more tenuous connection with picture-making (such as glaziers) would also offer professional services as artists. Almost inevitably small towns were more favourable for these mixed practices than large ones. The street directory for Rugby in 1835, for example, lists no artists or sign painters. But one of the 'plumbers and glaziers' there (William Bagshaw) added 'painter' in brackets after his principal professional designation. Sometimes a craftsman would develop a popular enough practice to move into picture-making altogether.

125

This happened with John Kay of Edinburgh (1742–1826) who moved from being a barber to becoming a miniaturist and engraver. Others managed to adapt their trade to picture-making, as did George Smart, a tailor in the village of Frant near Tunbridge Wells who made a speciality out of felt collages around 1830.

All too little is known about these practices, or the works they produced. We should not assume that they were simply pale reflections of what went on in high art. Mention has already been made of the pictorial freedoms enjoyed by such artists. Perhaps these freedoms also extended to communications with the cultures of non-Europeans which went beyond the structured impositions of colonial expansion. An intruiging wool picture that has survived is *A Present from India* made by J. Wackett of the 4th Battalion Rifle Brigade. There is nothing within the British pictorial tradition to match the bold colours and patterns of this work. It has, not unreasonably, been suggested that there is a response here to Indian Tantra art. No professionally trained British artist of the period would have been capable of making such a response. And even if this is not in fact the case, the visual proximity of the two suggests the vernacular tradition was touching on areas that fine art of that time simply could not access.

126. **J. Wackett** *A Present from India*, mid-nineteenth century. This British soldier's present home appears to have been influenced by Tantra art. It lies quite outside the Western tradition.

Chapter 12: Travel and Topography

'What is the point of landscape? Why do people want it?' One can imagine such thoughts passing through the head of Rowlandson's hapless artist, as he doggedly presses onward on his pony through the mountains of Wales, drenched by a rainstorm. For it is the accursed taste for nature that has brought him here. It is all those people who flock to the exhibition halls to buy 'picturesque' views of remote impenetrable areas. And it does not stop there. For there are those guidebooks to such parts containing pictures of mountain tops and waterfalls done by people like himself. And then there are all those paint suppliers who devise neat little travelling boxes of watercolours for gentlemen and lady amateurs to come and dabble with, leaning out of their coaches on a fine summer's day. They don't do that kind of thing for a livelihood, so they can just come when they please, and in comfort. But our poor artist – who cannot afford a coach – must come here, whatever the weather. For he needs the results to sell at exhibition, and to publishers.

The vogue for landscape paintings is one of the most notable features of artistic taste in Britain in the late eighteenth and early nineteenth centuries. More than a third of exhibited paintings at the Royal Academy were in this category, and the prints and publications on the subject were legion. It generated a huge amount of work. It is not surprising, given the investment and the competition, that much of it was of high quality. Arguably Britain's greatest artist, Turner, was the leading practitioner, and he was surrounded by a host of others not far off in ability.

In general terms the taste can be associated with that great revaluation of nature that formed a central part of the Romantic movement. Landscape was now taken seriously in a way that it had not been before. But this does not altogether explain its popularity – nor why it should seem to have been so much more dominant in Britain than in any other European country.

In surveying the rise of landscape I shall divide the topic into four aspects. I shall first look at the phenomenon of travel and the habit of recording the views encountered on it. Next I shall look at the yearning for a lost 'arcadia' that accompanied this. In the following chapter I shall look at landscape's challenge to the artistic hierarchy, its claim to be taken as seriously as historical painting. Finally I shall consider the 'special case' that appears to lift landscape beyond the historical to a point where it presaged the developments of modern art – that of work produced by Turner in his last years.

127. **Thomas Rowlandson**
An Artist Travelling in Wales, 1799. Coinciding with Wordsworthian nature worship, the *Tour of Dr. Syntax* was a satire on the taste for Picturesque travel.

Travel and touring

Increased travel was made possible first by the rise of an efficient stage coach system, then by the spread of the canals, and finally by the emergence of the railway in the 1830s. The growing network of communication systems reflected both commercial growth and social change. Europe – and Britain in particular – was becoming wealthier and trade was increasing. It began to be safe for individuals to travel in a way that it had not been before. Around 1700 only hardy merchants, military personnel, government officials and well-protected aristocrats would normally have risked long distance travel. By the end of the period the annual holiday was an established middle class ritual.

128. Samuel Scott
The Arch of Westminster Bridge, c. 1750. Scott learned much from Canaletto, but his depiction of the north bank of the Thames through the arch of the bridge is strikingly original.

129. Thomas Jones
Building in Naples, 1782.
Jones's apparently quite artless views taken from his window were not intended for sale, and anticipate the nineteenth century to a surprising degree.

Travel brought with it a desire to acquire pictures of the places visited, partly to satisfy curiosity; and partly as a source of self-reflection.

Initially the pictures that satisfied this taste were a kind of mapping. Minutely painted, they communicated an overview and detail, usually delivered with a breezy sense of well-being. They drew on both the meticulous style of the Dutch and the cheerful *vedute* of the Italians. The Italians were used to being visited and stared at, and were past masters at selling their country to the tourists. In the eighteenth century Venice – which by that time had little else to keep it going – made a speciality of producing festive views that appealed to the visitors. Canaletto was the master of such work. When war prevented his British clients coming to Venice he settled in London for a while, producing views of the Thames that made it almost as attractive as the Grand Canal, opening up new possibilities to local artists. Samuel Scott (*c*. 1702–72) was one of those who profited from the example. In *Westminster Bridge* he celebrates a new metropolitan improve- 128 ment. Some scaffolding still remains from the construction. Scott himself chose a carefully restricted frontal view which emphasized the geometry of the architecture. But there is life as well in the work. Visitors are seen on the parapet and youths disport themselves in the river beneath. Such an optimistic view of London could not have been painted much later. Soon the river would be too polluted for people to bathe in and the blue skies would be replaced by the grimy smoke of domestic and commercial coal fires. The squalor of the modern city was one of the impetuses for people to travel elsewhere to find scenes of beauty and gratification.

In the early eighteenth century the main form of leisure travel was the Grand Tour, that educational excursion (sometimes lasting several years) that provided the ultimate polish to a nobleman's upbringing. This encouraged the production of pictures of places visited, first developed by Italians such as Canaletto. But in the later eighteenth century the business was sufficiently large for artists from other countries to gain a foothold. Since the British were the dominating group who undertook the Grand Tour, it is not surprising that British painters should have been amongst the principle benefactors from the patronage on offer.

Francis Towne (1739/40–1816) was amongst the army of topographers who came to record famous Italian sites, such as of the *Temple of the Sibyl at Tivoli*. His picture is in watercolour, the light and easily transportable medium that became increasingly popular for such work. Like so many watercolourists Towne eked out his living as a teacher, and this might help explain the particularly rigorous and clear outlines of his work. On the other hand such analytical clarity might have been held appropriate for such a classic site.

130

130. **Francis Towne**
The Temple of the Sibyl at Tivoli, 1781–84. A whole army of watercolourists made a living from recording scenes visited by travellers on the Grand Tour.

By the time Towne painted his picture touring – Grand or otherwise – had moved far beyond Italy. As Britons moved into more and more remote areas, for reasons of trade, scientific investigation or conquest, the topographer went too. William Hodges (1744–97) accompanied Captain Cook on his celebrated explorations of the South Seas, returning with images that reinforced the view of Tahiti and other Islands as a living Arcadia. Others would record the exotic buildings and practices of other cultures with more precision – as William Alexander (1767–1816) did those of China. But even here the oriental site has been rendered according to the laws of Western composition. These pictures accommodated the unfamiliar, rendering them part of a universal scheme of knowledge. China could be Westernized in the imagination if not in reality.

131

131. **William Alexander**
The Pingze Men, 1799. Artists who travelled to the most remote areas of the world still retained Western conventions to record what they saw.

Science and observation

Travelling for information and for appropriation were intimately connected at that time. Nor did topography stop at what could be visited. For the eye could travel beyond the reach of man, particularly with the aid of the telescope. John Russell was able to use such means to capture a minute rendering of the surface of the moon. Dreams of going to the moon by rocket were already amongst the fantasies of the conquistadors of the eighteenth century.

This was a great age of natural history, and one in which visual description was held to be uniquely informative. The flora and fauna of the world received increasing attention in studies and publications.

Books such as Thornton's *Temple of Flora* addressed both a scientific and a popular market. They described both well known and newly discovered species with minute precision, but also in a manner sufficiently exotic to promote wonderment.

While scientists used artists to record natural phenomena, artists used science as a means of getting a close understanding of the natural world they were recording. Constable, who once referred to paintings as 'experiments', typified this mood of enquiry which was for him one of the principal justifications of the practice. He was an enthusiastic naturalist. Gilbert White's *Natural History of Selbourne* (1789) was amongst his favourite books and in his later years he claimed mainly to read works on geology. His own studies show this keen involvement both in the detailed rendering of the structures of plants, and in the more effervescent effects of nature – evident in his cloud studies.

132. **John Russell**
The Moon, c. 1795. This pastel study was made using a telescope. It is a fine example of the use of art in the period to aid scientific investigation.

133. **Philip Reinagle** and **Abraham Pether** *The Night Blowing Cereus* from Thornton's *The Temple of Flora*, 1800. Like so many botanical illustrations of the day, this picture combines meticulous and accurate detail with a dramatized setting and exaggeration of form to suggest wonderment at the splendour of nature.

134. **John Constable** *Elms at Flatford*, 22nd October 1817. Constable had a passion for trees and made many fine and detailed studies of them.

Constable's cloud studies introduce a new dimension to naturalistic enquiry, the exploration of growth and change. This, too, was in line with the more organic approach to science being pioneered at the time. But it also encouraged the view of landscape painting as the exploration of a living system.

Technically, Constable's cloud studies represent a practice that grew to new importance in this age: painting in oil in the open air. On the face of it, this might seem to be a simple technical matter. But in fact it involved a whole new philosophy of picture-making and was in time to lead to one of the greatest revolutions in the whole history of painting – that epitomized by the Impressionists. Behind the practice of working directly from nature in oils lay the notion that direct recording of experience was in itself an authentic form of artistic creation. And this was only the case because it was assumed that the artist was exploring not just the features of a terrain, but also the very essence of natural processes. Working in oils not only made the painter feel 'serious' before the subject – for he was using the technique usually reserved for 'finished' pictures. It also gave him a new pictorial challenge. Oil could record more depth and power than watercolour or other sketching techniques could. It was also harder to handle extemporarily and encouraged a new gamut of shorthand expressions to convey mood. Constable, when setting himself the impossible task of recording cirrus clouds as they drifted past him, must have been engaged in a

135. John Constable
Study of Cirrus Clouds, c. 1822. Constable's interest in cloud formations was scientific as well as aesthetic. This study shows an up-to-date knowledge of meteorology.

furious activity of observation and codification that tested his resources and brought out unexpected facilities.

Constable is the most celebrated user of this method, but he was far from being the first. It may have originated in Rome as early as the seventeenth century. By the late eighteenth century it was a common practice amongst landscapists working in Rome. Often the results are remarkably fresh and vivid – as in the case of studies made by the Welsh painter Thomas Jones. However 129 Constable certainly took *plein-air* study to a new level of intensity and made it central to the process of picture making.

The Picturesque

At the popular level, the notion of landscape addressing the inner as well as the outer world took a more codified form. This was conveyed largely through the vogue for the 'Picturesque'. Meaning literally 'like a picture', the Picturesque became a visual criterion whereby the amateur traveller, the tourist, could judge the beauty or appropriateness of the places he or she visited. The expansion of middle class wealth and leisure brought the practice of such touring into being in the latter part of the eighteenth century. In comparison to the aristocratic Grand Tour, such 'Picturesque tours' were modest, and undertaken by those who could afford a degree of leisure, but not to take off a couple of years as *milordi* might. The vogue encouraged local travel within Britain. One can see the birth of a solid commercial enterprise behind the Picturesque movement – that of the tourist industry that has flourished ever since. With the touring came travel guides. Indeed, this is how the Picturesque movement first became widespread – through the 'Picturesque Tour' books published by the Reverend William 136 Gilpin.

136. **William Gilpin** *Plate from 'A Tour of the River Wye'*, 1782. A scene demonstrating the principles of a picturesquely arranged landscape, which were now being reduced to rules that could be taught.

137. **Thomas Girtin**
The White House, Chelsea, 1800.
Even Turner felt that he could not
produce anything to match this painting.
The telling effect of the white house
shows how important the momentary can
be in setting the mood of the landscape.

Gilpin's tours really began in his own mind, with an idea of landscape composition that he had formulated. An amateur artist and connoisseur he knew about the rules for picture-making and wished to judge nature accordingly. Systematic compositional methods for landscape were commonly taught by drawing instructors of the day. The most remarkable was that proposed by the highly original painter Alexander Cozens (1717?–86), who proposed that landscape composition could be constructed out of random blots. 138

Gilpin did not aspire to such heights of serendipity. He had a more prosaic set of rules by which a scene should be judged according to its 'picturesqueness'. The principal aim was to find 'variety'. The foreground of a view had to be varied and the background smooth – a form of contrast that also aided a sense of recession.

Panoramas

Meanwhile travel topography was taking on even more popular and sensational forms. In 1787 Robert Barker patented the panorama – a 360-degree view that provided the spectator with the sense of all round vision. Barker's own panoramas, which began with one in Edinburgh, were eventually overtaken by more skillful treatments. The panorama, and the related illusionist landscape spectacle of the Diorama, remained highly popular forms throughout the nineteenth century. Many artists looked on them with disdain – for they seemed to promote admiration of mere illusionism. But they did at the same time emphasize a sensational response to landscape, and one that had moved far away from compositional rules. 139

The potential of the panorama attracted artists with a most sophisticated sense of the momentary. A particular case is Thomas Girtin (1775–1802), a landscape painter who died tragically young, but who became a legend amongst his colleagues for the originality and refinement of his vision.

Like his friend and rival Turner, Girtin began his career as a landscape topographer. In 1800 he planned a panorama of London. This is now lost, but contemporary accounts of it as a 'connoisseur's panorama' suggest it was something out of the ordinary. Surviving studies for it show him exploring the appearance and atmospherics of the banks of the Thames with unprecedented freshness. His *White House, Chelsea* was painted at the time that he was preparing his panorama. Its remarkable form seems to have developed from his concerns for recording unmediated by the conventions of the vista. 137

138. **Alexander Cozens**
*Blot Drawing: Plate 40 from
'A New Method of Assisting the
Invention in Drawing Original
Compositions of Landscape'*,
1785. Like Leonardo before him,
Alexander Cozens recommended
the use of blots and random
marks to stimulate landscape
composition.

139. **Anon**
*A View of London
and the Surrounding
Country taken from
the top of St Paul's
Cathedral*, c. 1845.
Panoramas became a popular
form of entertainment in the
period, and special buildings
were put up in which they
could be viewed.

140. **Joseph Mallord William Turner** *Venice: Looking East from the Giudecca, Sunrise*, 1819. This was Turner's first visit to Italy (he was forty-four) and marked a new stage in his career, a subordination of topography to effects of light, atmosphere and colour.

It shows a place of no particular importance – a part of the river above London. There is no conventional foreground. Instead of spatial recession we concentrate on the transient effect of light, when the sun is low in the sky. The white house itself sings out like a musical note in the half light. It is the first example of a landscape constructed entirely around a sense of moment. Turner admitted that he had never painted anything to match it. It is the ancestor of Whistler's *Nocturnes* and of much beyond.

Girtin was a radical, in politics as well as art. Working in the 'lowly' medium of watercolour he cut no figure at the Royal Academy and was largely known and supported by a small but enthusiastic circle of patrons such as the Yorkshire nobleman Edward Lascelles – from whose house he painted such poignant evocations of the momentary as *Stepping Stones on the Wharfe*. 141

Doubtless Girtin was of immense importance for Turner, with whom he had worked closely in the 1790s. Unlike Girtin, Turner developed a career as an oil painter and thereby gained success at the Royal Academy. But his understanding of the peculiar proper- 140 ties of watercolour to record effect remained central to his art.

For a short while in the early nineteenth century the Norfolk artist John Sell Cotman (1782–1842) exhibited a similar radical- 143 ism of approach. But it found little support and he was soon forced to abandon London and return to his native Norwich to practice as

141. **Thomas Girtin** *Stepping Stones on the Wharfe*, c. 1801 Girtin had a particular attachment for Yorkshire scenery, and was stimulated by it to produce some of his finest paintings.

a drawing master. Although he continued to practice topography he never returned to the adventurousness of his early work. For, as he complained, 'most of the world are more interested in what a picture is of than in how it is painted'.

Modernity and the Picturesque

Later topographical painting was not completely uninfluenced by Girtin's revolution. There remained an emphasis on painterliness and effect, although this was never carried to the point of diminishing the importance of the subject. Instead there was a focus on individual brilliance. Such brilliance was quite different from the quiet sense of moment that Girtin had achieved, or the solid sense of presence that early Cotman watercolours provide. It had to sparkle. Turner could and did master it when he wished, but he knew that the art had more than that to offer.

142. **Richard Parkes Bonington**
Verona: The Castelbarco Tomb, 1827. Bonington's combination of Romanticism with historical detail would have made him a serious rival to Turner had he not died in his late twenties.

143. **John Sell Cotman**
Croyland Abbey, Lincolnshire,
c. 1804. Cotman remained firmly
in the English topographical
tradition, though his feeling for
the past and for atmosphere
anticipate Romanticism.

The coming of the railway provided a subject of genuinely new experience and led to a renewed urgency. This dramatic new form of travel of unprecedented rapidity put the landscape in a totally different context – something that Turner perceived in his late masterpiece *Rain, Steam and Speed*. For many the railway threat- 175
ened to destroy for ever the integrity of the nature it traversed. 'Is there no nook of English ground secure from rash assault?' com- plained Wordsworth when hearing of plans to take a railway line through the Lake District. It seemed to drive a greater wedge than ever between modernity and picturesqueness. Yet topographical painting of the traditional kind could still record the new phenom- enon. The artist who achieved this best was J. C. Bourne, who pro- duced a classic record of the London and Birmingham Railway and the Great Western Railway. *Kilsby Tunnel* records the building of a 144
tunnel that created near insuperable problems of construction. Thirteen pumps had to be employed for a period of nine months to remove nearly two thousand gallons of water before work on the construction could begin. By this time work was so far behind that teams of navvies had to be employed day and night to effect the excavations. The disruptive effects of so many workmen in the quiet village of Kilsby meant that troops had to be called in to keep the peace. Knowledge of these events may well have been in con- temporaries' minds when they saw the sublime treatment Bourne had given the shaft. But even if this was not the case they could capture his sense that the railway is an awesome experience.

144. **J. C. Bourne**
Kilsby Tunnel, Northants,
1838–39. Bourne represents
the awesome achievement of
constructing the new railways
using dramatic effects of light.

Chapter 13: Arcadias

Every society has its dream of a golden age, a better time. The Garden of Eden is the Judaic one; Arcadia – the land of the happy shepherd – that of Ancient Greece. Whatever it is, it will be clothed in the imagery of nature; for nature is where we come from.

In modern western society the development of landscape painting provided a new way of seeing Arcadia. From the seventeenth century onwards, it could be represented as a broad and tranquil terrain, bathed in golden light. This was the ideal created by Claude and other landscape painters working in Rome at that time.

The tranquil landscape created by artists in seventeenth-century Rome provided the most powerful image of Arcadia for contemporaries and was much copied subsequently in Britain as elsewhere, as for example by the Scottish painter Jacob More 145 (c. 1740–93). Yet in another sense every kind of view had the promise of Arcadia in it. Local landscapes could also provide a road to the happy land. For the Dutch at the same time their own native terrain could look Arcadian – perhaps because they had so recently won their freedom to possess it from Spain. In subsequent centuries, as national identity grew, it became increasingly common to see local landscape as the Arcadia in which the nation had once lived in ideal bliss.

Eighteenth-century Arcadia
In Britain the image of Arcadia underwent many transformations. At the beginning of the eighteenth century it was largely a nobleman's dream. Inspired by reading classical pastoral poetry – particularly that of the Roman poet Virgil – and by seeing the ideal landscape paintings of Claude, they sought to turn their own estates into Arcadias. This is, in essence the beginning of the landscape garden, that most characteristic of British art forms.

Unlike the 'artificial' gardens of the French, the English garden took on an informal air, full of the rolling glades and meandering streams of classical landscape. Richard Wilson's painting of *Croome* 146 *Court* shows such a landscape garden, designed by 'Capability' Brown, the leading landscape gardener of the mid-century.

145. **Jacob More**
Morning, 1785. The Scottish artist Jacob More was one of many painting classical landscapes inspired by the seventeenth-century French painter Claude.

146. **Richard Wilson**
Croome Court, Worcestershire, 1758–59. Here the ideal classical landscape has been physically recreated in England.

There was a political dimension to the preference by the British landowner for this kind of scenery. Horace Walpole, for example, argued that 'the English spirit of liberty manifested itself in the school of gardening perfected by Brown'. The artificial garden, of which the stereotype was the geometric layout that surrounded Versailles, was seen as a sign of brute hierarchical power – the hated *Ancien Régime* of France. The Arcadian landscape, on the other hand, suggested a natural order, and by inference that the kind of power and authority that they wielded was natural: the idea, as the poet Pope put it, that 'all nature was a garden'.

It was an important aspect of these landscapes that they provided vistas. For vistas conveyed a sense of that openness that indicated freedom. As Addison wrote in 'Pleasures of the Imagination' in 1712:

A spacious Horizon is an Image of Liberty, where the Eye has Room to range abroad, to expatiate at large on the Immensity of its views, and to lose it self amidst the Variety of objects that offer themselves to its observation. Such wide and undetermined Prospects are as pleasing to the Fancy, as the Speculations of Eternity or Infinitude are to the Understanding.

147. **William Hodges**
Tahiti Revisited, c. 1773. Hodges travelled to the South Seas with Captain Cook. On his return he produced idyllic views of Tahiti and other islands.

It is not hard to see how the Arcadian English garden appealed as much to the nouveau riche as to the old aristocracy. For they, too, wished to legitimate their power by seeming natural. When the banker Henry Hoare, for example, bought Stourhead in Wiltshire, he turned its grounds into a gracious expanse of woods, silvery lakes and gentle glades. As was so common at the time, he peopled it with statues and classical temples as though Arcady had truly come to life once more.

Travel and Arcadia

There is no doubt that travel promoted the search for Arcadia. In a sense this was one of the themes of the Grand Tour (see Chapter 12). The artists who flocked to Rome to provide topographical views were also those who constructed ideal Arcadias based upon the model of Claude. Richard Wilson was the most prominent of British landscapists to provide both types of imagery. The Arcadian vision that he created proved appropriate for depicting English landscape gardens. It was also a dream that could accompany the travellers to distant places, as when it was used by his pupil William Hodges to describe Tahiti in an Arcadian mode. 147

Such an ideal was particularly influenced by the concept of the 'noble savage' that had been invoked by Rousseau. Here there seemed proof that a golden age really had existed, that man could live in ease in nature without the corrupting effect of civilization. It has been suggested that the Arcadian vision was particularly easy to promote in Tahiti because of the lack of resistance to Westerners offered by the natives there. Elsewhere, where the indigenous natives countered the invaders, the view was not so rosy.

A safer place to locate Arcadia was in the past. Even Wilson, in his 'Arcadian' views of the Roman *campagna*, had emphasized the ruins of Roman antiquity to introduce a note of yearning. This mood grew as attempts to create a modern day Arcadia became more problematic. John Robert Cozens (1752–97), the son of the ingenious Alexander (see Chapter 12), captured this mood with greatest poignancy in his poetic watercolours of Italian scenery. 148 Many of these were painted for William Beckford, the unruly millionaire Gothic novelist who built a medieval fantasy for himself surrounded by wild woods at Fonthill. Cozens raised watercolour to a new pitch of sensitivity to give a sense of Arcadia as a departing vision.

Landscapes of mood and sentiment

The yearning of Cozens and his patron Beckford belong to an age that had already abandoned the comforting belief that Arcadia could be reconstructed in the English garden. The classical dream now seemed remote. But it was replaced by an Arcadian dream closer to home – that of the British countryside. The taste for the Picturesque already shows this being sought by bourgeois travellers. But the Picturesque vision was an abstract one that looked for formal pleasure. There was as well a more associative interest in the idea of a local Arcadia, as much dependent upon a sense of community as on visual appeal.

The pictorial roots of this local Arcadia can be found in Dutch art. 'The Dutch were stay-at-home people. Hence their originality,' wrote John Constable in the 1830s. He was looking back on a tradition of celebrating local landscape which he had himself brought to a new level of importance. Between him and the Dutch lay his fellow East-Anglian Gainsborough, who had in his early career painted attentive renderings of local scenery. *Cornard Wood*, which Gainsborough later dismissed as being in his 'schoolboy stile', reproduces the trees with loving care. It also shows local figures inhabiting the woods – a woodman, a milkmaid and a traveller. It reminds us that at that time the countryside was still quite open and more available to all members of the community before the great age of enclosures. In later life Gainsborough looked at the landscape quite differently.

149

By 1761, in *The Harvest Wagon*, his manner of painting has become broader, and his view of the landscape more sentimental and abstract. These peasants who travel in the harvest wagon – replete with the goods of the land – form one of those artful grouping that could come from a history painting. Gainsborough has moved from the particularity of the local to become a propagandist for an idealized vision of the countryside. Significantly he was no longer living there himself when he did this, but sat in London yearning to leave his portrait business and wander freely in nature with his viola da gamba. This poeticized view of nature commended itself greatly to his contemporaries. Uvedale Price commented that Gainsborough's landscapes 'humanized' the mind, much as Goldsmith's poetry did.

150

148. **John Robert Cozens**
Lake Albano and Castel Gandolfo,
c. 1783–88. Here the model is not so much Claude as the wilder and more fantastic Salvator Rosa.

149. **Thomas Gainsborough**
Cornard Wood, c. 1748.
An idyllic depiction by Gainsborough of his local countryside.

150. **Thomas Gainsborough**
The Harvest Wagon, c. 1767.
Gainsborough's late landscapes,
after he had left Suffolk for
London, are more idealized and
farther from reality, his view of
peasant life more sentimental.

The new naturalism

The reputation of Gainsborough's landscapes continued to grow after his death. In a period of war they reinforced an idyllic image of the countryside that could be used to bolster a national identity. It mattered little that this image, like the parallel ones that Morland was creating of rural life (see Chapter 9) were increasingly unlike the reality. Rural unrest was growing – exacerbated by the suppression of common rights for the poor as the result of enclosures. But Gainsborough's and Morland's peasants remained tranquil and compliant, enjoying the fruits of a 'free' nature and letting us enjoy the sight of their fresh, fecund bodies.

Nevertheless, there grew a desire to move beyond the generalities of such artists and discover a more vivid image of rural resilience. This movement runs in parallel with Wilkie's intervention in genre painting, when he arrived in London with a grittier image of rural life. More generally it can be seen as a response to the greater earthiness of the poetry of Burns, or the use of common speech by Wordsworth in his lyrics.

Signs of a new naturalistic endeavour can be found in the landscape literature of the period. William Marshall Craig's book on landscape drawing criticized Gilpin's over-generalized drawing style and formulaic approach and advocates working from the details of nature and letting their individuality guide the composition. *Plein-air* oil painting became a vogue around 1805, promoted by a host of young landscapists – including William Henry Hunt, John Linnell, Constable and Turner.

151

The need for an earthier Arcadia also reflected a need to pit an image of Britain as a healthy and thriving agricultural economy against the challenge of Napoleonic France. This seems to have been particularly the case after the Battle of Trafalgar in 1805 and Napoleon's subsequent Continental blockade. Britain had at that point scored a notable victory against the French and secured itself from invasion. On the other hand, the blockade – which prevented Continental ports from trading with Britain – meant that Britain had to rely on its own resources to survive. British agriculture now took on a new importance as the essential means of supporting the country during the rest of the conflict. The degree to which this affected landscape painting must remain conjectural. Nevertheless, it is striking that between 1805 and 1815 – the date of the Battle of Waterloo when Napoleon was finally defeated – British landscape painting witnessed a decade of unprecedentedly detailed and naturalistic representations of agricultural scenes.

Turner's *Ploughing up Turnips, Windsor* appears to reflect such interests. It emphasizes a patriotic image of the productive British land, with its stress on a crop as unpoetic as turnips and a vision beyond of the seat of the monarch. The situation of the scene on the Thames is also significant, for much patriotic writing at the time emphasizes the Thames as the heart of Britain and the site of its most productive areas. The term 'Georgic' is sometimes used to describe this way of representing rural scenes, from the poems of that name by Virgil which celebrated the fruitfulness of his native Italy through detailed descriptions of farming and husbandry. In one sense this might seem to be a matter-of-fact kind of poetry setting the real against the ideal. But this was only true to a certain point. For the Georgic is really a sub-group of the pastoral. It emphasizes husbandry and the details of farming far more than do the lyrical discourses of shepherds. Yet it is still at heart an idealized image designed to present rural life as one of health and plenty.

In the second decade of the nineteenth century John Constable rose to become the principal promoter of this Georgic image. Coming from a rural background himself (albeit that of a landowner rather than a labourer) he felt intensely protective about his heritage. He was the son of a mill-owner in East Bergholt in Suffolk. His art was intimately involved in the portrayal of his childhood world. 'These scenes made me a painter' he declared 'and I am grateful'. But family disapproval of his chosen career also intensified his need to justify what he was doing. He needed to make clear that his celebration of local landscape was as important as any other kind of painting. He believed, too, in the need to record the effect of nature in the country directly and, far more obsessively than any of his contemporaries, to make *plein-air* studies from nature. Many impress today more for their passion than their accuracy. The broadest of them seem to be records of fierce encounters with experience, in which he is forcing the medium to its limits to suggest the wetness of water, or the breeziness of a sky. Magnificent though such studies are, they were only preparations for his great large-scale, heroic celebrations of the local scene.

His *Flatford Mill* – painted soon after Wellington's victory at Waterloo – is a triumphant representation of what he termed a 'navigable river'. It shows the lock before a mill owned by his father. There is bustle and activity. It depicts modern trade: that of the barge bringing grain from the countryside to the city. The 'authenticity' of this image of productive countryside is

153

151. John Linnell
River Kennett, near Newbury, 1815. For Linnell, a painter in the circle of Palmer and Blake, nature was less a sublime spectacle than the setting for ordinary human life.

152. Joseph Mallord William Turner *Ploughing up Turnips, Windsor, c.* 1808–10. Many of Turner's early works are similarly rooted in mundane reality. This scene emphasizes the productivity of the land.

153. John Constable
Flatford Mill, 1817.
Constable's archetypal vision of
the English countryside as a
place where nature has been
domesticated to human needs –
fecund and inspiring but part of
an economy that serves both
country and town.

underlined by the minute accuracy of the scene. Every detail has been guaranteed, and enlivened by the warmth and sparkle of a breezy summers day.

Constable was not the only painter who painted large celebratory depictions of the productive English countryside at this time. There was, for example, his fellow East-Anglian Peter de Wint, whose *Cornfield* (1815), shows a naturalistically rendered harvest being gathered in under the broad skies of his native Lincolnshire. Nor was this genre restricted to artists from rural backgrounds. The London-based G. R. Lewis painted harvest scenes in Herefordshire. Like Constable and de Wint, he based these on *plein-air* studies. It has been argued recently that these bold, naturalistic paintings of a healthy and fruitful land relate to the mood of well-being that surrounded Britain's military triumphs. It also reflected a reality – for farming had never been so prosperous as at the end of the Napoleonic Wars. What none of these artists knew was that this was a peak that was going to lead to an inexorable decline. From this time onwards the countryside began to lose both power and tranquility. Soon the returning soldiers would be precipitating unemployment and unrest. And as the cities grew in industrial power in the decades to come the countryside began to play a diminishing role in national politics.

The vision of a healthy Britain presented in *Flatford Mill* is also given in the picture that has become Constable's talisman, *The Haywain*. Like *Flatford Mill*, it is based on the careful recording of local topography and naturalistic effect. But there are added elements – which perhaps account for its particular popularity as an archetypal image of the English countryside. The picture has now been given a more harmonious grandeur, with the broad sweep of the river and tall spreading trees. There is also less work going on than in the earlier picture. The horses of the haywain appear to be watering or cooling off. The man is very much at ease. There is, it is true, some reaping in the field beyond. But it is so far off as to be unreadable. It is hardly surprising that some observers have mistaken it for a cricket match! There might have been some doubt about the Arcadian nature of the Georgic *Flatford Mill*. There is certainly none here.

The Haywain is one of a series of large-scale celebrations of the scenes around his native village that Constable exhibited at the Royal Academy from 1819 onwards. These were grander than his earlier works and were aimed more at an urban audience. Constable was by this time no longer living in his native Suffolk. After his marriage in 1817 he had settled permanently in London.

Marriage brought with it new responsibilities and this might help explain why he now made such strong efforts to succeed. He was, in the long term, successful in this. In 1819 he was made an associate, in 1829 a full member of the Royal Academy. Constable himself felt these honours were coming too late in his life. However, as the President of the Royal Academy pointed out to him, many landscape painters never achieved such honours at all. Despite the evident quality of British landscape painters of the time, there was still a prejudice against them in academic circles.

Constable's later pictures were painted away from his Suffolk 154 background. Nor would he have drawn much sustenance from it had he stayed, for the scenes of 'careless boyhood' that he so treasured had been replaced by riots and rick-burning as the countryside moved into deep crisis following the Napoleonic Wars. Constable knew about this situation, both from newspaper accounts and from letters from members of his own family. He became more pessimistic, particularly about the future for the rural community. He viewed with horror the passing of the Reform Bill through Parliament in 1832. For that bill – which decreased the number of rural constituencies and increased those of the cities – was a dramatic sign of the decrease of the power of

154. John Constable
Chain Pier, Brighton, 1827. An unusual case of Constable, away from his native Suffolk, choosing a subject from the achievements of the Industrial Revolution.

the countryside. His later, doom-laden pictures, seem to be a warning that the Arcadian vision of the landscape no longer bore any relationship to the realities of rural life.

As the countryside retreated from the image of health so desired of it, Arcadian visions intensified. The 1820s – the years of Constable's heroic grandiose images of Suffolk – saw many celebrations of local beauty. Some, like those painted by Francis Danby in Bristol, are avowedly poetic. He depicts the bourgeoisie of the great city going out to enjoy the romantic terrain around Clifton.

156

155. **John Constable**
Barges at Flatford Lock,
c. 1810–12. A scene of human
activity that has become an
almost abstract study of clouds
and water.

The Arcadia of vision

Such images emphasize that the vision of rural bliss was – Constable notwithstanding – largely an urban affair. It represented a civic need to relate back to imagined roots. The most intense vision of Arcadian landscape in the period was in fact created by the urban Blake, who provided visionary dells as his contribution to the pastoral poems of Virgil in 1821.

Such work inspired young landscape painters, in particular Samuel Palmer (1805–81), who was inspired by the primitivizing tendencies in Blake's art to create rich imaginative visions of rural life.

Palmer, together with a number of friends, formed a break-away group called 'The Ancients'. They went to live for a time in the Kent village of Shoreham where they disconcerted the local inhabitants by wandering around in long flowing robes with long hair and beards. Never has there been a clearer case of the seekers of Arcadia bringing their vision to the countryside and projecting it almost without meditation. Despite the rural unrest evident here as much as in Contstable's native Suffolk, Palmer persisted in producing images, glowing like church windows with rich colours and showing a dutiful well-behaved populace marching to the sway of church and state. The riots in favour of the Reform Bill shook him as much as they did Constable. Palmer retreated from Shoreham to continue producing Arcadian images from his own imagination, though with diminished strength.

Constable, like Palmer, felt pessimism at what was happening in the country. But at least he had some understanding of what was

158. **Samuel Palmer**
A Rustic Scene, 1825. Palmer drew inspiration from Blake, and sought to portray the English countryside as a visionary Arcadia.

happening. His *Salisbury Cathedral* – the work that he himself
wished to be remembered by – shows the cathedral, symbol of the
Anglican establishment that he supported, 'under a cloud' – as one
of his friends, the Anglican archdeacon John Fisher, put it.

This statement was as sincere as any he had made as a land-
scape painter. But it has not been heeded as closely as his more
idyllic scenes. For in his earlier works Constable had succeeded in
constructing the most powerful of all Arcadian images of Britain –
one that convinced because it seemed so *natural* – based on careful

159. John Constable
*Salisbury Cathedral from the
Meadows*, 1831. A stormy view
of Salisbury Cathedral that reflects
Constable's unease over political
and social changes in the last
years of his life. He regarded it
as the most important of his later
pictures.

160. John Constable
The Cornfield, 1826. The first work by a British artist to enter the collection of the National Gallery, *The Cornfield* has sealed Constable's reputation as the painter of the English rural idyll.

and skilful observation of the facts. Whatever Constable wished after he had been personally disabused of the situation, the public at large were not going to let that one go.

The Arcadian image was also emphasized by Constable's friends and supporters. The artist had valued his *Salisbury Cathedral* most highly and after his death one of his friends wished to have this work presented to the National Gallery. But others argued that 'the boldness of its execution rendered it less likely to address itself to the general taste than others of his work,' and *The Cornfield* was chosen instead. Even more than *The Haywain*, this picture communicated an Arcadian vision of England. Constable himself felt he had overstepped the mark with this work, commenting that he had put more 'eye-salve' in it than usual for the public. It was a hostage to fortune. The first work by a modern British artist to enter the National Gallery, it has hung there for a century and a half, reconfirming the view of its author as the 'natural painter' of English rural paradise from which he doubtless will never now be separated.

160

Chapter 14: Landscape and History

Perhaps the most dramatic change in landscape in this period was the way it strove to take on the mantle of history painting and assume a new importance.

There had always been a place for 'historical' landscape within the academic artistic hierarchy. Landscape frequently provided the background to great historical events. The master of such work was the seventeenth-century French painter Poussin who, according to Sir Joshua Reynolds, had a mind 'thrown back two thousand years'.

But such landscape painting was not naturalistic. It was severe and noble. Reynolds made it clear in his discourses that modern landscape could not achieve such grandeur unless it too renounced the world of sensational effect and naturalistic depiction. It was for this reason that he disparaged the attempts of his older contemporary Richard Wilson (1713?–82) to produce a more vivid kind of historical landscape. When he represented the tragic mythological subject of *The Destruction of the Children of Niobe* in such a manner Reynolds censured him for impropriety. The President cattily talked of

...a very admirable picture of a storm...many figures are introduced in the fore-ground, some in apparent distress, and some struck dead, as a spectator would naturally suppose, by the lightning; had not the painter injudiciously (as I think) rather chosen that their death should be imputed to a little Apollo who appears in the sky, with his bent bow, and that those figures should be considered as the children of Niobe.

Reynolds' attack might seem unkind. But it was actually made in 1788, well after Wilson's death. Its real target was not Wilson himself so much as a dangerous tendency towards sensationalist landscape that he saw growing up around him. This type of landscape was influenced as Wilson himself had been by the French painter Claude-Joseph Vernet. Just as Fuseli and his circle had responded to Burke's idea of the Sublime by bringing in a new kind of dramatized history painting, so Vernet took the notion of the

Sublime to pioneer a new and more awe-inspiring form of landscape. Wilson's Niobe shows a classical tragedy with that of the storm echoing the drama of the destruction of mortals by the gods, in particular Apollo. But this method could be applied equally well to the modern world.

Doubtless Reynolds had in mind that pupil of Vernet's who had come from Paris to settle in London in 1771 and who achieved a remarkable success for his dramatic landscapes both on the stage and in the Academy: Philippe De Loutherbourg (1740–1812). He worked as a scene painter – introducing illusionistic landscape into theatrical displays and mounting in 1781 his own kind of primitive diorama, the EIDOPHUSIKON, in which both scenes of overpowering natural beauty and historical subjects such as the Miltonic *Satan Summoning up his Legions* were played out. Like so many of his generation, he also had inflated ideas of the power of the artist and even practised faith healing for a time, an unsuccessful venture that led to his house being besieged by a vengeful – and presumably unhealed – mob.

161. **Richard Wilson**
The Destruction of the Children of Niobe, 1760. A classic historical landscape, in which the tragedy of Niobe and her children being destroyed by the God Apollo is acted out against a stormy setting. Wilson's excursion into classical mythology was not admired by Sir Joshua Reynolds.

162. Philippe De Loutherbourg
An Avalanche in the Alps, 1803.
De Loutherbourg specialized
in landscapes of drama and
disaster. Here he shows travellers
destroyed by an avalanche,
a force of nature.

163. Philippe De Loutherbourg
Coalbrookdale by Night, 1801. In
the early years of the Industrial
Revolution, factories could be
admired for their sublimity. The
artist shows the famous iron
foundries at Coalbrookdale
creating dramatic effects in the
night sky.

De Loutherbourg pioneered the idea of landscape itself taking over the role of protagonist. Whereas Wilson has Apollo, striding out of a cloud, wreak vengeance on the hapless Niobe in his picture, it is nature herself that causes havoc to man in De Loutherbourg's *Avalanche*. This is a modern subject, yet it has the dimensions of history. For man is engaging with fate in it. All his skills as a scene painter have been used to give the cascade of snow a truly photographic realism. And the drama is orchestrated by the foreground traveller who throws up his hands in horror at the sight of people on the bridge being swept to destruction.

162

Only a mastery of illusionistic effect could bring off this sense of the drama of nature, and De Loutherbourg signalled the way for landscape to challenge history by moving precisely in the opposite direction from that which Reynolds recommended.

De Loutherbourg could be modishly up to date in his subjects. Perhaps his most memorable subject is a celebration of modern industry, *Coalbrookdale by Night*. By this date Coalbrookdale had become a tourist attraction on account of its spectacular iron foundry. De Loutherbourg had originally included the subject as part of a set of illustrations to a book on the area. However, he recognized the subject's potential for a grander treatment and made a large oil painting of it. By representing the subject at night, he enhanced its awesome mystery. Once again he addresses the archetypal theme of man's relations with the elements. Here man might be seen more in the character of Faustus, making a pact with the Devil to gain access to supernatural forces.

Turner

De Loutherbourg's example was all important for Turner. He gave a sense of the potential for historicizing landscape that encouraged Turner to pursue his own revisions of the genre.

By the time *Coalbrookdale* was exhibited Turner was an Academician. His rise had been rapid. He was only twenty-seven. Coming from a modest background as the son of a cockney barber, he had had to earn his keep young and had done this first of all by topographical painting. He was the close associate of Girtin and progressed like him, as has already been seen, through a mastery of topographical detail to an understanding of the deeper significance of atmosphere for landscape. While (by his own admission) no better at this than Girtin, he was already enjoying a more successful career. This was largely because he had supplemented his watercolour practice with that of oils and had shown himself ready to emphasize the poetic and historical dimensions of landscape.

163

In *The Shipwreck* he is already in full command of this genre.
Like De Loutherbourg's *Avalanche*, it addresses the theme of man's
struggle with nature. But Turner has expressed this even more
vividly. We, the spectator, are no longer viewing this drama from a
secure vantage point. We have been cast into the middle of the sea,
in the trough of the waves. Danger is signalled by the angle of the
pale sail of the rescue boat, which is made to look all the starker by
the lowering gloom of the sky behind. Turner has also turned the
proverbial limitation of the visual image, its ability to show only
one moment, to advantage. For we do not know – and never can
know – whether the figures cowering in the centre will actually be
saved. They remain for ever in danger.

The fact that landscape could now be used to express such dra-
mas tells us a lot about the changes that had been taking place. It
shows how the academic hierarchy was being undermined – even
if the Academy itself did not begin to admit this for another half-
century. The ability of landscape to do this was partly due to the
new valuation of nature that had been pioneered by the poets of the
period. But it was also because of the sense of the turmoil of the
times, which seemed to have brought man once more into an ele-
mental crisis. In the case of this picture there is perhaps a further
element to consider. Painted at a time of war, the sight of danger
at sea might have been able to provid some surrogate for acting
out fears. The picture was put on show in 1805, only months before
the Battle of Trafalgar, at a time when there was still a fear
that Napoleon would be able to mount his threatened invasion
of Britain.

A few years later Turner produced an even greater scene of
tempestuous conflict which seems to have an even closer reference
to contemporary politics. *Hannibal Crossing the Alps* shows the
Carthaginian general of antiquity performing his legendary feat
of crossing the Alps with his army and elephants as part of his bold
bid to conquer Rome. It is a tragic theme in which the final out-
come will be defeat. But in the picture there is the glimmer of hope.
Hannibal is pushing forward – through the snowstorm and the
skirmishes of local tribesmen – to the promised land of Italy just
visible in the sunlight beyond the gloom. If there was any doubt
about the intended irony this was dispelled by the extract that
Turner put in the catalogue when the work was exhibited at the
Academy. This was from his own poem entitled the *Fallacies of
Hope*. Nowadays the picture is believed to be a comment on the fate
of Napoleon, who was at that moment embarked on his disastrous
march on Moscow. Even if this is not the case, the picture still has

import for the tremendous way in which it combines a vivid storm – apparently first observed in Yorkshire – with Alpine scenery and an important historic event. The small scale of the figures also made its own point about the relative frailty of man in the hands of the forces of destiny.

One of the most important developments in these pictures is the way in which they show Turner thinking for himself. The landscape painter was no longer merely the transcriber of the stories of others. Now he could devise his own narratives, make his own observations on history and fate. Turner was hampered in his use of words by an imperfect education, and perhaps also by dyslexia. But those who knew him well recognized that he had the keenest of intelligences. As Constable remarked, he had a 'wonderful range of mind'. And that wonderful range was brought to bear on all aspects of his artistic practice.

164. **Joseph Mallord William Turner**
The Shipwreck, 1805. Turner follows De Loutherbourg in responding to the destructive power of nature, but his picture is more disturbing since there is no point of safety to reassure the spectator.

165. **Joseph Mallord William Turner** *Snow Storm: Hannibal and his Army Crossing the Alps*, 1812. Here the puny strength of man is overwhelmed by huge forces over which he has no control. The picture is at the same time an ironic comment on human ambition and a tribute to human heroism.

Turner was not the only artist to profit from the new dispensation. Many others were encouraged to paint heroic landscapes in a variety of ways. James Ward – who is more commonly known for his dramatic animal paintings – produced one of the most remarkable of these, a giant rendering of a view of *Gordale Scar* in Yorkshire.

166

Such a picture has moved far away from mere topography. The celebrated beauty spot has become an image of awesomeness, overpowering us. Ward's mastery of brooding atmospherics helps the effect – though he also achieves this to some degree by an unashamed exaggeration. The cattle as the base of the monumental scar are made deliberately tiny to heighten the contrast of scale.

Martin and the popular audience

Ward never repeated this monumental treatment, and Turner too moved away from dramatic and sensational works for a time. Perhaps the end of the Napoleonic Wars in 1815 made such work seem less appropriate. However a popular taste for the genre had arisen that did not abate and which was serviced by others.

166. James Ward
Gordale Scar, 1812–14. Ward, in a picture nearly eleven feet high, exaggerates a feature in the Yorkshire countryside to almost Alpine proportions.

The most successful and spectacular of these was John Martin (1789–1854). Martin arrived in London from Newcastle around 1809, having previously worked as a glass painter. He was always something of an outsider and never became an Academician. Yet this did not prevent him achieving fame and prosperity – a comment in itself on the declining power of the Academy.

Martin was deeply impressed by the dramatic historical landscapes of Turner and De Loutherbourg. Yet he translates them into a different mode. His own painting style makes free use of huge exaggerations to gain its effect. It has all the excitement and absurdity of popular melodrama. His first great success, *Belshazzar's Feast*, was described as a 'poetical and sublime conception in the grandest style of art' – a hyperbolic statement that seemed perfectly to fit the mood of the work. It is an exercise in the Sublime, taking the aesthetic of fear to a new height. Yet while Martin specialized in disaster, his work was in one sense less frightening than that of Turner's. Turner genuinely questions the nature of fate and opens up the daunting prospect of an indifferent universe. Martin, on the other hand, had faith in the essential goodness and protective power of the Divine. As in popular fiction, it is always the bad guys who get punished in his pictures. To a large extent he drew the themes for his sublime landscapes from the Old Testament where God is clearly on the side of the Jews and smites their enemies. *Belshazzar* shows the legendary Babylonian

167

167. John Martin
Belshazzar's Feast, 1826. Martin's grandiose scenes of biblical and apocalyptic disaster bring sublimity to the edge of melodrama.

168. **John Martin** *The Great Day of His Wrath*, 1852. Martin's vision of the end of the earth was part of a trilogy of vast canvases which focused on the Last Judgement and its consequences. These were immensely popular and toured as a travelling exhibition for over twenty years.

oppressor of the chosen people getting his come-uppance in no uncertain manner. The awesomeness of the scene is enhanced by the huge scale of the architecture. In the pamphlet that accompanied the work Martin justified this scale on the basis of ancient records, claiming that his fantastic scene was not an exaggeration but was based on accurate historical research. He was in fact well versed in contemporary geological and archaelogical studies as well as being something of an engineer in his own right. Like Blake and De Loutherbourg, he was influenced by popular millennialism and may well have been intending his biblical fantasies as dire warnings to the present not to stray from the paths of righteousness.

As has been mentioned, Martin was no friend of the Academy and ceased to exhibit there after a dispute. The Academy certainly disparaged the populism of Martin. Yet at the same time they did

169. **Francis Danby**
The Deluge, 1840. Danby's attempt to out-Martin Martin hardly succeeds. The scene, though turbulent, is not threatening, and the number of nude bodies gives it a touch of the academic and even the erotic.

not wish altogether to lose the market that he exploited. For a time they promoted Francis Danby (1793–1861) as a rival. Danby was a painter of considerable poetic refinement who produced idyllic scenes in his early years. His success as a rival to Martin was blighted by a marriage scandal that forced him to go abroad. Later, in 1840, he returned and tried to set himself up again with a huge rendering of *The Deluge*. Yet while this is an impressive work it was too restrained in tone to be able to match Martin's populist fire. It would probably have been impossible to out-Martin Martin without sharing his own religious conviction and sense of destiny.

169

Landscape, for Martin, was a prophetic art, and he used it much as Blake had used his for spiritual guidance and prediction. However, while Blake was preaching to a tiny minority Martin was addressing the public at large. He made full use of the opportunities provided by the exhibition system outside the Academy to display his works as popular sensations. This culminated in his most spectacular trilogy of *The Last Days*, which showed the end of the world as described in the Bible but interpreted in terms of landscape, The three giant canvases showed *The Great Day of His Wrath*, *The Last Judgement* and *The Plains of Heaven*.

The most startling and original of these is the *The Great Day of His Wrath* which shows the earth literally folding in on itself at the end of time, as described in the Book of *Revelations*. The imaginative power with which this is realized is stupendous and remained unrivalled until the coming of disaster movies in the twentieth century. It was envisaged with a sense of utter certainty. Martin was, as has already been mentioned, a keen student of geology and he conceived this event as a geological occurence – something that would have given it added reality for his audience.

168

Martin's trilogy – his last work – was an immense popular success. It toured throughout Britain and America for twenty years after it was painted. After that it fell into oblivion, like its creator, ultimately reaching the indignity of being sold for a mere £9.00 in the 1930s. Martin's fall from favour represented the end of an era. For by the time of his death landscapes of disaster had long been frowned upon by the artistic establishment.

Yet this did not mean that the raising of landscape to the status of historical painting had ended. Instead it had taken different directions. The most profound of these was that explored, as will be seen in the next and final chapter, by Turner in his late years.

170. **Joseph Mallord William Turner**
Norham Castle, Sunrise, *c.* 1844. With Turner's late pictures,
the line between finished and unfinished work is often difficult to
draw. He probably did not intend *Norham Castle* to be exhibited.

Chapter 15: The Case of Late Turner

At the end of a long career some artists seem to develop new and surprising dimensions. A shift of vision, the product of age and experience, gives them a different way of understanding and making. It happened to Michelangelo, Titian and Rembrandt. It doesn't happen just in painting, either. It can be found in the music of Beethoven, for example, and the poetry of Yeats.

We usually respond to this late style as something particularly profound and moving. Usually there is some loosening of technique and compensating breadth of view. Yet it is not without energy or passion.

Of all British painters, Turner is probably the only one who can be said to have had a 'late style' in this sense. From his mid-fifties onwards his art grew in boldness, richness, and beauty. Always a fine colourist, he now achieved sublime effects, hovering on the brink of pure vision.

Turner's late style is his principal claim to fame today. Yet in his own lifetime it was nearly his undoing. Most contemporaries found his manner increasingly disturbing, and many considered him to have gone mad and lost his powers. Much of this great work would doubtless have been discarded, if it had not been left to the nation by Turner in his will and thereby preserved in the National Gallery and at the Tate.

In the twentieth century late-Turner has been seen as a triumph. His bold, near-abstract canvases have been hailed as precursors of modern art from Impressionism to Abstract Expressionism. Yet historically they present a problem. Turner painted them, certainly. But what did he intend them to be? Most of the canvases from his last years were never exhibited in his lifetime. And indeed, it is uncertain that he ever looked upon them as pictures at all. In his will he stipulated that his *finished* pictures should be left to the nation. Did he intend such works as *Norham Castle*, an unexhibited and arguably unfinished picture of 1844, to be included? And indeed, some of the canvases now hanging in the Clore Gallery of the Tate, are so bare that one can hardly believe that the artist did more than make the merest beginnings with them.

170

'Studio scrapings' is what one contemporary critic has called these. It is possible to play Devil's advocate and claim that none of these late unexhibited works would be considered as art at all if it had not been for the impact of subsequent artistic movements that have accustomed us to looser, more abstract and informal methods of painting. It is not so much that Turner is a precursor of Impressionism and Abstraction, one could argue. It is that Impressionism and Abstraction made these works into paintings. In a literal sense this is true. Almost all of Turner's unexhibited pictures lay unseen in the vaults of the National Gallery through-out the nineteenth century. Only after Impressionism became established as a major art form were such pictures as *Norham Castle* taken out of the cellar, given an accession number and exhib-ited on the walls as a treasure of the National Collection. Other works had to wait much longer than this. *Yacht Approaching the Coast*, for example, was not considered a painting until the mid-1930s. Others had to wait as late as 1950 before they were acknowledged to be part of his pictorial bequest.

Turner's late style, therefore, presents a particular problem. There is probably no way of determining whether he did or did not consider his unexhibited canvases to be pictures. However we can get a closer sense of what his late style was about by looking at the historical evidence. This leads us back to the works that he did exhibit.

By the late 1820s, Turner was effectively a man of independent means. While painting ambitious historical works he had also kept up his business as a topographical artist and a designer of illustra-tions for lucrative publications. These had made him a substantial sum of money. He was also a relatively isolated man, particularly after his father – to whom he was very close – died in 1827. Although he had a number of affairs and a mistress with whom he lived towards the end of his life, he kept his counsel much to him-self. His late style seems to have been a product of this process of internalization. As well as being financially independent, he was also free to exhibit what he liked at the Academy without fear of rejection. It was his privilege as an Academician to show works without their having to be put before the exhibition selection jury.

After the Napoleonic Wars Turner had become a regular trav-eller to the Continent. This led to the production of numerous topographical works; but his trips to Italy, beginning with one to Rome in 1819, also appear to have stimulated him to think more seriously about the nature and effects of colour. The fruits of this can be seen in *Ulysses Deriding Polyphemus*, a work that Ruskin later

171. **Joseph Mallord William Turner** *Ulysses Deriding Polyphemus*, 1829. The blinded giant Polyphemus is shown as a nebulous figure above the ship, as Ulysses and his companions sail away into a typically Turneresque sunset.

172. **Joseph Mallord William Turner** *Interior at Petworth*, c. 1837. This strangely unreal vision of Petworth almost dissolving into light may have had a personal meaning for Turner.

described as the central picture of the artist's career. The subject is based on the story from the *Odyssey* of how Ulysses escaped from the cave of the Cyclops Polyphemus after having blinded his one eye with a firebrand. In the picture Ulysses is taunting the enraged blind Cyclops as he sails away to freedom. Typically for Turner, there is an irony in the plot. For by blinding Polyphemus Ulysses had made an enemy of Poseidon, God of the Sea, who was the Cyclops' father. As a result of this Ulysses had to travel for ten more years before he finally reached his home. The picture is about rage and hurt. One reviewer remarked that just because Ulysses had put out Polyphemus' eye there was no reason to put out our eye with such a strident tones. But there was, for Turner wished to use colour to convey the pain of the subject.

From this time onwards Turner seems to have thought of expressing his subjects in terms of colour. He began to paint habitually on a light canvas, so that the hues would shine more brightly.

It also seems to have been around this time that Turner began amassing unexhibited pictures. He was in any case becoming acquisitive of his own work, and began to buy back paintings previously sold so that he could assemble a comprehensive coverage

of his oeuvre. He wrote his will leaving his work to the nation – a will that he constantly changed with codicils.

While relatively isolated, Turner did have a close circle of patrons who were also friends. They were wealthy people, but came from very different backgrounds. Some – like the Earl of Egrement – were aristocrats of ancient lineage. Some – like Walter Fawkes in Yorkshire – were landed gentry. Some – like Ruskin's father – were self-made businessmen. They were all independent-minded and they all practiced to some degree as amateur artists. They respected the individualism of Turner's art, even if they could not always follow what he was doing. Their experiences as amateurs made them respect his sheer virtuosity, even when it displayed unheard of liberties. It was these supporters, rather than his fellow artists, who sustained Turner in his pictorial explorations.

Lord Egremont provided a great service by making his house at Petworth available for Turner to stay in more or less as he liked in the dark years after the death of his father. Some of the freest of all Turner's studies come from those visits. His great oil *Interior at Petworth* appears to have been painted around the time when Egremont died in 1835. In it light takes on a visionary force, dissolving the room it bursts into, almost as though Petworth itself was disintegrating for Turner now that his friend and supporter was gone. This was one of Turner's unexhibited canvases. One can imagine it having a very private meaning for him.

172

Yet Turner did not withdraw from making public statements in these later years. Another close friend, Walter Fawkes of Farnley (from the same stock as Guy Fawkes and nearly as subversive) was a radical in his politics and may have encouraged Turner to engage in commentaries on contemporary events. No work shows this side of his art more clearly than *Slavers Throwing Overboard the Dead and Dying – Typhoon coming on*. It told the horrific true story of how the captain of the slave ship *Zong* had ordered dying slaves to be cast into the sea so that they could be described as having been 'lost at sea' and insurance be claimed on them. This dreadful event had occured in 1783. But Turner revived it at this moment to coincide with an anti-slavery congress which was meeting in London. This could be seen as opportunism – though it could also be a reminder of the moral issues that underpinned the debates. Nowhere did he use his new sense of colour with more power than when he painted the ship's rigging blood red to suggest guilt and the sky with purple and violent orange to intimate Divine retribution.

173

Increasing age sharpened Turner's awareness of the passage

173. **Joseph Mallord William Turner** *The Slave Ship (Slavers Throwing Overboard the Dead and Dying – Typhoon coming on)*, 1840. Turner's intensely dramatic technique matches the horror of the real incident when dying slaves were thrown overboard.

174. **Joseph Mallord William Turner** *The Fighting Temeraire Tugged to her Last Berth to be Broken Up*, 1838.
The picture has become an icon of Romanticism, contrasting the glamour of a world about to disappear with the black, polluting reality of the present.

of time. His work often harked back to earlier times, particularly when some occurence stirred up reminiscences. The breaking up of a famous ship from the Napoleonic wars led him to produce *The Fighting Temeraire Tugged to her Last Berth*. In it, Turner emphasized the contrast between the ghostly old warship and the squat, grubby little steam tug that is towing it to its extinction. He counterpoises the strident reds and oranges on the right – the side of the tug and the setting sun – with beautiful pale and ethereal harmonies on the left – the side of the old ship and a sickle moon. On this occasion Turner captured the public. The patriotism and sentiment in it made it one of his best loved pictures. 174

Turner may have lamented the passing of earlier days. Yet he retained an excitement about the present. Unlike many of his generation – such as the poet Wordsworth – he did not see the coming of the machine age as an unmitigated disaster. He took a keen interest in photography and in the awe-inspiring nature of the railway. *Rain, Steam and Speed* both celebrates the Great Western Railway and shows its destructive impact. He devised a completely new type of pictorial composition to express the power of the train as it rushed diagonally out of the canvas, leaving a tranquil rural world stranded in the background. He also developed new ways of putting on paint to produce the effect of features dimly seen through steam and driving rain. 175

While viewed with perplexity and amazement by most of his contemporaries, Turner did enjoy a form of canonization. In 1843 he emerged as the hero of the first volume of the young critic John Ruskin's study of contemporary art, *Modern Painters*. This work set out to explain both why landscape painting was the quintessential modern art, and why Turner was its greatest and most profound exponent. Ruskin argued that the puzzling 'abstraction' of Turner's later works was in fact the result of a deeper perception of natural forces.

Turner appreciated Ruskin's efforts on his behalf, although he never seems to have been altogether happy with the young critic's interpretation of his work. Inspired by Romantic poetry, Ruskin wished to see an intimation of Divine benevolence in Turner's vision of nature. Yet the artist seems in fact to have been motived by a bleaker vision of a powerful yet indifferent universe. An ironic fatalism seems to have given his painting its particular energy.

After Turner's death Ruskin, almost inevitably, became one of those responsible for seeing that his bequest to the nation was secured. It was he who arranged and catalogued the works. This turned out to be a mixed blessing. For a start Ruskin, who was

prudish in these matters, destroyed a large number of erotic pictures. He also seems to have been instrumental in deciding that – with a couple of exceptions – only Turner's exhibited works should be put on show. For while he was a defender of Turner's later work, there was a limit beyond which he, too, could not go. He did not believe that paintings like *Norham Castle* were exhibitable, and left them in the uncatalogued part of the collection. They might have been discarded altogether for all he cared. It was probably nothing more than inertia that saved such pictures from being swept away from the vaults of the National Gallery where they were stored. Only after 1900, when the Impressionists had risen to fame, did curators return once more to the vaults and decide that such works could be treated as pictures after all.

I have already referred to the sceptical view that these late unfinished canvases have only been made into pictures by the modernist tastes of the twentieth century. Certainly, if one sees art as being defined solely by reception and audience, this has to be the case. Yet I do not think that this is adequate, since it ignores the presence of the artist as an active agent. We may all be conditioned and limited by the social and political structures of the age in which we live: But we have the possibility of engaging with these positively and, in some circumstances, changing them. Turner painted far too many of these pictures – and worked on them far too assiduously – for them to be seen simply as discarded 'beginnings' of pictures. Furthermore, the pictures can be seen as an active engagement in and extension of contemporary aesthetics. With the coming of greater interest in subjectivity and association aesthetics at the turn of the century there had developed a renewed interest in the sketch. In Germany the critic A. W. Schlegel had praised outline drawing because it stimulated the imagination to complete the work in the mind. In Britain, more arrogantly, the connoisseur Richard Payne Knight had advanced the view that the sketch was preferred to the finished work by those with taste, as these could appreciate suggestive qualities in it inaccessible to the vulgar. In his late work Turner seems to be exploring suggestivenes, testing how far a picture could intimate transient effects, the life of atmospherics, the thresholds of vision. He was excited by the new possibilities of form and colour that emerged in this art of ever freer association. He would have been aware, too, that such explorations involved the inner as well as the outer world. These pictures were developed reflectively in the studio. They were drawn from his memories. As he worked alone in privacy he became the only audience for his art. When even a

175. **Jospeh Mallord William Turner** *Rain, Steam and Speed – The Great Western Railway*, 1844. Here Turner focuses his Romantic vision upon the railway, for the Victorians the pre-eminent symbol of the Industrial Revolution and itself almost a force of nature.

sympathetic critic like Ruskin could not really see the point of what he was doing, what hope did he have of others? Turner kept on working, deliberately, intentionally. Yet he may have been increasingly uncertain about the ultimate outcome of this work and what should be done with it. Perhaps the growing confusion created in his will by the codicils he continuously added to it were a symptom of this. We shall never know for certain quite how much of his work Turner wanted to have preserved for posterity. But it is clear that he wanted his works kept together and in public ownership. Only if a substantial number of them were preserved as a group did he believe that their meanings would become clear.

If it had been left to Britain alone, this might never have occured. Fortunately the direction he took was eventually arrived at by separate means in France, and this eventually enabled the British to see what they had got in this master of light and vision.

In one sense the story is a triumphant one. But in another it is a sad one. For it reminds us that the move towards a new progressive art that had been the leitmotif of the period covered by this book ran out of steam in the Victorian era. Turner's late work is the last and most brilliant outburst of a forward-looking modernity that had been initiated by Hogarth. After that, British painting lost its radical edge.

Selected Bibliography

Historical and Cultural Context

Butler, Marilyn, *Romantics, Rebels and Reactionaries: English Literature and its Background, 1796–1830*, Oxford and New York, 1981

Colley, Linda, *Britons: Forging the Nation, 1707–1837*, London, 1994

Honour, Hugh, *Romanticism*, Harmondsworth, 1979

Klingender, Francis, *Art and the Industrial Revolution*, revised ed., Edinburgh, 1968

Vaughan, William, *Romanticism and Art*, London and New York, 1994

Williams, Raymond, *Culture and Society*, Harmondsworth, 1958

Painting

Ackroyd, Peter, *Blake*, London, 1995

Ayres, James, *English Naive Art, 1750–1900*, London and New York, 1980

Barrell, John, *The Political Theory of Painting from Reynolds to Hazlitt*, New Haven and London, 1986

Barrell, John (ed), *Painting and the Politics of Culture: New Essays on British Art 1700–1850*, Oxford and New York, 1992

Bermingham, Ann, *Landscape and Ideology: the English Rustic Tradition, 1740–1860*, London and New York, 1987.

Bindman, David, *Hogarth*, London and New York, 1981

Bindman, David, *William Blake: His Art and Times*, London and New York, 1982

Bindman, David (ed), *The Thames and Hudson Encyclopaedia of British Art*, London, 1985

Brilliant, Richard, *Portraiture*, London, 1991

Butlin, Martin, *The Paintings and Drawings of William Blake*, 2 vols., New Haven and London, 1981.

Butlin, Martin and Joll, Evelyn, *The Paintings of J. M. W. Turner*, 2 vols., New Haven and London, 2nd edit., 1984

Deuchar, Stephen, *Sporting Art in Eighteenth-Century England: A Social and Political History*, New Haven and London, 1998

Feaver, William, *The Art of John Martin*, Oxford, 1975

Gage, John, *J. M. W. Turner: 'A Wonderful Range of Mind'*, New Haven and London, 1987

Gowing, Lawrence, *Turner: Imagination and Reality*, New York, 1966

Graham-Dixon, Andrew, *A History of British Art*, London, 1996

Grigson, Geoffrey, *Samuel Palmer: The Visionary Years*, London, 1947

Hill, Draper, *Mr. Gillray the Caricaturist*, London, 1965

Johnstone, Christopher, *John Martin*, London, 1974

Lindsay, Jack, *Turner: The Man and his Art*, London, 1990.

Lister, Raymond, *Catalogue Raisonné of the Works of Samuel Palmer*, Cambridge, 1988

Parris, Leslie, *Constable*, exh. cat., London, 1991

Paulson, Ronald, *The Art of Hogarth*, London, 1975

Paulson, Ronald, *Hogarth*, 3. vols, Cambridge, 1992

Paulson, Ronald, *Hogarth's Graphic Works*, London, 3rd Edn, 1989

Paulson, Ronald, *Literary Landscapes: Turner and Constable*, New Haven and London, 1982

Pears, Iain, *The Discovery of Painting. The Growth of Interest in the Arts in England, 1680–1768*, New Haven and London, 1988

Penny, Nicholas, *Reynolds*, exh. cat., London, 1986

Pointon, Marcia, *Hanging the Head. Portraiture and Social Formation in Eighteenth-Century England*, New Haven and London, 1993

Pressly, William, *The Life and Art of James Barry*, New Haven and London, 1981

Reynolds, Joshua, *Discourses on Art*, ed. R. Wark, New Haven and London, 1975

Rosenblum, Robert, *Transformations in Late Eighteenth-Century Art*, Princeton, 1967

Rosenblum, Robert, *Modern Painting and the Northern Romantic Tradition, Friedrich to Rothko*, London and New York, 1975.

Rosenthal, Michael, *Constable: The Painter and his Landscape*, New Haven and London, 1983

Shaw-Taylor, Desmond, *The Georgians: Eighteenth-Century Portraiture and Society*, London, 1990.

Smart, Alastair, *Allan Ramsay: Painter, Essayist and Man of the Enlightenment*, New Haven and London, 1992.

Solkin, David, *Painting for Money: The Visual Arts and the Public Sphere in Eighteenth-Century England*, New Haven and London, 1993.

Taylor, Basil, *Stubbs*, London, 1971

Waterhouse, Ellis, *Gainsborough*, London, 1958

Waterhouse, Ellis, *Painting in Britain 1530 to 1790*, New Haven and London, 1994

List and sources of illustration

Measurements in centimetres, followed by inches

1. Joseph Mallord William Turner, *Yacht Approaching the Coast*, c. 1835–40. Oil on canvas, 102.2 × 142.2 (40⅛ × 55⅞). Tate Gallery, London.

2. John Constable, *The Haywain*, 1821. Oil on canvas, 130.2 × 185.4 (51¼ × 73). © National Gallery, London.

3. William Hogarth, *The Painter and His Pug*, 1745. Oil on canvas, 90.2 × 69.8 (35½ × 27¼). Tate Gallery, London.

4. Benjamin West, *The Death of General Wolfe*, 1771. Oil on canvas, 151.1 × 213.4 (59½ × 84). National Gallery of Canada, Ottawa.

5. Pugin and Thomas Rowlandson, *Private View at the Summer Exhibition*, 1807. Aquatint from Ackerman's *Microcosm of London.*

6. Thomas Gainsborough, *Mr and Mrs Andrews*, c. 1750. Oil on canvas, 69.8 × 119.4 (27½ × 47). © National Gallery, London.

7. Sir Thomas Lawrence, *Pinkie*, c. 1795. Oil on canvas, 146 × 99.8 (57½ × 39¼). Courtesy of the Huntington Library and Art Collections and Botanical Gardens, San Marino, California.

8. Allan Ramsay, *The Painter's Wife (Margaret Lindsay)*, c. 1757. Oil on canvas, 184.1 × 243.8 (72½ × 96). National Gallery of Scotland, Edinburgh.

9. Sir Godfrey Kneller, *Joseph Tonson*, 1717. Oil on canvas, 90.8 × 70.2 (35¾ × 27⅝). By courtesy of the National Portrait Gallery, London.

10. Joseph Wright of Derby, *Experiment with an Air Pump*, 1768. Oil on canvas, 184.1 × 243.8 (72½ × 96). © National Gallery, London.

11. John Crome, *The Poringland Oak*, c. 1818–20. Oil on canvas, 125.1 × 100.3 (49¼ × 39¼). Tate Gallery, London.

12. W. Williams, *A Prize Bull and a Prize Cabbage*, 1804. Oil on board, 59 × 72 (13¾ × 28¼). Private Collection.

13. William Hogarth, *Marriage a la Mode: I: The Marriage Contract*, 1743. Oil on canvas, 69.9 × 90.8 (27½ × 35¾). © National Gallery, London.

14. William Hogarth, *A Scene from 'The Beggar's Opera'*, 1729–31. Oil on canvas, 57.1 × 75.9 (22½ × 29⅞). Tate Gallery, London.

15. William Hogarth, *The Harlot's Progress*, Plate 3, 1732. Engraving. © British Museum, London.

16. William Hogarth, *The Rake's Progress: VI: The Rake at a Gambling House*, 1735. Oil on canvas, 62.2 × 75 (24½ × 29½). By courtesy of the Trustees of Sir John Soane's Museum, London.

17. Francis Hayman, *The Milkmaid's Garland*, c. 1741–42. Oil on canvas, 138.5 × 240 (54½ × 94½) The Victoria and Albert Museum, London. Photo: The V&A Picture Library.

18. Joseph Highmore, *Samuel Richardson's Pamela. II: Pamela and Mr B. in the Summer House*, 1744. Oil on canvas, 63 × 76 (25 × 30). The Fitzwilliam Museum, Cambridge.

19. William Hogarth, *Captain Thomas Coram*, 1740. Oil on canvas, 239 × 147.5 (94 × 58). The Thomas Coram Foundation, London.

20. William Hogarth, *An Election: IV: Chairing the Member*, 1754–55. Oil on canvas, 101.5 × 127 (40 × 50). By courtesy of the Trustees of Sir John Soane's Museum, London.

21. William Hogarth, *The Artist's Servants*, c. 1750–55. Oil on canvas, 62.2 × 74.9 (24½ × 29½). Tate Gallery, London.

22. William Hogarth, *The Shrimp Girl*, before 1781. Oil on canvas, 63.5 × 50.8 (25 × 20). © National Gallery, London.

23. William Dickinson, (after Henry Bunbury), *A Family Piece*, 1781, stipple, 24.7 × 36.3 (9⅞ × 14¼). © British Museum, London.

24. Henry Fuseli, *Bust of Brutus.* Engraving for Lavater's *Essays on Physiognomy*, c. 1779.

25. Roubilliac's *Artist's Lay Figure*, c. 1740, Museum of London.

26. Sir Godfrey Kneller, *Richard Boyle, 2nd Viscount Shannon*, 1733. Oil on canvas, 91.4 × 71.1 (36 × 28). By courtesy of the National Portrait Gallery, London.

27. Richard Cosway, *Mary Anne Fitzherbert, c.* 1789. Miniature on ivory, oval, 0.74 × 0.59 (3 × 2¼). The Royal Collection © Her Majesty Queen Elizabeth II.

28. Samuel Palmer, *Self-Portrait, c.* 1824/5. Oil on canvas, 29.1 × 22.9 (11⅜ × 9). Ashmolean Museum, Oxford.

29. Robert Dighton, *A Real Scene in St Paul's Churchyard on a Windy Day, c.* 1783. Mezzotint, 32.1 × 24.4 (12⅝ × 9⅝). The Victoria and Albert Museum, London. Photo: The V&A Picture Library.

30. After Sir Joshua Reynolds, *Mrs Siddons as the Tragic Muse,* 1784. Mezzotint after the oil painting.

31. George Beare, *Portrait of an Elderly Lady and a Young Girl,* 1747. Oil on canvas, 124.6 × 102.2 (49 × 40¼). Yale Center for British Art, Paul Mellon Collection, New Haven, Ct.

32. Joseph Van Aken, *An English Family at Tea, c.* 1720. Oil on canvas, 99.4 × 116.2 (39⅛ × 45¾). Tate Gallery, London.

33. William Hogarth, *Before, c.* 1730–31. Oil on canvas, 36.5 × 44.8 (14⅜ × 17⅝). Fitzwilliam Museum, Cambridge.

34. William Hogarth, *After, c.* 1730–31. Oil on canvas, 37 × 44.6 (14⅝ × 17½). Fitzwilliam Museum, Cambridge.

35. Philip Mercier, *'The Music Party', Frederick Prince of Wales and his Sisters at Kew,* 1733. Oil on canvas, 45.1 × 57.8 (17¾ × 22¾). By courtesy of the National Portrait Gallery, London.

36. William Hogarth, *A Performance of 'The Indian Emperor or the Conquest of Mexico by the Spaniards',* 1732–35. Oil on canvas, 131 × 146.7 (51½ × 57¾). Private Collection.

37. Joseph Highmore, *Mr Oldham and his Guests, c.* 1750. Oil on canvas, 105.4 × 129.5 (41½ × 51). Tate Gallery, London.

38. Arthur Devis, *Sir George and Lady Strickland, of Boynton Hall,* 1751. Oil on canvas, 90 × 113 (35½ × 44½). Ferens Art Gallery: Kingston upon Hull City Museums, Art Galleries and Archives.

39. Thomas Gainsborough, *The Painter's Daughters Chasing a Butterfly, c.* 1756. Oil on canvas, 113.5 × 105 (44¾ × 41¼). © National Gallery, London.

40. Johann Zoffany, *David Garrick in 'The Farmer's Return', c.* 1762. Oil on canvas, 101.5 × 127 (40 × 50). Yale Center for British Art, Paul Mellon Collection, New Haven, Ct.

41. Johann Zoffany, *Colonel Poitier with his Friends,* 1786. Oil on canvas, 137 × 183.5 (54 × 72¼). Victoria Memorial Hall, Calcutta.

42. George Stubbs, *The Melbourne and Milbanke Families,* 1770. Oil on canvas, 97.2 × 149.3 (38¼ × 58¾). © National Gallery.

43. Sir Anthony Van Dyck, *Charles I in Robes of State,* 1636. Oil on canvas, 248.3 × 153.7 (97¾ × 60½). The Royal Collection © Her Majesty Queen Elizabeth II.

44. Thomas Gainsborough, *The Blue Boy, c.* 1770. Oil on canvas, 177.8 × 122 (70 × 48). Courtesy of the Huntington Library and Art Collections and Botanical Gardens, San Marino, Ca.

45. Jonathan Richardson, *Lady Mary Wortley Montagu, c.* 1725. Oil on canvas, 239 × 144.8 (94 × 57). The Earl of Harrowby.

46. Thomas Hudson, *Theodore Jacobsen,* 1746. Oil on canvas, 235.6 × 136.8 (92⅞ × 53⅞). The Thomas Coram Foundation, London. Photo: The Bridgeman Art Library.

47. Allan Ramsay, *Self-Portrait, c.* 1739. Oil on canvas, 61 × 46.4 (24 × 18¼). By courtesy of the National Portrait Gallery, London.

48. Allan Ramsay, *Archibald Campbell, 3rd Duke of Argyll,* 1749. Oil on canvas, 238.8 × 156.2 (94 × 61½). Glasgow Museums: Art Gallery and Museum, Kelvingrove.

49. Sir Joshua Reynolds, *Commodore Keppel, c.* 1753–54. Oil on canvas, 239 × 147.5 (94⅛ × 58). National Maritime Museum, Greenwich, London.

50. Sir Joshua Reynolds, *Nellie O'Brien, c.* 1763. Oil on canvas, 127.6 × 101 (50⅜ × 39). The Wallace Collection, London.

51. Sir Joshua Reynolds, *Lawrence Sterne,* 1760. Oil on canvas, 127.3 × 100.4 (50⅛ × 39½). By courtesy of the National Portrait Gallery, London.

52. Allan Ramsay, *Jean-Jacques Rousseau,* 1766. Oil on canvas, 75.5 × 63 (29¾ × 24¾). National Gallery of Scotland, Edinburgh.

53. Thomas Gainsborough, *The Morning Walk (Mr & Mrs Hallett), c.* 1785. Oil on canvas, 236.2 × 179.1 (93 × 70½). © National Gallery, London.

54. Sir Joshua Reynolds, *Three Ladies Decorating a Herm of Hymen (the Montgomery Sisters),* 1773. Oil on canvas, 233.7 × 290.8 (92 × 114½). Tate Gallery, London.

55. Joseph Wright of Derby, *Sir Brooke Boothby,* 1781. Oil on canvas, 148.6 × 207.6 (58½ × 81¾). Tate Gallery, London.

56. Thomas Gainsborough, *Portrait of Mrs Philip Thicknesse (Miss Ann Ford),* 1760. Oil on canvas, 197 × 135 (77½ × 53). Cincinnati Art Museum, Bequest of Mary M. Emery.

57. Sir Thomas Lawrence, *Queen Charlotte,* 1789. Oil on canvas, 239.4 × 147.3 (94¼ × 58). © National Gallery, London.

58. George Romney, *The Spinstress, Lady Hamilton at the Spinning Wheel,* 1787. Oil on canvas, 172.7 × 127 (68 × 50). Iveagh Bequest, Kenwood. Photo: English Heritage Photographic Library, London.

59. Sir Henry Raeburn, *The Reverend Robert Walker Skating on Duddingston Loch, c.* 1790. Oil on canvas, 76.2 × 63.5 (30 × 25). National Gallery of Scotland, Edinburgh.

60. Sir Henry Raeburn, *Isabella McLeod, Mrs James Gregory, c.* 1778. Oil on canvas, 127 × 101.6 (50 × 40). Reproduced by kind permission of the National Trust for Scotland.

61. Johann Zoffany, *Members of the Royal Academy,* 1771–72. Oil on canvas, 120.6 × 151 (47½ × 59½). The Royal Collection © Her Majesty Queen Elizabeth II.

62. Sir Joshua Reynolds, *Portrait of the Artist,* 1780. Oil on canvas, 127 × 101.6 (50 × 39¾). The Royal Academy of Arts, London.

63. Gawen Hamilton, *A Conversation of Virtuosi…at the Kings Arms,* 1736. Oil on canvas, 87.6 × 111.5 (34½ × 43¾). By courtesy of the National Portrait Gallery, London.

64. Joseph Wright of Derby, *An Academy by Lamplight*, c. 1768–69. Oil on canvas, 127 × 101.6 (50 × 39¾). Paul Mellon Collection, Upperville, VA.

65. After Charles Lebrun, *The Expressions of the Passions*, 1692. Etching by Sebastian Leclerc. © Bibliothèque Nationale de France, Paris.

66. Pugin and Thomas Rowlandson, *The Life Class at the Royal Academy*. Engraving from Ackerman's *Microcosm of London*, 1808.

67. Thomas Rowlandson, *The Exhibition Stare Case*, c. 1800. Watercolour with grey and brown wash over pencil on wove paper, 44.7 × 29.8 (17⅝ × 11¾). Yale Centre for British Art, Paul Mellon Collection.

68. George Sharf, *Interior of the Gallery of the New Society of Painters in Watercolour*, 1834. Oil on canvas, 29.5 × 36.8 (11⅝ × 14½). The Victoria and Albert Museum, London. Photo: The V&A Picture Library.

69. Francis Hayman, *Robert Clive and Mir Jaffir after the Battle of Plassey, 1757*, c. 1760. Oil on canvas, 100.3 × 127 (39½ × 50). By courtesy of The National Portrait Gallery, London.

70. Gavin Hamilton, *The Oath of Brutus*, c. 1763–64. Oil on canvas, 213.3 × 264 (84 × 104). Yale Center for British Art, Paul Mellon Collection.

71. Benjamin West, *Non Dolet*, 1766. Oil on canvas, 91.5 × 71 (36 × 28). Yale Center for British Art, Paul Mellon Collection, New Haven, Ct.

72. John Singleton Copley, *Brook Watson and the Shark*, 1778. Oil on canvas, 182.1 × 229.7 (71¾ × 90½). National Gallery of Art, Washington D.C.

73. John Singleton Copley, *The Death of Major Peirson*, 1783. Oil on canvas, 251.5 × 365.8 (99 × 144). Tate Gallery, London.

74. Sir Joshua Reynolds, *Count Ugolino and his Children*, 1775. Oil on canvas, 124.8 × 175.9 (49 × 69). Knole, The Sackville Collection (The National Trust). Photo: Photographic Survey of Private Collections, Courtauld Institute of Art, London.

75. Angelica Kauffmann, *The Artist in the Character of Design Listening to the Inspiration of Poetry*, 1782. Oil on canvas, circular, diameter 61 (diameter 24) Iveagh Bequest, Kenwood. Photo: English Heritage Photographic Library.

76. James Barry, *The Crowning of the Victors at Olympia* (detail), 1801. Oil on canvas, 142 × 515 (360 × 1308). The Royal Society of Arts, London. Photo: The Bridgeman Art Library.

77. Richard Parkes Bonington, *Francis I and Marguerite of Navarre*, c. 1826–27. Oil on canvas, 46 × 34.3 (18⅛ × 13½). The Wallace Collection, London.

78. Benjamin Haydon, *Marcus Curtius Leaping into the Gulf*, 1843. Oil on canvas, 320 × 228.6 (126 × 90). Exeter City Museums and Art Gallery: Royal Albert Memorial Museum and Gallery.

79. John Hamilton Mortimer, *Death on a Pale Horse*, 1784. Etching, engraved by J. Haynes, 28.9 × 47.7 (11⅜ × 18¾).

80. Henry Fuseli, *Self-Portrait*, c. 1780. Black chalk heightened with white on paper, 27 × 20 (10⅝ × 7⅞). The Victoria and Albert Museum, London. Photo: The V&A Picture Library.

81. Henry Fuseli, *The Nightmare*, 1790–91. Oil on canvas, 76 × 63 (29⅞ × 24¾). Goethehaus, Frankfurt. Photo: Peter Willi/Bridgeman Art Library.

82. Henry Fuseli, *The Oath of the Rutlii*, 1779. Drawing.

83. William Blake, *Joseph Making Himself Known to his Brethren*, c. 1785. Pen, ink and watercolour over pencil, 40.5 × 56.1 (16 × 22). Fitzwilliam Museum, Cambridge.

84. William Blake, *The Sick Rose*, 1789–94. Relief etching with pen and watercolour, 10.8 × 6.7 (4¼ × 2⅝). © British Museum.

85. William Blake, *Jerusalem (Bentley copy E)* pl. 28: '*Jerusalem / Chapter 2*', 1804–20. Relief etching with pen and watercolour, 22.2 × 16 (8¾ × 6¼). Yale Center for British Art, Paul Mellon Collection, New Haven, Ct.

86. William Blake, *Christ in the Sepulchre, Guarded by Angels*, c. 1806. Watercolour with pen, 42 × 30 (16½ × 11⅞). The Victoria and Albert Museum, London. Photo: The V&A Picture Library.

87. William Blake, *Hecate*, c. 1795. Colour printed monotype, 43 × 57 (17⅛ × 22). Tate Gallery, London.

88. William Blake, *The Sun Standing at His Eastern Gate*, illustration to Milton's *L'Allegro*, 1816–20. Pen and brush, black and grey ink and watercolour, 16.1 × 12.2 (6⅜ × 4¾). The Pierpont Morgan Library, New York. Photo: Art Resource, New York.

89. William Blake, *Book of Job: Plate 21: Job and his Wife Restored to Prosperity*, 1823–25. Line engraving, 19.8 × 15.2 (7¾ × 6). By kind permission of the British Library, London.

90. William Blake, *Paolo and Francesca and the Whirlwind of Lovers*, c. 1824. Ink and watercolour, 37.1 × 52.8 (14⁹⁄₁₆ × 20¾). Birmingham Museum and Art Gallery.

91. James Gillray, *The Plum Pudding in Danger or State Epicures Taking un Petit Souper*, 1805. Engraving, 25.9 × 35.7 (10 × 14). Copyright British Museum.

92. William Hogarth, *Characters and Caricatures*, 1743. Engraving, 19.7 × 20.6 (7¾ × 8⅛). British Museum, London.

93. Thomas Patch, *A Gathering of Dilettanti around the Medici Venus*, 1760–70. Oil on canvas, 137.2 × 228.6 (53¾ × 89⅞) Brinsley Ford Collection.

94. George Townshend, *The Duke of Cumberland or 'Gloria Mundi'*, 1756. Etching, British Museum.

95. James Gillray, *The Death of the Great Wolf*, 1795. Engraving, 29 × 43.5 (11¼ × 17).

96. James Gillray, *Fashionable Contrasts or the Duchess' Little Shoe Yielding to the Magnitude of the Duke's Foot*, 1792. Engraving, 25 × 35.7 (9⅞ × 13¾).

97. Thomas Rowlandson, *Vauxhall Gardens*. Ink drawing and watercolour, 33 × 46 (13 × 18¼). Paul Mellon Collection, Upperville, Va.

98. George Cruikshank, *The Drunkard's Children: Suicide of the Daughter*, 1848. Engraving, Private Collection. Photo: The Bridgeman Art Library.

99. Sir David Wilkie, *The Penny Wedding*, 1818. Oil on panel, 64.4 × 95.6 (25⅜ × 37½). The Royal Collection © Her Majesty Queen Elizabeth II.

100. Thomas Gainsborough, *Cottage Girl with Dog and Pitcher*, 1785. Oil on canvas, 174 × 124.5 (68½ × 49). National Gallery of Ireland, Dublin.

101. George Stubbs, *The Reapers*, 1783. Oil on canvas, 90.16 × 137.54 (35.5 × 54). National Trust Photographic Library/Upton House (Bearstead Collection)/Angelo Hornak.

102. Francis Wheatley, *The Milkmaid*, engraving from *Cries of London*, 1793.

103. George Morland, *Morning: Higglers preparing for Market*, 1791. Oil on canvas, 70 × 90 (27¾ × 35½). Tate Gallery, London.

104. Sir David Wilkie, *The Letter of Introduction*, 1813. Oil on panel, 61 × 50 (24 × 19¾). National Gallery of Scotland, Edinburgh.

105. Sir David Wilkie, *Distraining for Rent*, 1815. Oil on panel, 81.3 × 123 (32 × 48¾). National Gallery of Scotland, Edinburgh.

106. Sir David Wilkie, *Chelsea Pensioners Reading the News of the Battle of Waterloo*, 1822. Oil on canvas, 36.5 × 60.5 (14⅜ × 23⅞). Apsley House, London.

107. Walter Geikie, *Our Gudeman's a Drucken Carle*, 1830. Etching, 15.3 × 14.7 (6 × 5¾). Private Collection.

108. William Collins, *Rustic Civility*, 1833. Oil on canvas, 45.75 × 61 (18 × 24). The Victoria and Albert Museum, London. Photo: The V&A Picture Library.

109. William Mulready, *The Sonnet*, 1839. Oil on canvas, 34.3 × 29.8 (13½ × 11¾). The Victoria and Albert Museum, London. Photo: The V&A Picture Library.

110. George Stubbs, *The Lincolnshire Ox*, c. 1790. Oil on panel, 67.9 × 99 (26¾ × 39). Walker Art Gallery, Liverpool. Photo: Board of Trustees of the National Museums & Galleries on Merseyside.

111. Thomas Bewick, *Hedge Sparrow*, c. 1795. Woodcut from *History of British Birds*, 1797–1804.

112. John Wootton, *The Beaufort Hunt*, 1744. Oil on canvas, 203.9 × 245.1 (80¼ × 96½). Tate Gallery, London.

113. James Seymour, *The Chaise Match run on Newmarket Heath on Wednesday the 29th of August 1750*, 1750. Oil on canvas, 106.7 × 167.6 (42 × 66). Paul Mellon Collection, Upperville, Va.

114. George Stubbs, *Whistlejacket*, 1762. Oil on canvas, 292 × 246.4 (115 × 97). © National Gallery, London.

115. George Stubbs, *A Zebra*, 1763. Oil on canvas, 103 × 127.5 (40¼ × 50¼). Yale Center for British Art, Paul Mellon Collection, New Haven, CT.

116. George Stubbs, *Horse Frightened by a Lion*, 1770. Oil on canvas, 100.1 × 126.1 (39½ × 29¾). Walker Art Gallery, Liverpool. Photo: Board of Trustees of the National Museums & Galleries on Merseyside.

117. George Stubbs, *Anatomy of the Horse: Table II: Skeleton*, 1766. 35.6 × 17.8 (14 × 7). Royal Academy of Arts.

118. Philip Reinagle, *A Musical Dog*, before 1805. Oil on canvas, 72 × 92.5 (28¼ × 36½). Virgina Museum of Fine Arts, Richmond, Va. The Paul Mellon Collection. Photo: Ron Jennings. © Virginia Museum of Fine Arts.

119. Sir Edwin Landseer, *The Old Shepherd's Chief Mourner*, 1837. 45.75 × 61 (18 × 24). The Victoria and Albert Museum, London. Photo: The V&A Picture Library.

120. Anon, *Joseph Pestell, Wife and Child, 1844, of Her Majesty's 21st Regiment, or Royal North British Fusiliers*, 1844. Watercolour on paper with sequins, 22 × 18.5 (8¾ × 7¼). Private Collection.

121. Walters, *The William Miles of Bristol*, 1827. Oil on canvas, 47 × 79.5 cms (18½ × 31¼). City of Bristol Museum and Art Gallery.

122. Anon, *The Market Cross, Ipswich*, early nineteenth century. Oil on board, 44.5 × 63.5 (17½ × 25). Rutland Gallery, London.

123. W. H. Rogers, *The Lion Tamer*, mid-nineteenth century. Oil on canvas, 28 × 37 (11 × 14½). Private Collection.

124. Anon, *The Nine Angry Bulls*, mid-nineteenth century. Oil on canvas, 49.5 × 73.6 (19½ × 29). Private Collection.

125. *Popular print from the Bristol Police Chronicle*, published by J. Sherring, Bristol, 1837. Woodcut, 13 × 19.6 (5⅛ × 7⅝).

126. J. Wackett, *A Present from India*, mid-nineteenth century. Wool, 33.5 × 33 (13 × 12⅞). Private Collection.

127. Thomas Rowlandson, *An Artist Travelling in Wales*, 1799. Colour aquatint, 26.7 × 32.7 (10½ × 12⅞). National Museum of Wales, Cardiff.

128. Samuel Scott, *The Arch of Westminster Bridge*, c. 1750. Oil on canvas, 135.5 × 163.8 (53¼ × 64½). Tate Gallery, London.

129. Thomas Jones, *Building in Naples*, 1782. Oil on paper, 14 × 21.5 (5½ × 8½). National Museums & Galleries of Wales.

130. Francis Towne, *The Temple of the Sibyl at Tivoli*, 1781–84. Watercolour with pen, 49.7 × 38.5 (19½ × 15⅛). © British Museum.

131. William Alexander, *The Pingze Men*, 1799. Watercolour over pencil with touches of black ink, 28.4 × 44.8 (8⅞ × 17⅝). British Museum/ Bridgeman Art Library.

132. John Russell, *The Moon*, c. 1795. Pastel on board, 64.1 × 47 (25¼ × 18½). Birmingham City Art Gallery.

133. Philip Reinagle and Abraham Pether, *The Night Blowing Cereus* from Thornton's *The Temple of Flora*, 1800. Mezzotint printed in colour, hand finished, plate size 48.6 × 36.6 (19 × 14¼). By permission of the syndics of Cambridge University Library.

134. John Constable, *Elms at Flatford*, 22nd October 1817. Pencil drawing, 55.2 × 38.5 (21⅞ × 38¼). The Victoria and Albert Museum. Photo: The V&A Picture Library.

135. John Constable, *Study of Cirrus Clouds*, c. 1822. 11.4 × 17.8 (4½ × 7). The Victoria and Albert Museum. Photo: The V&A Picture Library.

136. William Gilpin, Plate from *A Tour of the River Wye*, 1782. Aquatint.

137. Thomas Girtin, *The White House, Chelsea*, 1800. Watercolour on paper, 29.8 × 51.4 (11¾ × 20¼). Tate Gallery, London.

138. Alexander Cozens, *Blot Drawing: Plate 40 from 'A New Method of Assisting the Invention in Drawing Original Compositions of Landscape'*, 1785. Ink on paper, 24.13 × 31.12 (9½ × 12¼).

139. Anon, *A View of London and the Surrounding Country taken from the top of St Paul's Cathedral, c.* 1845. Tinted aquatint, 75.5 (29⅞) in diameter. Private Collection.

140. Joseph Mallord William Turner, *Venice: Looking East from the Giudecca, Sunrise,* 1819. Watercolour, 22.2 × 28.7 (8¾ × 11⅜). Tate Gallery, London.

141. Thomas Girtin, *Stepping Stones on the Wharfe, c.* 1801. Watercolour, 32.4 × 52 (12¾ × 20½). Private Collection.

142. Richard Parkes Bonington, *Verona: The Castelbarco Tomb,* 1827. Watercolour and bodycolour over pencil, 19.1 × 13.3 (7½ × 5¼). City of Nottingham Museums and Art Gallery.

143. John Sell Cotman, *Croyland Abbey, Lincolnshire, c.* 1804. Pencil and watercolour with scrapping out on laid paper, 29.5 × 53.7 (11½ × 21). © British Museum, London.

144. J. C. Bourne, *Kilsby Tunnel, Northants,* 1838–39. From *London to Birmingham Railway.*

145. Jacob More, *Morning,* 1785. Oil on canvas, 52.2 × 202 (20½ × 79½). Glasgow Museums: Art Gallery and Museum, Kelvingrove.

146. Richard Wilson, *Croome Court, Worcestershire,* 1758–59. Oil on canvas, 48 × 66 (129½ × 165). By permission of the Croome Court Estate Trustees.

147. William Hodges, *Tahiti Revisited, c.* 1773. Oil on canvas, 89.5 × 136 (35¼ × 53½). National Maritime Museum, Greenwich, London.

148. John Robert Cozens, *Lake Albano and Castel Gandolfo, c.* 1783–88. Watercolour on paper, 48.9 × 67.9 (19¼ × 26¾). Tate Gallery, London.

149. Thomas Gainsborough, *Cornard Wood,* 1748. Oil on canvas, 121.9 × 154.9 (48 × 61). © National Gallery, London.

150. Thomas Gainsborough, *The Harvest Wagon, c.* 1767. Oil on canvas, 120.5 × 144 (47⅝ × 56¾). Barber Institute of Fine Arts, University of Birmingham/ Bridgeman Art Library.

151. John Linnell, *River Kennett, near Newbury,* 1815. Oil on canvas on wood, 45.1 × 65.2 (17¾ × 25¾). Fitzwilliam Museum, Cambridge.

152. Joseph Mallord William Turner, *Ploughing up Turnips, Windsor, c.* 1808–10. Oil on canvas, 70 × 128 (27½ × 50½). Tate Gallery, London.

153. John Constable, *Flatford Mill,* 1817. Oil on canvas, 101.7 × 127 (40 × 50). Tate Gallery, London.

154. John Constable, *Chain Pier, Brighton,* 1827. Oil on canvas, 127 × 182.9 (50 × 72). Tate Gallery, London.

155. John Constable, *Barges at Flatford Lock, c.* 1810–12. Oil on paper laid on canvas, 26 × 31.1 (101.4 × 12¼). The Victoria and Albert Museum. Photo: The V&A Picture Library.

156. Francis Danby, *Clifton Rocks from Rownham Fields. c.* 1821. Oil on panel, 40 × 50.8 (15¾ × 20). Bristol City Museum and Art Gallery/Bridgeman Art Library.

157. William Blake, *Illustrations to the Pastorals of Virgil,* edited by Dr. R. J. Thornton from *The Imitations of the Eclogues,* Ambrose Phillips, 1821. Wood engravings, each approximately 3.3 × 7.3 (1¼ × 2⅞).

158. Samuel Palmer, *A Rustic Scene,* 1825. Sepia drawing, 17.5 × 20.8 (7 × 9.3). Ashmolean Museum, Oxford

159. John Constable, *Salisbury Cathedral from the Meadows,* 1831. Oil on canvas, 151.8 × 189.9 (59¾ × 74¾). Private Collection on loan to the National Gallery, London.

160. John Constable, *The Cornfield,* 1826. Oil on canvas, 143 × 122 (56¼ × 48). © National Gallery, London.

161. Richard Wilson, *The Destruction of the Children of Niobe,* 1760. Oil on canvas, 147.3 × 188 (58 × 74). Yale Center for British Art, Paul Mellon Collection, New Haven, Ct.

162. Philippe De Loutherbourg, *An Avalanche in the Alps,* 1803. Oil on canvas, 109.9 × 160 (43¼ × 63). Tate Gallery, London.

163. Philippe De Loutherbourg, *Coalbrookdale by Night,* 1801. Oil on canvas, 67.9 × 106.7 (26¾ × 42). Science Museum. Photo: Science and Society Picture Library.

164. Joseph Mallord William Turner, *The Shipwreck,* 1805. Oil on canvas, 170.5 × 241.6 (67⅛ × 95⅛). Tate Gallery, London.

165. Joseph Mallord William Turner, *Snow Storm: Hannibal and his Army Crossing the Alps,* 1812. Oil on canvas, 146 × 237.5 (57½ × 93½). Tate Gallery, London.

166. James Ward, *Gordale Scar,* 1812–14. Oil on canvas, 332.7 × 421.6 (131 × 166). Tate Gallery, London.

167. John Martin, *Belshazzar's Feast,* 1826. Mezzotint, 60.5 × 88 (23¾ × 34¾). Laing Art Gallery, Newcastle.

168. John Martin, *The Great Day of His Wrath,* 1852. Oil on canvas, 196.5 × 303.2 (77⅜ × 119⅜). Tate Gallery, London.

169. Francis Danby, *The Deluge,* 1840. Oil on canvas, 71.1 × 109.2 (28 × 43). Tate Gallery, London.

170. Joseph Mallord William Turner, *Norham Castle, Sunrise, c.* 1844. Oil on canvas, 90.8 × 121.9 (35¾ × 48). Tate Gallery, London.

171. Joseph Mallord William Turner, *Ulysses Deriding Polyphemus,* 1829. Oil on canvas, 132.7 × 203.2 (52¼ × 80). © National Gallery, London.

172. Joseph Mallord William Turner, *Interior at Petworth, c.* 1837. Oil on canvas, 90.8 × 121.9 (35¾ × 48). Tate Gallery, London.

173. Joseph Mallord William Turner, *The Slave Ship (Slavers Throwing Overboard the Dead and Dying – Typhoon coming on),* 1840. Oil on canvas, 90.8 × 122.6 (35¾ × 48¼). Courtesy Museum of Fine Arts, Boston. Henry Willie Pierce Fund.

174. Joseph Mallord William Turner, *The Fighting Temeraire Tugged to her Last Berth to be Broken Up,* 1838. Oil on canvas, 90.8 × 121.9 (35¾ × 48). © National Gallery, London.

175. Joseph Mallord William Turner, *Rain, Steam and Speed – The Great Western Railway,* 1844. Oil on canvas, 90.8 × 121.9 (35¾ × 48). © National Gallery, London.

Index